Surrealism and Dadaism

Front cover:

Hans Arp
The dancer, **1917**
Oil on canvas, 121 × **109 cm**
Paris, Private Collection

Salvador Dali
The burning giraffe
Oil on wood, 35 × **27 cm**
Basle, Kunstmuseum
Emanuel Hoffman Foundation

Back cover:

Kurt Schwitters
Star picture, Merz picture 25A, **1920**
Montage, collage, oil on cardboard,
104.5 × **79 cm**
Düsseldorf, Kunstsammlung
Nordrhein-Westfalen

Joan Miró
Persons and dog before the sun, **1949**
Tempera on canvas, 81 × **54.5 cm**
Basle, Kunstmuseum,
Emanuel Hoffman Foundation

Phaidon 20th-century art

With 74 colour illustrations

Arp	Ernst	Morandi
Blume	Fini	Oelze
Brauer	Fuchs	Picabia
Carrà	Hausmann	Picasso
Chagall	Hausner	Pollock
Chirico, de	Hutter	Ray
Dali	Lam	Schwitters
Delvaux	Lehmden	Tanguy
Dominguez	Magritte	Tanning
Dubuffet	Masson	Toyen
Duchamp	Matta	Wols
Ende	Miró	Zimmermann

Marianne Oesterreicher-Mollwo

Surrealism and Dadaism

Provocative Destruction, the Path within
and the Exacerbation of the Problem of a
Reconciliation of Art and Life

Phaidon · Oxford

Contents

The author and publishers would like to thank the museums and galleries for their support in the production of this volume.

Bibliography

A. Breton: *Der Surrealismus und die Malerei* (collection of texts, Berlin, 1967)

P. Bürger: *Der französische Surrealismus* (Frankfurt am Main, 1971)

G. R. Hocke: *Malerei der Gegenwart: der Neo-Manierismus* (Wiesbaden-Mainz, 1975)

R. Huelsenbeck (ed.): *Dada, eine literarische Dokumentation* (Hamburg, 1964)

G. Metken (ed.): *Als die Surrealisten noch recht hatten* (texts and documents, Stuttgart, 1976)

J. Muschik: *Die Wiener Schule des phantastischen Realismus* (Gütersloh, 1974)

M. Nadeau: *Geschichte des Surrealismus* (Hamburg, 1965)

G. Picon: *Der Surrealismus in Wort und Bild* (Paris, Geneva and Brussels, 1976)

H. Richter: *Dada-Art and Anti-Art: Texts and Perspectives* (London, 1965)

W. S. Rubin: *Dada and Surrealist Art* (London, 1969)

W. Verkauf, M. Janco, H. Bollinger: *Dada, Monographie einer Bewegung* (Teufen, 1965)

Translated by Stephen Crawshaw

Phaidon Press Limited, Littlegate House, St Ebbe's Street, Oxford
First published in Great Britain 1979
Published in the United States of America by E. P. Dutton, New York.
Originally published as *Surrealismus und Dadaismus*
© 1978 by Smeets Offset BV, Weert, The Netherlands
German text © 1978 by Verlag Herder, Freiburg im Breisgau
English translation © 1979 by Phaidon Press Limited
Illustrations © Beeldrecht, Amsterdam.
ISBN 0 7148 1954 9
Library of Congress Catalog Card Number 79-83785
Printed in The Netherlands by Smeets Offset BV, Weert

The contemporary situation

The first quarter of the 20th century was full of tensions and intensely lived; it was as though powerful streams, leaving the old times behind them, were attempting to burst their banks. Developments which had proceeded from earlier, perhaps essential, beliefs and decisions, principles and rules which for a long time had been useful to the practical coexistence of man, had, by the end of the 19th century—if not before—developed in their different ways into monstrosities which threatened to crush the spiritual substance of man.

There was undoubtedly a series of very complicated interacting factors and impulses whose combined effect gave us the situation, still far from being clearly defined, that we have today. Here, in dealing with this contemporization of the situation, we will of course concentrate especially on the aspects and problems which probably most strongly influenced and affected the artists of Dadaism and Surrealism.

1. The rapid development of technology and the constantly growing industrialization associated with it made 'the machine' a force which, together with its many advantages, also had a menacing aspect for man. The main stream of general enthusiastic belief in progress was already at an early stage accompanied by an undercurrent of fear towards the new forms of life and work which were coming to the fore with the new technology.

The machine affected man's way of living in the most varied areas, which were often tailored to the conditions dictated by the machine. Such changes ranged from enthusiastically received changes in modes of communication brought about by the telephone, the railways, and so on, to the brutally stupefying subjection of the personality, in ten-hour or longer piece-work, to the demands of purely mechanical progress.

The First World War then showed in an unexpectedly shocking way how perfectly the new technology could be used as military machinery for the mass extermination of man. The horror at this fact, especially amongst intellectuals and artists, was felt particularly strongly because a kind of European internationalism had already developed at an intellectual level.

In art, there was, admittedly, little trace of any fear of technology. Futurism talked rapturously of 'a racing car, whose steel body is adorned with thick pipes, in which glowing snake's breath seethes . . . , a screaming car, seeming to run on grapeshot, is more beautiful than Nike of Samothrace.' The nature-mystical aspects of Expressionism and the mythologizing devout mystery of Symbolism may well, of course, be taken as the expression of unease with an increasingly industrialized world, perhaps also as a nostalgic glance back to more intensely experienced worlds, and, at the same time, as the dreamed-of reflection or manifestation of a more human world, close to nature once more. Abstract Art may in this sense (even if it does at the same time show a

5

preference for 'technical' forms) also be seen as a withdrawal from the complexity of an ever more incomprehensible world, towards formal simplicity and discipline.

2. Together with the failure to cope with the fast-developing technology, ever since the mid-19th century the inhuman features of capitalist economic organization, most blatant around the turn of the century, had been becoming clearer and clearer, and had impressed themselves on the general consciousness. The number of production workers, usually receiving very poor wages, had increased rapidly as a result of industrialization, and the situation of workers in general was critical, without any kind of security, either social or in terms of labour rights.

The Russian Revolution of 1917, which brought communists to power for the first time, represented for all Europe, both for workers and for many intellectuals, a fascinating challenge, which was finally to be of greater significance for the history of the Surrealist movement than its founders had ever dreamed.

In art, the reflection of social critical ideas was much less obvious than one might have expected, given the seismographic sensitivity usually ascribed to the artist. This is no doubt partly connected with the fact that causal and processal connections can only with great difficulty be realized directly in visual terms. Satire and clear accusation were the means best suited to this end, as used by Expressionists or artists close to Expressionism such as Max Beckmann, Otto Dix, George Grosz, or Käthe Kollwitz.

3. The upsurge of the sciences in the 19th century and the popularization of scientific thought, together with its penetration into the most intimate recesses of consciousness, had caused a paralysis of previously religious or general metaphysical thought and experience. Since the middle of the 19th century, positivism, recognizing only empirical data as the basis for knowledge, had for several decades been the dominant scientific ideal. This went hand in hand with a scientifically optimistic, materialist philosophy, based on achieved scientific progress. At the same time—and as a reaction to this situation—esoteric and spiritualist circles flourished, a phenomenon which should perhaps be seen not simply as a parlour game for bored high society ladies, but rather as a general symptom of the insistent dissatisfaction of those levels of consciousness which in a sense lacked a subject for their attentions.

Symbolism, dominant on the European art scene around the turn of the century, must also partly be seen as a reaction to the 'non-spirituality' of the ever more powerful industrial age. It turned towards the mysterious, the ambiguous, and the significant, in the hope of finding new dimensions here, which would be able to give new heights and depths to the flattened perspectives. Looking forward to Surrealism, one is on the one hand struck by the artificial, deliberately arranged quality of Symbolist art, but also by the awareness of a new thematic approach. Symbolism admittedly preferred the field of the mythologizing semi-conscious, but at the same time it touched on the level of the dream and the unconscious, later to become *the* dominant theme of the Surrealists. Odilon Redon (1840–1916) had already expressed the view that: 'In art, nothing occurs by the will alone, and everything by the obedient submission to the unconscious which opens up below it.'

The abstract painters had already attempted, in a very different way to the Symbolists, to reactivate in art the meditative qualities which had been relegated to oblivion. In 1912, Wassily Kandinsky's fundamental and influential *Über das Geistige in der Kunst* ('On the Spiritual in Art') was published. Piet Mondrian (who was a member of the Theosophical Society) and Kasimir Malevich were especially metaphysically oriented in their work. The 'non-objective world' gave them a spiritual lucidity that they could no longer find elsewhere.

4. The end of the 19th century suffered more and more clearly from the dichotomy between the hypocritical 'correctness' of public morality and the elementary needs of eroticism and sexuality, often satisfied in secret and with a bad conscience—a situation that became all the more absurd when the rules of moral behaviour were no longer even propped up by any

religious framework determining everyday life, and thus existed in a void. Attitudes to love and to women were often distorted by the pressure of guilt feelings on the one hand and by homosexual fantasies on the other. The situation was characterized by a kind of double standard, which publicly enthusiastically advocated highly stylized ideals of purity, while secretly indulging in 'sin'. This situation of social conflict demanded solutions, and one was provided towards the end of the century with the 'discovery' of hysteria. The subsequent development of psychoanalysis was to be an essential catalyst for the Surrealists in the development of their own views and methods.

In the field of art, Expressionism had already attempted to break down the barriers of anaemic decorum, by turning to themes touching man at the most basic level (love, conception, birth, death, and so on). Symbolism played on various levels an aesthetically veiled, very ambiguous game of hide-and-seek with officially condemned 'sin'; Franz von Stuck's 1891 painting with this title clearly embodies this simultaneous mixture of attraction and revulsion. Dadaism's and Surrealism's all-out attack on the bourgeois mechanisms of repression then obviously took place in a more complete way, as an attempt to get to the roots of the whole problem.

5. While the four preceding points have emphasized general features of the time which were relevant to the development of Dadaism and Surrealism, one last consideration should be mentioned which was pertinent specifically to art: the *formal* possibilities of painting had already been exhausted in various different directions before the growth of Dadaism and Surrealism. Naturalism had long since developed into a mere illusionist technique of reproduction, and found itself moreover being gradually ousted by photography. Experiments with visible reality had apparently, with Impressionism and Fauvism (in terms of colour) and with Cubism and Futurism (in terms of form), reached a stage beyond which there seemed to be no further possibilities. Even Abstract Art had as early as 1913, with Kasimir Malevich's famous *Black Square on a White Background*, reached the basic limit of its possibilities. Innovations in the further development of art could thus very probably be expected only in the field of content, *i.e.* by turning towards new *thematic* levels.

Dadaism: clean slate, or how far does absolute nonsense go?

It is possible earnestly and with dignity to inform one's contemporaries that one is disappointed and helpless, but it is also possible to thump one's fist down on the table so that the crockery slides off it, the coffee spurts up to the ceiling, and the rolls find themselves sitting on the couch, whereupon one can then laugh loudly and violently once more. The Dadaists chose the second of these two alternatives, in order, as it were, pantomimically to liberate themselves from the tensions created within them by the whole contemporary situation, and particularly the First World War, in which several of them saw active service.

The proclamation of worthy ideals and values like patriotism, courage, and God's will, in favour of nationalism, militarism, capitalism, etc. had completely shattered any remaining credibility of the bourgeois ideals. Even reason and logic, with whose aid those ideals had been twisted and turned in such a way as to fit in with particular people's interests, had thus come into disrepute. It suddenly seemed as though one could say everything and nothing with words, as though logical argument could turn 'evil' into 'good', and as though the best thing was not to speak at all—or, if one did speak, then only illogically and unreasonably.

'Dada is the revolt of the unbelievers against unbelief. Dada is the longing for belief. Dada

is the disgust with the foolish rational explanation of the world' (Hans Arp). In other words: we Dadaists do not believe in your bourgeois declarations of belief and in your promises, and therefore we are unbelievers in protest. Your 'belief' amounts to nothing, and is thus itself unbelief; but your unbelief is not the same as our unbelief; and, in addition—in order to complete the dialectic, and to keep any programmatic significance hanging in the balance—we long for belief, even if none of us knows what it really is.

Dada is above all an attitude of mind without a specific programme, 'disgusted by the slaughter of the world war' (Hans Arp), an activity corresponding to the needs of this attitude of mind. One of the Dadaists' own definitions is: 'Dada exists when one is alive.' But in order to be able to live, as the Dadaists saw it, it was apparently crucial to tear down the conventional masks of the age, and to destroy the bourgeois façade of harmony.

The word 'dada' means 'hobbyhorse' in French; it was found during the random thumbing through a German-French dictionary. But in its apparently senseless stammer it nevertheless corresponded to the international make-up of the whole movement, for 'in Russian it means yes, yes; in French, it means rocking horse—and hobbyhorse. For the Germans it is a sign of foolish naivety and attachment, with delight in procreation and the perambulator' (Tristan Tzara). It is in addition worthy of note that both the concept 'Dada' and later the concept 'Surrealism' were either coined by the representatives themselves or explicitly taken over, in contrast to many designations of the modern isms, which were initially invented by outsiders as terms of mockery.

We shall later give a brief outline of the individual Dada groups, but let us first examine some of the facts and circumstances affecting the Dada movement as a whole.

It would undoubtedly be wrong to try and suggest that Dada *necessarily* must have developed out of some previous direction in art. But it is helpful to the understanding (dependent as this is on comparisons and definitions) of an art-historical phenomenon to mention analogous or similar phenomena in a different context. The attitude of protest had, since the turn of the century, become quite normal in art both aesthetically and thematically, as anti-academicism. The avant-garde of the time usually dissociated itself, with protests and often hostility, from other movements, and especially from academic art. A protest on a larger scale, which went beyond the traditional boundaries of visual art itself, had been made by the Italian Futurists in the pre-war period. They fought vehemently against logic, intellect, bourgeois culture and bourgeois values, and glorified instead speed, technology, battle and war. Like the Dadaists later, they sought a public forum, regularly organized provocative events for the propagation of their ideas, and, driven on by missionary zeal, composed countless manifestos and leaflets. They experimented with the collage technique developed by Picasso and Braque. Occasionally they (particularly Carrà) advocated the idea of a total art including music, visual art, and literature. In addition, they were already writing pure sound poems, like the German 'verbal art' representatives in the Sturm circle around Herwarth Walden.

These activities, all more or less outside the range of classical artistic production, gained a new and radical significance with the Dadaists for whom they occupied the central place. Unlike Futurism, which had after all created its own style of painting, Dada did not produce any particular 'style'. They also lacked the optimism with which the Futurists celebrated the achievements of the industrial age. And they completely lacked the nationalist attitudes which brought the Futurists ideologically close to Fascism. As a whole, the Dadaists were much less directed towards an end than the Futurists. The experiences of the First World War made them considerably more sceptical and more distanced than the Futurists could be, and they largely lacked the revolutionary impetus which wants 'something'. Dada's attitude was on the one hand negative, destructive, and on the other gingerly seeking for new structures; the fact that the whole Dada movement was much more individual and many-sided was also of significance in this connection.

The central concepts in terms of which the negative destructive activities of the Dadaists can be summed up are 'provocation' and 'nonsense', a kind of positive reverse side of the coin to the concept of 'chance'.

Chance has, it is true, always played an important part as a source of inspiration for artists. Leonardo da Vinci wrote in his *Treatise on Painting*: 'It is in my opinion not useless if you pause in the realization of pictorial forms and look at the spots on the wall, at the ashes of the hearth, at the clouds, or in the gutter: on careful observation, you will make wonderful discoveries there, which the genius of the painter can turn to good account in the composition of human and animal battles, landscapes, monsters, devils, and other fantastic things which you can use to your advantage. These confused things awaken the genius to new inventions, although one must have learnt well how to do all the parts, especially the limbs of the animals and the forms of the landscape, its plants, and its stones.' At the same time, however, it is clear that chance is only allotted the role of an outside stimulus for the artist; the completed work must no longer reveal anything of this influence. The Dadaists' approach was different. They did not only make use of chance, rather they turned it explicitly into their theme and displayed it—particularly in literary and scenic terms—with all its bereftness of sense. Why? As has already been suggested, the Dadaists at first saw in the existing situation no other possibility of action than total negation. What remains after the dissolution of all rational connections, as that which cannot be discussed away, is chance. The mind which abandons all logical and rational connections does not produce a void, it simply moves, without any preparatory and structuring perceptional attitude, from one phenomenon to another, which then appears as chance. But such an attitude makes it possible to perceive more than the usual selective perception and thought: the impetus in the creative relation to chance is thus the hope of learning to see with *new eyes*. A radical questioning and removal of old-established approaches, comparable in very general terms, was also propagated at approximately the same time as the conscious method of the perception renewal expressed in the philosophical phenomenology of Edmund Husserl (*Ideen zu einer reinen Phänomenologie*, 1913). Husserl advocated a 'bracketing' (temporary deferment) of any judgement of existence with regard to all phenomena occurring in consciousness, in order thus to prevent any specific elements being dropped or distorted through previous knowledge or pre-judging of issues; to start with, everything existent in one's consciousness was merely to be *looked at* on an equal basis. Descartes, whom Husserl quotes, had in his *Meditationes de prima philosophia* already attempted to penetrate to the essential principles of perception by the hypothetical lifting of all judging acts of the conscious.

We do not wish to suggest with these examples that the Dadaists did the same—but it seems significant that whenever old structures are no longer able to bear their burden, and new ones have not yet been found, then it is apparently natural for the slate to be wiped clean, in order to learn to see with new eyes. Dada is not a philosophy, and thus it did not act systematically, but rather playfully, and provoked with its deliberate nonsense. For the Dadaists thought existed less in their heads than, as Tzara formulated it challengingly, 'in the mouth', or, in the case of visual artists, in their hands. Surrealism later probed the possibilities of the wide field of consciousness opened up after the setting aside of all bourgeois prejudging and pre-knowledge structures.

The creative means of Dadaism were applied in different areas of art in analogous ways. Dadaist music used noises above all. The Futurist Luigi Russolo had for this purpose invented a noise organ ('intona rumori'), and performed 'Bruitist' compositions on it. The Dadaist writers used primarily alogical combinations of sentence and word fragments: unusual and senseless combinations, which, however, for exactly that reason conveyed new information. In addition, new typographical and typesetting forms were developed. The main creative means of the visual artists were collage, painted collage, and the exhibition of found objects. The individual fields

of art were of course often not separated, but brought together as a unity in something approaching total art events, in which there was simultaneously noisy 'music-making', reciting, and visual display. Occasionally, happening-like events were held with an emphatically shocking character, like the following description by Georges Hugnet of a performance in Zurich: 'On the stage, keys and tins were beaten. That was supposed to be the music. The public went wild and protested. Instead of reciting poems, Serner laid a bouquet of flowers in front of a dressmaker's dummy. Under a huge sugarloaf-shaped hat, a voice declaimed poems by Arp. Huelsenbeck bawled out his poems, increasing more and more into a roar. Tzara accompanied him at the same time, beating on a large drum, with the same rhythm and crescendo as the reciter. Huelsenbeck and Tzara also danced and made noises like young bears, or waggled and hopped, one in a sack and with a pipe over his head, in a choreography which they called the Black Cockatoo.'

Literature could appear more Dadaist, i.e. more destructive and more 'random' than visual art and music, since the removal of sense connections can be made clearer in a medium which is in itself designed for sense and logic. Visual art, especially painting, and music, are already in any case closer to the non-rational. But here too the shocking break with artistic tradition had a powerful effectiveness in the Dadaist sense.

It should at this point not be forgotten that Dada, with all its bitter provocation and all its therapeutically administered nonsense, never completely abandoned the level of refined taste, the aesthetically attractive, and, above all, the explicitly witty elevated absurdity. We only have to look at the work of Joachim Ringelnatz or at Christian Morgenstern's *Gallows Songs* to see that profound 'imbecilities' were in any case in the air at that time. But provocation with blood-curdling horrors did not occur in later happenings.

We shall later give a brief outline of the various Dada groups, but it would go beyond the bounds of this book if we were to follow up the various cross-connections of the groups and the paths followed by individual artistic personalities who were important in different places one after another. We shall therefore restrict ourselves to mentioning the most outstanding characteristics and artists of any given group.

The Dada movement was only alive for a brief period, from about 1916 to 1922, and almost simultaneously in different places. On February 5, 1916, the German writer Hugo Ball together with some friends founded the Cabaret Voltaire in Zurich, in the hope that 'there might be some young people in Switzerland to whom, like me, it matters not only to enjoy but also to demonstrate their independence.'

Intellectual emigrés from various countries were gathered in Zurich at that time. The dominant intellectual atmosphere tended towards an anarchistic philosophy. The Cabaret Voltaire—the name already suggests free-thinking aspirations—not only put on cabaret performances, but also organized exhibitions, and at the same time became a kind of club for Dadaist gatherings. The most important literary personalities of this first Dada group were, apart from the founder Hugo Ball, another German writer, Richard Huelsenbeck, and the Rumanian writer Tristan Tzara, whose activities included editing the magazine *Dada* and the composition of various Dadaist manifestos.

Particularly important amongst the literary events of the cabaret stage were the performances of simultaneous poems by Tzara, Huelsenbeck, and Marcel Janco, accompanied by Bruitist music: multilingual 'composed' monologues, delivered simultaneously by various people at different volumes and speeds, composed of illogical combinations of language fragments, aiming at various different emotional associations. They were to make evident 'the confusion of everything in the consciousness'.

Amongst the visual artists of the Zurich Dada group, the Rumanian Marcel Janco and the

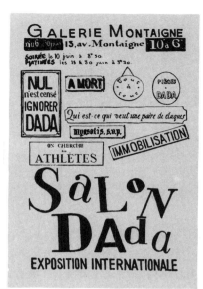

Poster and catalogue of the Salon Dada, 1921

Alsation Hans (or Jean) Arp were of especial significance. Janco soon devoted himself exclusively to concrete painting. Arp, too, is closer to pure concrete art than most of the other Dadaists. His work was admittedly only Dadaist inasmuch as it was often inspired by accidentally discovered natural forms and various technical experiments (e.g. the application of paint on crumpled paper)—his creations are usually so balanced and harmonious that their provocative nature is very limited.

The most radical Dadaist artist was probably the French Marcel Duchamp. From 1915 he lived in New York, and, together with Francis Picabia and Man Ray, he became one of the central figures of the Dada group there, formed around the photographer Alfred Stieglitz and the journal *291*. Duchamp was 'constantly ruminating on the laws of chance' (Maurice Nadeau) and tinkered with various fantastic 'machines', which, together with Picabia's ironic machine pictures, demonstrate the often erotic overtones of the Dadaists' approach to the machine. Duchamp was the most consistent in his exploitation of the perceptional possibilities offered by chance, the random found object, if we look at it with different eyes from usual. He exhibited a series of manufactured objects (of which the urinal and the bottle rack were to become the most famous) as 'works of art' in an empty museum space. These so-called 'ready-mades' provoked a series of different interpretative reactions—initially, most conspicuously, indignation. On the one hand they undoubtedly represent a mockery of the solemn approach to museums, but they were at the same time a positive step towards removing the public's inhibited attitude towards the 'holy halls'. Their exhibition in a museum can also be seen as a call for the uniting of art and life (a concept which became one of the main slogans of modern art). In a very vague way, which as yet conveys little information, the demand is made that the artist should not create a 'counter-world' to the ordinary everyday world. The concentration with which the viewer is forced to look at an individual object emphasized in this way may, in addition, cause him to see the object's aesthetic qualities impartially for the first time, and an object with which he has previously had only practical dealings, can give him 'disinterested pleasure'. This aspect of ready-mades also led to the fact that, against the original tone of provocation, they finally became marketed just like any other art object, and thus prepared the way for the aestheticizing of the trivial in Pop Art. One further notable aspect of Duchamp's decision to exhibit ready-made industrial products is the fact that it no longer involved any artistic creative act, and the *idea*, the *gesture* was honoured. Subsequently, many variants of this reassessment of the creative act were developed with increasing emphasis on the literary aspect—finally leading to Concept Art and happenings, which were no longer even executed, but were limited to the detailed announcement of programmes.

We have gone into the Duchamp phenomenon in some detail, because with him a decisive turning point in artistic development was indeed reached, whose initial effect was so extreme and shocking that it seemed as though it must be a final stage—though it carried within it the germ of many new tendencies.

Around 1920, inspired by the Zurich Dadaist Huelsenbeck, the Dada Club in Berlin was formed. The members, apart from Huelsenbeck, included George Grosz, Raoul Hausmann, John Heartfield (Helmut Herzfelde), Hannah Höch and Walter Mehring. The Berlin group was essentially socially critical, without being politically committed. They were close to communism, but were at the same time (particularly Grosz and Heartfield) enthusiastic about everything American. The most notable artistic innovation of this group was the photomontage, which was often used for political ends, particularly in posters.

The Hanover artist Kurt Schwitters cultivated the principle of 'chance' in an attractive and varied way with his creation of material collages from waste products like pieces of string, tram tickets, matches, business papers, etc. His acceptance into the Berlin Dada Club was refused in 1918 on the basis of his eccentric and at the same time solidly bourgeois life-style; according

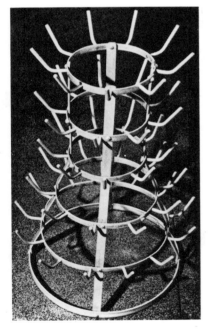

Marcel Duchamp,
Bottle drier, **1914**

to Huelsenbeck, he lived 'like a Victorian *petit bourgeois*', and the Berlin Dadaists called him the 'abstract Spitzweg', the 'Caspar David Friedrich of the Dadaist revolution'.

In Cologne a new Dada group was formed, inspired by Hans Arp, Max Ernst, and Johannes Baargeld, which, however, soon moved towards Surrealism. Parisian attempts to bring Dadaism to life again formed an essentially literary prelude to the Surrealism that developed there subsequently. Dadaism could only last for a short time, for it lived on the power of basically uncomprehended contradictions. Its main problem was the fact that it was thought of as an appeal, yet, at the same time, it neglected any genuinely comprehensible intersubjectivity (using the word 'intersubjective' to mean the possession of insight into the consciousness of other people). It should be stressed, however, that it emphatically pointed to unconventional artistic means, and thus propagated the letters for the alphabet of a new 'language' which was subsequently stammered out and spoken from the Surrealists to Joseph Beuys.

Surrealism:
the attempt at a creative reconciliation of
pure subjectivity and general consciousness

John Heartfield,
photomontage, 1932

Aims and methods

The Surrealist movement might be described as both the common denominator and the most extreme variants of irrational, fantastic phenomena recurring throughout the history of art, in which context names like Arcimboldo, Bosch, Brueghel, Goya, Füssli, E. T. A. Hoffmann, Poe, Rabelais, and so on, might be mentioned. But we will here avoid such comparisons, which without taking into account a vast corpus of material would inevitably remain only very vague analogies. In addition, we must in this short introduction also omit a fully coherent description of the history of Surrealism, which may best be provided by Maurice Nadeau's *History of Surrealism*, still the most informative work on the subject.

Rather, we will restrict ourselves to touching on the chronology of the Surrealist movement with the help of some of its aspects which seem to us to be essential.

With Tzara's appearance in Paris in December 1919, Dadaism finally spread to the then capital of the art world. The initial grouping around him included Francis Picabia, Louis Aragon, André Breton, Paul Eluard, Marcel Duchamp and Arthur Cravan, among others. André Breton later wrote of Tzara in *Caractères de l'évolution moderne*, calling him the man 'with the provocative look': 'His mere presence finally put an end to all the banal respectable discussions which at that time were increasingly reducing Paris to a provincial level.' For a time, the Dadaists succeeded in shocking the Parisians with their nonsense performances. D'Esparbès, a journalist with little love for the Dada movement, described an orgy of the absurd put on by the Dadaists on the occasion of an exhibition of collages by Max Ernst: 'With the tastelessness typical of them, the Dadaists on this occasion resorted to frightening people. The scene was played out in the cellar, and all light in the establishment was extinguished. From a trapdoor came constant sighing and groaning. One of the wits had hidden behind a cupboard and showered the audience with obscenities. . . . The Dadaists, without ties and in white gloves, constantly wandered up and down. . . . André Breton chewed on matches, Ribemont-Dessaignes kept shouting "it's raining on a skull", Aragon miaowed like a cat, Philippe Soupault played hide-and-seek with Tzara, Benjamin Peret and Charchoune endlessly shook each other's hands. Jacques Rigaut lounged by the entrance and counted aloud the cars and the pearls of the ladies in the audience. . . .' The witty effect of such scenes suggests that the Parisian public, cushioned by all the artistic scandals of the avantgarde

De nos oiseaux
**by Tristan Tzara;
illustration by Hans Arp
and page of text, 1923**

of the time, only gained enjoyment from such provocations. The phenomenon has since become familiar in modern art, which increasingly aims not so much to achieve beautiful effects to make people think again, thus often leading to provocation, while that provocation is often followed by marketing and delighted consumption by snobs.

But the writer André Breton, who a little later became the leading figure of the Surrealist movement, soon sounded a more dangerous and serious note, and thus showed that mere nonsense was not enough for him, and that he wanted rather to see more tangible results. Breton's group was essentially from the very beginning a separate group swimming along with Dadaism.

A Dadaist show trial, held on Breton's initiative and against Tzara's advice, against Maurice Barrès, an egocentric, anti-German, nationalist and chauvinist writer, became the occasion of a clear confrontation between Breton and Tzara: at 8.30 pm on May 13, 1921, in the Salle des Sociétés Savantes at 8, Rue Danton, the Dadaists appeared in working overalls, white aprons, and judge's caps, and tried Barrès in the form of a wooden doll, in a trial which, thanks to Breton's participation, was carried out more logically than had come to be expected of Dada events. Breton was seriously concerned to deal a blow to the danger of nationalism and the glorification of the ego and of talent, as a representative of which he saw Barrès, and he understood that this could only be done systematically. Tzara, on the other hand, in good Dadaist style, played the madman in a completely unserious fashion, finally driving the court chairman Breton to utter the very un-Dadaist and logical warning: 'Does the witness wish to play the complete idiot here, or does he want to drive the court to have him locked up in a closed asylum?'

Two years later, on the occasion of a performance of Tzara's *Coeur à gaz* in July 1923, the final break occurred, amidst tumultuous scenes, between the newly developing Surrealist group and the stalwart Dadaists.

Dadaism had fulfilled its task, and the Surrealists profited from the spiritual and intellectual relaxation which it had achieved, as could be seen even in the most varied provocative events which they later put on. Breton later saw the relationship between Dadaism and Surrealism in the following way: 'It will be impossible to say that Dadaism was used for anything else except to put us into this state of readiness and total openness in which we waited until going into action, in order then to break out of it, without any illusions, towards what preoccupied us' (*Les pas perdus*).

Those who saw things in more than the short term had long understood that the search for new forms of a life which did not suppress man's needs—for that was the essential crux—had to be based on more solid principles. While Dadaism was finally victorious in the other places in which it had made itself felt, the group around André Breton, especially Louis Aragon, Paul Eluard, Philippe Soupault, Robert Desnos, Max Morise, and Roger Vitrac, among others, with energy and some persistence continued the trail blazed by Dadaism into hitherto unknown territory. They studied Hegel and Einstein and 'eagerly ran to Bergson's lectures at the Collège de France to hear how he dissected logic and declared the omnipotence of *élan vital* and of creative development' (Maurice Nadeau, *History of Surrealism*). But all that remained too general and verbal for them, they were basically interested in *experiencing* things which lay beyond the reach of mere intellect. The budding Surrealists thus at first patiently, seriously, and with a quasi-scientific approach, embarked on the 'path within'.

Some of them had studied a little medicine, and had thus become familiar both with the manifestations of mental illnesses and also partly with Freud's work. Breton, in particular, who had during the war worked for some time as an assistant doctor in the psychiatric centre of the Second Army in St. Dizier, soon saw that the key to the long-sought new realms lay in psycho-analysis. We should not of course give the impression that Freud was the only person who made

SELS DE MINUIT

arc voltaïque de ces deux nerfs qui ne se touchent pas
près du cœur,
on constate le frisson noir sous une lentille
est-ce sentiment ce blanc jaillissement
et l'amour méthodique
PARTAGE EN RAYONS MON CORPS
pâte dentifrice
accordéon transatlantique
la foule casse la colonne couchée du vent
l'éventail des fusées
sur ma tête
la revanche sanglante du two-step libéré
répertoire de prétentions à prix fixe
la folie à 3 heures 20
ou 3 fr 50
la cocaïne ronge pour son plaisir lentement les murs
des yeux tombent encore

38

the Surrealists aware of the subject of dreams; there is not room here, however, to go into less direct sources, like Gérard de Nerval, for instance.

One great hope inspired the little group of young people—almost all of them were at that time in their early twenties—and with new energy they started trying out what they had understood of the doctrines of the Viennese master and believed themselves capable of applying. A kind of collecting mania began for anything based on unconscious invention, dreams, or trance states. Aragon later wrote about it in *Une vague de rêves*: 'We came together like hunters in the evening, each described his day, the fabulous creatures that he had thought up, the fantastic plants, and the picturesque ideas that he had "bagged" . . .'

In particular, two aspects of psychoanalysis (which with its scientific pretensions and therapeutic aims was probably never fully understood by the Surrealists) led Breton and his friends to enthusiastic experiments with the unconscious: on the one hand, the technique of free association developed by Freud, and, on the other, the serious acceptance of the idea that man is not just an everyday being who incidentally also sleeps and often dreams 'some rubbish' while asleep, but that he comes into nightly contact with realities which in a fascinating way are extensions of the daytime side of his life. But whereas psychoanalysis was interested in curing psychic illnesses, the Surrealists were simply enchanted by anything which was even mentioned on this subject. Dreams interested them, together with many abnormal psychic reactions and conditions, because the interest in these things led beyond the 'rational' everyday reality and because at the same time it became clear to what extent these new areas were tied in with the everyday world and were felt in every aspect of it. In addition, the Surrealists saw in psychic illness the necessary, graphically visible rebellion of the unconscious against social pressures. Typically, they later celebrated the fiftieth 'birthday' of hysteria not because, for instance, its scientific 'discovery' provided the condition for its cure, but because they saw in it 'the greatest poetic achievement of the 19th century'.

Freud himself remained fairly reserved. A meeting between him and André Breton in 1921 was a disappointment on both sides, and Freud was fairly suspicious of the movement from that time on.

The interpretation of dream material through the uncovering of latent dream thoughts was not of essential importance for the Surrealists. For them, the thematic treatment of the previously too little heeded presence of this dream reality was aim enough. Thus, they knew little about Freud's central claim, of the dominance of consciousness over the realm of the dark, unconscious and irrational, extendable in terms of the famous dictum: 'Where Id was, Ego shall be.' The Surrealists on the other hand strongly advocated passive falling into the realms of the irrational. Breton, admittedly, later represented a slightly modified viewpoint: he sought to prove that dream content can help to solve problems of practical life, in which aim he is already closer to Freud's intentions. Without here being able to go into the complex and varied relations of the Surrealists to psychoanalysis, we want to show that the Surrealists were by no means all and by no means merely glorifiers of chaos, as is sometimes suggested. Their difference with Freud probably lay above all in a distrust of a quick and premature idealization of the rational as against the irrational —a programme which Freud himself of course carried out with reservations.

The Surrealists wanted to apply creatively what they had taken over from psychoanalysis. They saw themselves as pioneers, who, as representatives of all humanity, were to make Freud's achievements fruitful for a renewal of life. Men were to become 'whole' again, that which had been forgotten and pushed aside was to be revived and integrated. Behind this was the hope that a humanity which has become 'whole' in this way will not fall again into the same moral and political errors from which the present must suffer. The title page of the Surrealists' journal *La Révolution surréaliste* significantly carries the motto: 'We must attain a new declaration of human rights.'

After these preliminary observations, it is also possible to understand better what the concept of 'Surrealism' really means. The term was first used by Apollinaire, first in the programme to Erik Satie's ballet *Parade*, and then for the description of his own play *Les Mamelles de Tirésias*, which he called a 'surrealist drama'. The concept was defined by André Breton in the first Surrealist manifesto as follows: 'It would be very dishonest to quarrel with our right to use the word Surrealism in the particular sense in which we intend it; for it is manifest that the word amounted to nothing before us. I shall therefore define it once and for all: *surréalisme*, noun, masc.—pure psychic automatism, by which, orally or in writing or in any other way, one attempts to express the true function of thought. Thought dictated without any control by logic, beyond any aesthetic or ethical considerations.

'Encycl. Philos. Surrealism is based on the belief in the superior reality of certain hitherto neglected forms of association, in the omnipotence of dream, and the undirected play of thought. It aims to the final destruction of all other psychic mechanisms and to its substitution in their place as a solution to the main problems of life.' The idea of 'surreality' suggests, as is emphasized elsewhere, not a second reality lying 'above' the given reality, but the suspension of the distinctions between daily and dream reality, and the creation of a reality comprehending both.

The concept of 'surreality' may long since have inclined the reader to ask how far metaphysics is here relevant? The question cannot really be answered. The Surrealists were in this respect not always of the same view, either amongst themselves or at different times. *La Révolution surréaliste*, in any case, was consciously anti-religious. In general, one could say that the Surrealists were decisively anti-clerical and non-religious in their attitudes, but were so interested in extraordinary phenomena of the human psyche that they constantly touched on realms traditionally described as metaphysical. Since they had only adopted Freud's thought in a very incomplete way, they also had no coherent set of references, with whose help they would have been able, 'exposing' the miraculous, always to relate it to familiar concepts. Initially, they even flirted for a time with Oriental philosophy, religion, and mysticism, and believed that they had found spiritual guides in Buddha and in the Dalai Lama. The interpretations which they put upon the often astonishing results of psychic experiments in the initial period did not adhere strictly to the framework of empirical rational thought; Aragon wrote of this in 1924, still with a fairly moderate jusgement: 'Because talking in trance was so astonishing, we attempted to interpret the remarkable phenomenon in a correspondingly rapturous way: we were interested in the beyond, the transmigration of souls, the supernatural and marvellous, and were greeted only by disbelief and laughter. In fact, however, the explanations of the phenomenon were not nearly so wrong as one might think . . .' (*Une vague de rêves*).

One central theme which for a long time was one of the main interests of the Surrealists was that of 'woman', and everything which had in this connection been suppressed into the subconscious for all too long. This was clearly emphasized in the most varied contexts. Thus the first number of *La Révolution surréaliste* in December 1924 included a photomontage which showed the photos of the Surrealists around the photograph of the anarchist Germaine Berton, who had just murdered the royalist propagandist Marius Plateau. Underneath was a quotation from Baudelaire: 'Woman is the being that casts the greatest shadow and the greatest light into our dreams.' The twelfth number of the same journal (December 15, 1929) showed the photos of the Surrealists grouped around a nude painted by René Magritte, with the words: 'Je ne vois pas la femme cachée dans la forêt'; the word 'femme' is replaced by the picture of a woman.

Since everyone has an unconscious, and since this is for everybody, even if not all the time, essentially rich in the marvellous, the dominance of the unconscious over the creative act virtually annihilates the traditional conception of genius and talent. In the first Surrealist manifesto, Breton declared: 'Let us say it straight out: the marvellous is always beautiful; everything marvellous is beautiful; only the marvellous is in fact beautiful. . . .' The Surrealists could not say this often

enough; in another part of the manifesto, it is stated that 'we have no talent . . . we have become undemanding registering apparatuses. . . .' Admittedly, when attempts at writing from the unconscious produced more and more unreadable verbiage, Breton did press for a distinction between dustbin material and work of quality.

The rejection of the concept of 'genius', which, particularly at the beginning, went together with an explicit preference for collective work, already implicitly contains within it a 'communist' attitude in its broadest sense, which, however, at first remained completely spontaneous.

Dadaism had already basically been the voice of the unconscious, but it did not know it, and thus also did not know where the source lay from which it had for several years drawn its inspiration and motifs. Thus it was that this source dried up for the Dadaists and they found themselves grasping more and more into the void, the more they lost their original naivety. The Surrealists, on the other hand, beleaguered the source with all possible means, and, by digging and scooping, attempted to take away as much as their vessels could hold. The word proved at first to be the tool that was easiest to handle.

Surrealism and the word

Since we see this summary introduction as complementing, and not as a tautological 're-hash' of, the texts accompanying the illustrations, we may go here into a little more detail on the literary activities of the Surrealist group, especially since the literary figures formed the 'core' of the group, around which there was a much looser and more occasional grouping of painters.

Apollinaire, whom they revered as the 'magician', was initially *the* literary idol for the group of young writers like André Breton, Louis Aragon, Paul Eluard, Benjamin Péret and Philippe Soupault. In him they saw the new type of experimental writer. But his place as guiding light of the movement was later taken by writers like Baudelaire, Jarry, Nerval and Rimbaud, who were, during various stages of the further development of the Surrealist group, alternately praised and condemned. But the strongest literary influence was that of the constantly loved and admired Comte de Lautréamont, the *nom de plume* of Isidore Ducasse. Particularly the grotesque hallucinatory *Chants de Maldoror* were seen by the Surrealists as a revelation. Lautréamont's famous series of 'beautiful as' comparisons opened people's eyes to completely new realms of artistic productivity; the best known was later to be seen virtually as the Surrealist definition of 'beautiful': 'Beautiful as the accidental encounter of an umbrella and a sewing machine on an autopsy table.'

In outward and formal terms, the Dadaists, too, had worked with combinations of disparate elements ('your name drops like soft beef suet'), but this usually occurred on another level, for the fleeting provocative effect, while the Surrealists treated such arrangements as full of mystery and the threshold to realms of quite new realities.

The Surrealists detested psychological novels. They did not think much of a planned approach to literature in general, and propagated in its stead a quite new literary technique: *écriture automatique*, automatic writing, loosely connected to Freud's technique of associations. This is concerned with the concentrating-unconcentrating listening to the unconscious in the condition of a completely relaxed waking consciousness, which can of course never entirely be switched off. The frequently used interpretative description of this event as 'dictation of the unconscious' is therefore not quite accurate, since in fact there is simply the greatest possible damming of impeding compulsions and barriers.

The method is admittedly close to Dadaist practices in its use of chance. But the Dadaists had been attracted to writing on the basis of random ideas largely from the point of view of the unconventional possibilities of expression, as though corresponding to vital needs. Hans Arp

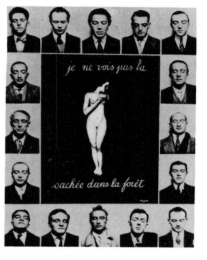

René Magritte, *I do not see the woman hidden in the forest,* **photomontage with painting, in** *La Révolution Surréaliste.* **December 1929**

16

declared: 'Automatic writing stems directly from the guts or other organs of the writer.' The Surrealists, on the other hand, only interpreted chance as 'apparent chance', since they basically saw in it the expression of a hidden psychic system; they thus did not wait until it occurred 'by chance', but attempted, based on Freud's technique of associations, to produce apparent 'chance' in a systematic way. Underlying this was the desire to overcome the traditional division between art and life, the hope of having discovered a means of liberating man for himself.

The automatically produced material was, after some experimenting, by no means seen as by definition of the same quality; a decision which of course implied the question, still left open, of making value judgements.

The first product of the automatic method was the joint work by André Breton and Philippe Soupault *Les champs magnétiques*, written in eight days and first published in three numbers of the journal *Littérature* between October and December 1919.

Breton and Soupault had withdrawn to Breton's room in the Hôtel des Grands Hommes and Soupault's office, and wrote a joint work consisting of eight chapters, which was originally to be called *The Fallen*. They distinguished five different speeds of writing, and were concerned 'to vary the speed of the pen from chapter to chapter, in order thus to ignite different sparks.' The result was celebrated as the expression of the beginning of a new era: 'We are in the position of someone who has just stumbled on a gold mine.' Aragon later wrote of the experiment in *Une vague de rêves*: 'It was as though the mind, having reached this turning point, had forfeited the ability to recognize where it was falling. . . . We felt the whole power of images. We had lost the ability to direct them. We had become their kingdom, their servants.'

In addition to the essentially cool and unimpassioned contact with the unconscious in automatic writing, the Surrealists in their animated early period also experimented with more dramatic methods. They put themselves in states of mind in which they could speak *directly* from the unconscious, and in particular they experimented with the inducement of hypnosis and other artificial sleep conditions. Robert Desnos proved to be especially gifted in this respect: 'In a café, in the middle of a loud babble of voices, in the brightest lighting, in spite of the crowding guests, Robert Desnos only needed to shut his eyes for him to be off, speaking in a trance; and amidst the confusion of beer glasses, plates, and saucers, the whole ocean washed over him with presageful roaring, with spray, haze, and fog, wafting away in tattered banners' (Aragon, *Une vague de rêves*).

The vogue for trance conditions admittedly only lasted for a short period; it was broken off because of its dangers in 1923, on Breton's initiative: the experimenters had lost weight, become irritable and nervous, and were suffering from lack of sleep; dangerous situations had also occasionally arisen, for instance when Desnos had once gone for Eluard with a knife while in a trance.

Independently of these experiments—whose verbally formulated results had still not been put down in writing—the Surrealists also enthusiastically wrote up their dreams. These 'dream reports' were particularly frequent in the first numbers of *La Révolution surréaliste*. They were usually fairly complex in literary terms, suggesting that they were worked over after the event. In addition, the Surrealists also attempted to gain an insight into often only semi-conscious convictions, not publicly discussed. They thus put out questionnaires in journals, for instance on suicide, and also arranged sessions in order to ask each other questions openly, without any inhibitions. The favourite themes were 'woman' and 'sexuality'.

In accordance with their quasi-scientific pretensions, the Surrealists published, in addition to the two manifestos composed by Breton (in 1924 and 1929), a large number of theoretical debates. These were published in the various journals to which the Surrealists contributed during the development of their group. A more comprehensive theoretical treatise was Breton's long essay entitled *Les vases communicants* (1931). In this essay Breton attempts, looking back at

the experiences of the group, to give a theoretical basis to the assertion of a dialectical relation between waking and sleeping, consciousness and dream, and the day and night side of life, which he sees as related to one another like connecting pipes. At the same time, the essay is also a defence of the achievements of psychoanalysis against orthodox Marxism, which Freud rejected; the question of why Breton should consider it necessary to justify himself with regard to Marxism will be gone into in the next chapter.

On the basis of the experiences and inner habits which had brought about the psychically relaxing and liberating practices of *écriture automatique*, larger poetic works subsequently also developed. Two works in particular may be mentioned here, both of which were the result of a habit frequently and enthusiastically practised by the Surrealists: attentively and without any special aim wandering through the streets of Paris and observing what the labyrinth of the metropolis had to offer in apparently accidental encounters and suggestions. Behind this was the basic idea that everything which strikes the soul from outside is simultaneously connected with its most intimate, secret law. On one of these escapades, Breton got to know a strangely fascinating, mentally ill, young woman. He described the mysterious development of this relationship very subjectively in diary-like prose (*Nadia*), illustrated with photos which for the outsider often seemed to have little relevance to the content. Aragon's *Paysan de Paris* had a similar origin, and was a very unconventionally compiled, mystifying documentary of the day and night experiences of an observer aimlessly wandering through Paris, studded with statistics, poster slogans, surveying results, and so on.

Our brief survey of the literary activities of the Surrealist group must remain fragmentary, but we hope that one aspect in particular has been made clear: the remarkable range of Surrealist literary production, from automatic writing and speech aiming at total directness to explanatory pronouncements and theoretical apologia.

The motto of automatic writing might be described as: 'Out with it!' What then came out adhered by and large to the rules of ordinary morphology and syntax, but was on the other hand so closely related to its subject that only with great difficulty could it be communicated to the unprepared consciousness of a broader public. Hence the theoretical writings. The Surrealists had established as their aim the identification of 'art' with life, from which it had previously been divorced as something 'quite different'. Since this was the basis of their hope for a more healthy humanity (Breton called it 'becoming man'), they had to attempt by means of theoretical reflections to create a bridge between their subjective experiences and the general consciousness: a problem which Dada had not yet faced—and a problem which the Surrealists, too, were unable to solve, and which accompanies especially the visual art of our own day in an increasingly acute form. This persistent problem can in itself be seen as the visual expression of basic underlying jarring qualities in our society; every artistic activity which makes it clear, even without solving it, takes a necessary step towards a more comprehensive insight.

Surrealism and communism

What appeared in literature as the problem of the reconciliation between subjective experience and the connected theory had a very specific analogue in the relation of Surrealism to political theory. The dramatically varying relation of the Surrealist group to communism was of such significance for the fate of individual members and for the development of the movement as a whole that it cannot here be passed over. We may suppose that without the central figure of Breton, with his condemnations and reprieves, and his constant search for a certain 'line', the group of Surrealists and in particular the literary core would probably, because of their conflicting relations to communism, have broken up considerably earlier than they in fact did.

Initially none of the young men would have dreamed that political questions would become so crucial for their association, which had been founded with artistic experimental considerations in mind. Breton retrospectively wrote in *Entretiens* ('Conversations'): 'In our circles the *politically* significant events had . . . hardly left a trace, and the significance of the Bolshevik revolution was by no means fully grasped. Anyone who had told us then that germs of dissension would spring from our differing conceptions of the magnitude of these events would of course have met with utter disbelief.'

The attempt to change their own lives and to liberate themselves gradually opened the Surrealists' eyes, however, to the fact that each of their individual fates was linked to that of all, so that in other words any self-liberation must by definition go hand in hand with social change. In a propaganda declaration of January 27, 1925, they stated: 'We are firmly determined to bring about a revolution.' Breton held the view that: 'Nowadays genuine art sides with social revolutionary activity: the former, like the latter, strives to cast into confusion and to destroy the capitalist social order.' There was admittedly much disagreement about the exact nature and means of the overthrow, but at first the concept of an intellectual revolution (even if not restricted to the traditionally narrow field of 'art') was dominant.

The French colonial war in Morocco revived in the Surrealists all the feelings of hate and disgust that the First World War had aroused in them. Unlike the members of the Académie Française and renowned men of letters, with their nationally conscious defence of the French standpoint, the Surrealists took a stand against this war, and in doing so found themselves side by side with the communists. The gradual contact with communist intellectuals made the question of their attitude to a social revolution of increasing importance. The attempts at collaboration with the communists dramatically determined the following ten years of the history of the Surrealist movement, ending disappointingly for both sides. Breton, who was enthusiastic about the Russian Revolution, and especially about Lenin and Trotsky, urged the Surrealists on to renewed perceptions—the results of *écriture automatique*, dream reports, spontaneous drawings, etc., paled by comparison with the prospects of global change for mankind.

Soon, however, Breton saw the most essential aims of Surrealism threatened by a too close relation to communism. He was not prepared to commit himself unambiguously to materialism, feared being under someone's wing, and therefore explained: 'There is not one of us who would not *wish* power to pass from the hands of the bourgeoisie into that of the proletariat. But until then, in our opinion, experiences and experiments with the inner life of the individual should be continued, without, however, anyone, even though he be a Marxist, dictating anything to us from outside.'

Not all the members of the movement were prepared to join in this precarious 'both-and' reconciliation of Surrealism and communism. In particular Naville, and later Aragon, decided unambiguously for communism, and were prepared for its sake to give up the specifically Surrealist intentions, which remained for them too tied to the subjective and the aesthetic. After dramatic debate, this finally led to their exclusion from the group. The writer, actor and director Antonin Artaud and the already mentioned Philippe Soupault took the opposite position: they refused to modify the artistic aims of the movement in favour of social revolutionary activity. Breton, treading a delicate path between the two, achieved their exclusion from the Surrealist movement.

In the hope of gaining some ground for his idea of a dialectical combination of Surrealist and communist aims, Breton and four other Surrealists joined the Communist Party in 1927. But the experiment turned out to be a failure after only a short time, and led to his exclusion from the Party in 1933. The communists, blindly following their own aims, were not interested in artistic support, and did not see themselves able to integrate it. The subjective factor of overall social development played virtually no role in their thought at that time. They were not prepared

(as Walter Benjamin wrote in *Angelus novus*) to 'win the forces of ecstasy for the revolution' with the help of uncontrollable methods forging ahead into unknown psychic realms.

Surrealism and the visual image

The core of the Parisian Surrealist movement was always predominantly orientated towards literature and philosophy, as indicated by, for instance, Max Ernst's 1922 group painting *Rendezvous of friends* (Ill. 21), depicting seventeen figures of which, however, only four (Arp, Baargeld, de Chirico and Ernst) are living painters. The Surrealist painters were only fairly loosely related to the core of the group around André Breton, whose ideas they by no means always shared, just as they, in turn, were not always understood by him.

The first Surrealist manifesto emphasizes as intellectually close to Surrealism the painters Braque, Derain, Matisse, and, above all, Picasso. De Chirico, Ernst, Klee and Masson, on the other hand, are merely mentioned. The painters already working in a Surrealist direction nevertheless derived from the manifesto a strengthening of their efforts; a call to give oneself over to experiment and to the pictures created within one's own self; and a free modification of ideas taken from Freud's associations technique.

Max Ernst had, through Tzara, been in touch with the Paris group during his Dada period in Cologne. In May 1920, as the result of a letter from Breton, the first Paris exhibition of his works was held, about which Breton was very enthusiastic. Masson and Miró were friendly with various Surrealist writers, thus coming into contact with the Surrealist movement. Yves Tanguy, belonging to a slightly younger generation, only joined them in 1925. Finally, at the end of the 1920's, the Surrealist scene was given new life by René Magritte and by Salvador Dali, who around 1930 was the leading figure.

The visual art of Surrealism was, in contrast to the purely French tendency of Surrealist literature, internationally inclined from the very beginning, as a mere glance at the nationalities of the main figures will suffice to show: Ernst was German, the sculptor Giacometti was Swiss, Magritte was Belgian, Masson and Tanguy were French, and Miró and Dali were Spaniards.

The style of the various painters was more individual, and a phase of collective production, as with the literary figures, did not have any serious equivalent in the field of visual art. One playful variant of this idea, admittedly, was the 'cadavre exquis' game, occasionally played both by writers and painters. The principle, as Breton pointed out, is that of the game of 'consequences'. A piece of paper is handed round, which is written on or drawn on by various people in turn. Without being able to see what has been previously drawn or written, each person must add a limb or a word, etc. In this way, associative collective products are created, like, for instance, the first sentence that gave the game its name: 'The exquisite corpse will drink the new wine.'

The language which *écriture automatique* used was predominantly bound to syntax. But this regulation seems to count for little in comparison with the various technical factors which the painter has to take into consideration. In particular, he is restricted to a given format. The Surrealist painters also usually based themselves on a certain compositional scheme and some of them used a time-consuming, 'Old Master' painting manner which, because of the time factor alone, provided a distancing effect from the subject and therefore the opportunity for reflection. But, in another respect, painting was especially close to semi-conscious or unconscious creative spontaneity: the unconscious 'thinks' in largely visual terms—painting, on the other hand, remains in a certain sense on the level of the dreaming unconscious when it transfers its 'inner model' to the outer world. In addition, the painter has the possibility of using his commitment to technique, which is in one sense a kind of restriction, almost as a catalyst for unconsciously direct inspirations, as the material experiments of Max Ernst show especially clearly. An exact

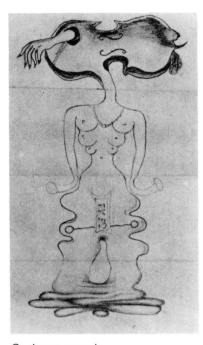

Cadavre exquis
**by Victor Brauner,
André Breton,
Jacques Herold, Yves
Tanguy; pencil, 1935**

equivalent of the kind of spontaneity practised in *écriture automatique*, largely excluding thought, was provided by the Tachism that developed after Surrealism.

The Surrealist writers were inspired by various historical models in their initial period. The painters, for whom the history of painting also provided many stimulating models, were nevertheless also, or even predominantly, interested in the art of primitive peoples and the painting of the mentally ill. Of contemporary artists, Picasso and de Chirico had a very marked influence on Surrealist painting.

The Surrealists would gladly have made the long since world-famous Picasso one of their own, but he himself of course always retained a benevolent distance, even though he occasionally sent works to Surrealist exhibitions and published in Surrealist literature. Through his collages he had already had a fruitful effect on the Futurists and Dadaists, and he had thus also indirectly, through Max Ernst, stimulated Surrealist practices. It was, however, the 'Cubist revolution' in general, so decisively brought about by Picasso and Braque, which appeared to the Surrealists as *the* liberating act, the redemption of painting trapped in the imitation of the visible. Admittedly, Picasso's Cubist works were seen by the Surrealists as the expression of a psychologically motivated alienation to a much greater extent than Picasso, orientated more towards artistic form, had ever intended. It is debatable whether Picasso, beyond his function in stimulating the movement, actually had a true 'Surrealist' phase himself, a question that in the last resort simply depends on how broad or narrow one makes one's definition of 'Surrealism'. In any case, it may be said that with a painting manner less tied to its physical model, the unconscious can achieve a breakthrough with far less inhibitions.

Whereas Dada, with its provocative acts and experiments with chance, had a relaxing and liberating influence on the future Surrealists, de Chirico, with his shop-window mannequins and plaster heads, his frightening empty squares, his discreetly open mysteries enacted in the full light of day— with his whole *pittura metafisica*, in fact—related to the Surrealists' inclination to create a mysterious transcending of daily life in a quite unexpected way. Breton later talked almost nostalgically of de Chirico's 'metaphysical' period as the 'time of columned halls, time of phantoms, mannequin dolls, interiors. . . .' From about 1919 on, de Chirico gradually drew away from this world of mysteries, and began to paint in a very worldly style, predominantly based on ancient tradition, thus provoking the bitter and angry contempt of the Surrealists.

After Surrealist painting had developed beyond its initial phase, the theoretical discussions about its sense and its possibilities became more marked. In the third number of *La Revolution surréaliste*, Pierre Naville could still write that: 'No one is any longer in any doubt that there is no Surrealist painting.' Breton's essay 'Surrealism and Painting', published in the fourth number of the journal, radically changed the attitude to painting within the movement; initially himself uncertain and sceptical about the possibilities of Surrealist painting, here he provided the first attempt at its theoretical categorization and justification. The basic idea of the essay is that painting has access to more, and more complex, realities than vision within the empirical world. Thus, Breton reminds the painters, it is not sufficient to 'paint the everyday sky, a bowl, and some sour fruit on canvas, and there's an end of the matter! Apart from that, you are required to account for the vanished phenomena, and if you cannot answer quickly enough, then people will turn from you in contempt.'

Since ruling values have to be subjected to basic examination, on which, according to Breton, all intellectual people are agreed, it is necessary to create new values. This occurs, as Breton sees it, through turning to the 'purely inner model', to which Surrealist poetry had already turned, but which painting was to present us with in *visual* terms, for 'our eyes, our dear eyes must reflect that which, admittedly, is not—but it is there as surely as the existent, and genuinely optical images had to be created which prevent us from mourning what we have left behind us, whatever it may be.'

How, one might well be tempted to ask oneself, can Max Ernst's black fish and bird forests or Dali's gnawed sexual monsters give us new values? The only answer to this must be: new values do not appear from one day to the next. The first and most important thing is to get rid of the dead wood and to strike out in the direction in which one can find these new values. The Surrealists were firmly convinced that the right way could not ignore the realm of the suppressed unconscious.

Since it is quite impossible to go into any detail here concerning the individual threads of the Surrealist painting movement, we will limit ourselves to the discussion of three different basic types of attitudes to the Surrealist artistic act. In doing so, we will attempt, from the point of view of the artistic personality, to emphasize some conspicuous points out of the wealth of phenomena, and will take for granted the clear distinction within Surrealist painting between, on the one hand, verist-reproductive illusionism (Dali, or Magritte—and, in their specific ways, Tanguy and Ernst, too), and, on the other hand, automatism which abandons the reproductive quality (Masson, Miró). Every artistic personality, of course, essentially embodies an individual 'type' of artistic 'attitude'—Miró, for example, with his apparently unconscious lightness of style, with which he succeeds in expressing the richness of a hieroglyph-like world of signs; or Man Ray, who with his photographic poetry takes all those pessimists *ad absurdum* who with the rise of photography prophesied the end of all painting creativity and the spread of a trivial naturalism. Here we can, however, only go into three extremely different type of position, which we will in each case illustrate by reference to one painter: these three categories are material experiment, reflection, and theatre-like demonstration.

The master of experiment with material was undoubtedly **Max Ernst**. He had already made a crucial discovery for his later work in 1919: prompted by reproduction of the most varied objects, which were juxtaposed in scientific catalogues of the time, he developed the typically Surrealist, illusionist collage and, using 19th-century woodcuts, the collage novel (for instance, *La femme 100 têtes*).

In 1925 followed a further important experience: 'On a rainy day in a guesthouse on the coast, I was seized by the visual compulsion and the irritation caused by the sight of thousands of scratch marks on the floor tiles. I decided to follow up the symbolism of this compulsive event, and, supporting my meditative and hallucinatory potential, I did a series of drawings on the tiles. I did this by deliberately putting sheets of drawing paper on the floor and rubbing them with the pencil lead. On looking at the drawings thus produced, their dark and their half-shadow effect, I was startled by the violent intensification of my visionary potential and the hallucinatory sequence of contradictory images which piled one on another with a speed and urgency such as one knows from memories of love.' The rubbing technique ('*frottage*') thus developed is based on the constant provocations of the artistic imagination, which interprets the resulting material— half conscious, half produced through unconscious control—into pictures, and changes them correspondingly. Both in the rubbing process and in the pictorial vision associated with it, the artist is predominantly passive and an onlooker, which led Ernst to describe this technique as the painting equivalent of *écriture automatique*. Later he also developed a transfer of this drawing technique to painting: *grattage*. This involved placing objects under a canvas and applying layers of paint; the paint is then scratched or scraped away in various raised places, following a similar technique with the stimulated imagination.

Max Ernst applied the techniques developed by him in a whole series of different fantastic creations, mostly orientated towards the organic world of forms. Breton called him 'the greatest phantoms brain of the age'.

René Magritte, who only became involved with the Surrealist movement at a late stage, was the thinker and philosopher of the Surrealist painters. He was less interested in an uninhibited outpouring of the unconscious into painting than in one specific problem: the

Man Ray, *Violon d'Ingres* (*Hobbyhorse*), **photo, 1924**

relation between the experienced reality and the reality depicted in words and visual images, or—to put it as a question—what 'right' does the artist have to create a secondary reality? How and what is really being 'reproduced'? The fact that painting has as its aim the external visualization of a previously invisible inner world seemed to be clear from all the previous artistic theoretical discussions of the Surrealists. Thus Magritte asserted: 'Painting—which really deserves to be called the art of similarity—permits the graphic description of a thought which can become visible.'

But can the painter simply deal with the given elements of this world by arbitrary combinations? Does he not become guilty of a confusion of the consciousness of reality if he creates a quite different, second, painted reality? From a concealed 'similarity' underlying everything, Magritte derives the 'right' to a painter's free treatment of things, and even a certain set of laws which have to be obeyed. Admittedly, it is not a similarity which exists in all things to the same degree and in the same way. There is evidence of underlying relations of things to one another which are more or less intersubjectively perceptible. In order to make this idea clearer, let us compare the well-known game where a particular person must be guessed, whom one member of the group has thought of. The other players ask questions like: what would X be as a drink, as a building, as a piece of music, and so on? And the person being questioned gives answers like: water, a Gothic cathedral, a Bach fugue. The fact that a person can be guessed by means of these 'similarities' with things existing on a quite different level seems to be an indication that the evidence of this 'similarity' apparently functions intersubjectively; we are in fact dealing with the set of laws which also underlies the lyrical metaphor. Every artist who uses such a mixture of categorical terms of reference—i.e. including Magritte—then of course shares not only something of the collective unconscious, but also elements of his own unconscious structures.

Magritte used this posing and solving of a puzzle particularly in two respects: he combined, on the one hand, apparently essentially alien things or elements, and on the other specific forms with apparently alien materials, for instance in the painting of a flying bird consisting of sky and clouds. At the same time, in many pictures he explicitly treated the problem of the relation between given and painted or described reality. He painted, for instance, a piece of cheese, and wrote underneath: 'This is a piece of cheese.' But he also painted a pipe and wrote underneath: 'This is not a pipe' (i.e. it is merely a painted, two-dimensional object). In addition, he also painted series of pictures with (apparently) inappropriate descriptions, so that an egg is called *Acacia*, a hat is described as *Snow*, a hammer as *Desert*, and so on. These works relate to Magritte's conviction that 'an object is not so closely bound to its name that it is not possible to give it another, more suitable one'. There is also a group of pictures in which the secondary, painted reality is itself the subject, for instance landscapes where easels are standing, on which there are depictions of these landscapes (III. 41).

The result of Magritte's partly painted reflections is that the artist may relate arbitrarily to the objects of this world, since the painted reality is in any case a second reality. In addition, he should sense the invisible affinities of things to one another based on 'similarities'. The evidence of this goes beyond the bounds of the ordinary subjective dream into the realm of a universally comprehensible language. Magritte was concerned with 'dreams which seek to make one not sleep but wake'.

Surrealism was, for all its interest in the paintings of the mentally ill, a *conscious* relation to the unconscious, and so it was only logical thoroughly to examine the justification of apparently wilful distortions of reality. Breton saw in Magritte's non-automatic, fully conscious work a prop for Surrealism from 1929.

Salvador Dali, too, worked largely consciously, though not so reflectingly as Magritte. Like Magritte, he only joined the Surrealist movement at the end of the twenties. The predominantly receptive methods of the Surrealists practised hitherto he considered too passive, and sought to

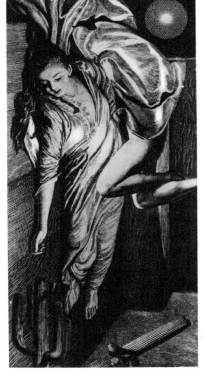

Max Ernst,
The woman of 100 heads
opens her raised sleeve,
collage from
La femme 100 têtes

apply his astonishing technical abilities more systematically to the depiction of unconscious and diseased mental conditions. He read widely, including Jacques Lacan's *On Paranoia in its Relation to the Personality*, published in 1932. In connection with his various studies he developed a method which he claimed enabled him to become mentally ill for a period, and to induce delusions, states of frenzy, and so on. He read descriptions of abnormal mental conditions, bound these in with the problems and intuitions of his own unconscious, and painted his inner visions in a kind of 'dream photography'. He called this method of conscious manipulation of the unconscious 'paranoiac critical', and referred to the necessity for a destructive process leading beyond the bounds of the real world. In his book *The Ass's Corpse* he wrote: 'I believe that the moment is near where a thought process of paranoiac, active character can, together with automatism and other passive conditions, raise confusion to a system and contribute to the total discrediting of the real world.' Dali combined a sensitive intuition for the world of images of the unconscious with a preference for highly dramatic realization; he no longer possessed the cautious, patient attitude of most of the other Surrealists, but was more inclined to an occasionally obtrusive exhibitionism, as Breton recognized at an early stage. Breton wrote, after Dali had appeared in the Surrealist group: 'New figures, with unambiguously evil intentions, have just set themselves in motion. One sees with dark joy that nothing occurs on their path other than themselves.'

In 1938, as a kind of reckoning and as proof of the reception and further development of the movement in many countries, the International Exhibition of Surrealism was held in Paris, bringing together in the Galérie des Beaux-Arts in Faubourg St. Honoré works by seventy artists from fourteen countries. With a dash of the old Dadaist provocative spirit, the crowds of astonished spectators were for two months here confronted with the strangest impressions: one room was hung with 1,200 coal sacks, in another was Dali's famous rainy taxi, in which a blonde mannequin doll sitting between real vegetables and live snails was exposed to a permanent downpour; and elsewhere was the 'Surrealist street', populated with wax dolls of many different Surrealist artists. There were also countless paintings, drawings, objects, engravings, woodcuts, photographs and books.

Man Ray, *Rayograph,* **1921**

The exhibition could take place only because already existent or imminent breaks between various artists and the core of the Surrealist group were overlooked. In 1939, with the outbreak of the Second World War, the movement finally broke up. Breton, like Masson and Ernst, went to America, where, in 1942, he gave a remarkable speech to students at Yale University, in which, on the one hand, he looks back almost nostalgically at the already historical Surrealism, which, as he said, 'is only to be understood in connection with war—from 1919 to 1938—both with the war from which it emerged and the one into which it ran.' On the other hand, however, Breton, rightly, explicitly emphasized that Surrealism was not dead. Admittedly, the unique historical grouping of the Surrealists had come to an end, but Surrealism could not be treated as dead just for that reason, since the problems which he had posed were still anything but solved. Above all, the problem of the reconciliation of subjective experience and general consciousness, of unconscious and conscious, of individual and society, of spontaneity and theory, of art and life, remained unsolved—indeed, through the activity of the Surrealists it presented itself in a more marked form. It is thus hardly surprising that the path embarked on by the Dadaists and Surrealists is still peopled with seekers and discoverers.

The consequences on the international art scene up to the present day

Historical Dadaism had only lasted for a short time, for constantly repeated provocation finally ceases to be provocation. It would of course have been possible to make the general provocation more specific and to transform it into directed criticism in certain directions. But the Dadaists were neither prepared nor in the position to do this. The methods of their approach had meanwhile become so embedded in the general consciousness that the Dadaist spirit even now appears again and again, especially when a provocation or a 'wiping the slate clean' is intended, or where thought on the part of the viewer is to be provoked. Since modern art in general is now more and more concerned to force a consumer-orientated public to think for itself, different manifestations of the original Dadaist spirit are to be found throughout the international art scene.

We do not unfortunately have space here to describe the extraordinarily varied details of the contemporary ramifications of Dadaism. Instead, we shall indicate some general aspects.

New developments with Dada-like features are generally more conscious, more intellectual, and thematically more directed than historical Dadaism. The individual artists often seek a fairly specific, narrowly defined area of reality, and specialize—like Christo, for instance, with packing materials—in a particular type of consciousness arousal or provocation; the danger of the marketing of a specific 'fad' which is then endlessly repeated, is here, unlike with the more versatile original Dadaists, sometimes clearly present.

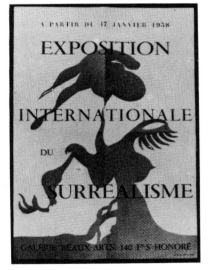

Poster for the International Exhibition of Surrealism, 1938

One trend develops the aspect of the collecting and putting on show of fragments of reality. 'Finds', such as stem from the technical environment, cultural activity and daily life, are of particular importance. The collage principle is now largely three-dimensional. The range of collected objects stretches from the Coca-Cola bottle and the compressed car to the breakfast table and half-eaten contents, fixed with synthetic resins. One variant of the presentation of real objects is the 'exhibiting' of processes, for instance the object-transforming destruction by fungus (Diter Rot).

The aspect of provocative action, which was so marked in historical Dadaism, exists in many contemporary trends, summed up by the word 'actions', of which we can here merely list the names of a few types—Fluxus, Happenings, Land art, Concept art, Process art. All these trends have in common the fact that the viewer more or less becomes the witness of or participant in events which visualize ideas, criticize false attitudes, or are supposed to show new forms of life in their beginnings. Since this art is in a large degree tied to time, situation, or landscape, it is largely outside the domain of art dealers and museums—a consequence which Duchamp had already envisaged with his ready-mades, although these were in fact later marketed.

The works of Christo, mentioned above, may be taken as representative of some symptomatic aspects of modern art close to Dadaist ideas. Through his packing actions, which at the same time create demonstration objects, Christo stands between the two trends which have been separately categorized by us as 'collecting' and 'action'. He creates new aesthetic qualities by using industrially produced materials (plastic foils). In addition, he gives the packaged objects (which range from a chair to a rocky coast) an enigmatic quality, a mysteriously veiled new form. At the same time, however, with his constant repetition of the same act, he takes the packaging mania of the industrial consumer society to its extreme, and by thus creating distance he prompts new modes of thought.

One especially curious further development of previously Dadaist, provocative methods has been achieved by Joseph Beuys, probably one of the best-known living German painters. He came out of the Fluxus movement, and is indebted both to action art and to the production of objects, with a politico-philosophical stance as an important background to his work. Beuys

believes his artistic work capable of bearing a whole system of thoughts, judgements and experiences, through their psychologically intensive visualization. Dadaism's provocation and demonstration, which originally was not working towards any positive goal, finally, after many detours and transformations, assumed the character of a means of reconciliation, which through art was to connect very logically conceived plans for world change with life itself.

Of course these metamorphoses of the Dadaist spirit often include something of the Surrealist philosophy, but it would be pedantic and absurd to attempt to divide the main Dadaist and the secondary Surrealist influences in this context. In addition, there are several more direct continuations of Surrealist thought which are of interest for us, and which we shall of course only be able to describe very sketchily. We will therefore limit ourselves to a brief description of two radically different sequels to tendencies which were coexistent in the original historical Surrealist group.

The Surrealists' demand for 'automatic' creation was, after the Second World War, taken up by Abstract Expressionism (largely covered by Action painting, Informal, Lyrical Abstraction, and Tachism), with a painting technique closely equivalent to *écriture automatique*. The artists of these trends were concerned to express spiritual conditions spontaneously and directly through the application of paint on to the canvas; any conscious influence of the brushstroke through formal intentions was to be excluded. The painter working in this way not only abandons any restriction through considerations of the visible world, but also drops any compositional scheme of whatever kind. The restriction imposed on a picture thus created by the picture frame has no connection with the structure of the picture itself, which could theoretically stretch for miles. In this sense, Abstract Expressionism and parallel phenomena represent not only—like all abstract art—a going beyond all figurative painting, but are also simultaneously opposed to the 'impersonal' order of Constructivism and any kind of geometrical abstract art.

Abstract Expressionism developed in the USA under the influence of the Surrealists who had emigrated there, especially Max Ernst and André Masson. Its most outstanding personality was Jackson Pollock, who tends, in a slow, almost meditative working process, to let the paint dribble on to a canvas lying on the floor with the aid of tins with holes in them.

Pollock's delight in materials and experiment, reminiscent of Max Ernst (Ernst, too, had already experimented with dripping paint) can be seen in the following statement: 'It rarely occurs that I set up the canvas before I begin to paint. I prefer to secure it to the hard brickwork, or stretch it out on the ground. I need the resistance of a hard surface. I feel better if I can work on the ground. I am then closer to the picture, as though I am a part of it, since I can walk round it, work at it from all sides, and can literally get to the heart of it. . . . More and more I am drawing away from usual painting equipment like easel, palette, brush, etc. I prefer sticks, brick-layer's trowels, knives, liquid paint which I pour, solid paint with sand, crushed glass, and other materials generally alien to art.' Unlike Ernst, Pollock, however, does not then transform the automatically created forms, but leaves the result as a preserved spiritual gesture. Abstract Expressionism had its equivalents—Informal, Lyrical Abstraction, Tachism—in many different countries, especially in France, where the German artist Wols (Ill. 64), living in Paris, was one of its main representatives.

The range of Surrealist influence on subsequent artistic trends becomes clear if we compare the movement described above with its extreme opposite, the Vienna School of Fantastic Realism. Whereas everything in Abstract Expressionism is subjective gesture, unformed spontaneity, undisciplined flowing, here everything has a complicated significance, presented with Old Master perfection.

The Vienna School, called by Gustav René Hocke 'one of the greatest surprises of modern intellectual Europe' developed after 1945 around the painter and writer Albert Paris Gütersloh. The painters in this circle were, on their first public appearance in 1947, without any programme

or manifestos, described as 'Surrealists'. Since their pictorial world is also largely based on the realms of the invisible and the subconscious, they are indeed very close to the original Surrealists, from whom they are, however, distinguished by a very high degree of conscious control of their artistic work and a more literary set of images, demanding interpretation on a symbolic level. The Old Master artistic techniques, largely indebted to Mannerism and in general even more minutely precise than those of an artist like Dali, were absorbed by the painters through regular visits to the Kunsthistorisches Museum and the Albertina. Through their technical perfection they create on the one hand an illusion fitted with all the features of a rich reality and, on the other hand, as a result of the cool clarity of the depiction, a probing and comparing distance.

The Viennese Fantastic Realists formed a school, and have found many imitators. The main representatives of the central Vienna group are: Ernst Fuchs, visualizing inner experiences and visions of a spiritual world; Rudolph Hausner, with psychoanalytical investigations of his own person; Erich Brauer, with his fairytale-like fabulous pictures taken from Jewish or Oriental tradition, from his own nature, or his own soul; Anton Lehmden, in whom the themes of man, landscape, and battle are mutually illumined; and Wolfgang Hutter, with his theatrically vivid plant waxworks.

The most interesting representatives, with regard to Surrealism and the problem of the reconciliation of subjective experience and general consciousness, seem to us to be Hausner and Fuchs. Hausner is interesting in his use of psychoanalytical ideas, which had primarily attracted the Surrealists as an explorative method for gaining material of unconscious content, and which he uses quite explicitly for painterly self-realization and self-healing. One of his pictures, referring to the Freudian concepts of Super-ego, Ego, and Id, is entitled *Ich bin es* (simultaneously signifying *It is I*, and *I am Id*). His paintings are variations on the different conditions and stages of the subject himself, who appears in various roles as Adam, sailor and Odysseus. He thus intensifies the subject aspect inherent in Surrealism in his own way. The sense and the 'justification' of his subtle self-thematization are based on two assumptions: firstly, that his own private problems have general human features, and can thus also be interesting for others, and, secondly, that the distanced style of his visualizations provokes thought in general. He neither gives himself over to the unconscious that guides his hand, nor to the fantasies that could produce already painted figurations in him, even if these stages play a part in his creative process, as he himself has stated on several occasions. The decisive factor is that Hausner already has a complicated foreknowledge of himself in his head before he visually objectivizes it in a whole system of general and private symbols. This means a very slow creative process, in which a synthesis of thoughts, as concentrated as possible, is to be clarified. The call for a classificatory interpretation of his pictures is taken to the extent that he, for instance, gives the cap of the child in a sailor suit (bearing his own features) in *Forum of Inwardly Directed Optics* the legend 'espoir'—'hope'. Such unambiguous statements were foreign to historical Surrealism.

Ernst Fuchs, on the other hand, hopes for intersubjective effectiveness of his work, operating on many symbolic levels, from the suggestion of a collective symbolic awareness, already manifested in the Old and New Testaments, but which, as he suggests, is also underlying the consciousness of modern civilization. In Ernst Fuchs' work the relationship—existent in a more or less evident form—between Surrealism and metaphysics is once more vividly expressed and forms its own world of images, peopled by different spiritual hierarchies.

The problem of the reconciliation of subjective experience and general consciousness is thus resolved by Hausner and Fuchs each in their individual way. Hausner does so by presenting his own subjective problems for discussion, while Fuchs takes as his starting point the hypothesis of a collective vocabulary of symbolic images still comprehensible today.

Both, through the explicitness of their intellectual programme and through their detailed and precise painting, aim more clearly at the conscious understanding of the viewer than any essentially automatic form of art.

Irritation and fascination—the viewer's reaction

The fact that Dada wanted to shock the viewer was clear and initially was also successful. But the Dadaist aims were not restricted to the achievement of such reactions. They wanted a basic renewal of the world, but did not yet really know what they wanted in its stead, and so they left all possibilities open. It is in this sense that Tzara's appeal should be understood: 'Dada demands strong, honest, eternally uncomprehended works.' When the whole movement, for lack of tangible statements, had run down, only the witty aspect remained. Nowadays, accustomed to shocks and gags, and, indeed, in the search for originality, accustomed even to treat them as the main thing, we often regard historical Dadaism as mere witticism. In doing so, we place it in the realm of pure art, art for art's sake, even though Dada saw itself as comprehensive and revolutionary. The possibility of new metamorphoses of the Dadaist spirit reaching us in a fruitful way is dependent not least on our ability to recognise contemporary problems in an artistic gesture.

The shocking effect of the Surrealist works was no longer so strong, but irritation remained and grew, together with the fascination of the public. The programmatic Surrealists rejected the *enjoyment* of art. Occasionally the viewer is offered something that he can laugh at, but which on a second look may well turn to shock. The Surrealists knew humour, but used it discreetly and sparingly, for laughter can only liberate for a moment—a laughing person seems to have got rid of the problem. But Surrealism possesses a remarkable attitude of digging further, not being satisfied; it demands effort, the paradoxical and the mysterious from the world of the psyche, and is presented to the viewer with the exhortation partly to open up his own person and his own unconscious, and partly to encourage the unconscious towards its own activity.

It is undoubtedly impossible for the viewer to solve all the countless puzzles and discrepancies presented to him by Surrealism from one day to the next—but they *visually* impress themselves on his consciousness, and occasionally he will perhaps sense the anticipation of a new consciousness, which can admittedly at first only have an equally vague form, like the solved riddle of a dream that Eluard once described: 'A young woman, who looked very unhappy, visited me in my office. In her arms she held a negro child. We did not speak; I wondered how this moderately pretty, but poor woman had come by a child of this colour. But suddenly she came up to me and kissed me on the mouth. Then I had the feeling, but only the feeling, of understanding everything.'

Short biographies

Arp, Hans (Jean)
Born in Strasbourg in 1887, he died in Basle in 1966. 1904: studied painting in Strasbourg, 1905–7 in Wiemar, 1908 at the Académie Julian in Paris. 1912: took part in the second Blaue Reiter exhibition; 1916: co-founder of the Zurich Dada group; 1925: moved to Meudon near Paris, came closer to Surrealism, also relations with the Cercle et Carré and Abstraction-Création groups and with the Swiss Allianz group; spent the war in Southern France and Switzerland; 1946: returned to Meudon.

Blume, Peter
Born at Smorgan, near Vilna (Lithuania) in 1906. 1911: emigrated to the USA; studied in New York (Art Students' League and Institute of Design); 1932 study trip to Italy.

Brauer, Erich (Arik)
Born in Vienna in 1929. After three years forced labour, he studied at the Vienna Academy 1945–51; participation in exhibitions of the Art-Club in Vienna; 1956: first one-man exhibition in the Neue Galerie, Vienna; lives mostly in Israel.

Carrà, Carlo
Born in Quargnento, Italy, in 1881, he died in Milan in 1966. From 1895 in Milan; 1910 he signed, together with Boccioni, Balla, Russolo, and Severini, the *Manifesto of Futurist Painting*; participation in several Futurist exhibitions; around 1915 he drew away from Futurism; 1916 meeting with de Chirico.

Chagall, Marc
Born in Lyosno, Russia. Studied at the Svanseva school in Petersburg; 1910: moved to Paris; 1914: returned to Russia; 1918–20: Commissar for Fine Art in the province of Vitebsk; moved to Moscow. 1922: returned to Paris; 1941: went to America; 1949: finally settled in Vence, in the South of France.

Chirico, Giorgio de
Born at Volo, Greece in 1888, he died in Rome in 1978. 1900: studied at the Athens Polytechnic, in the Faculty of Fine Art; 1906–10: at the Akademie der bildenden Künste in Munich; then protracted stays in Milan and Florence; 1911–15: in Paris; 1916–17: stayed in Ferrara, where the important meeting with Carrà took place; founded with the latter the 'scuola metafisica'; from 1918 in Rome; took part in the founding of *Valori plastici*. 1925: return to Paris; 1925: publication of his novel *Hebdomeros*; 1935 and 1936: in the USA on several occasions; 1939–49: mostly in Milan; 1945: return to Rome.

Dali, Salvador
Born in Figueras, Spain, in 1904. 1921–6: studied at the art school in Madrid; 1928: made the Surrealist film *Un chien andalou* with Luis Buñuel; first contacts with the Surrealist group in Paris; 1929: successful exhibition in Paris, and moved there; from the mid-1930's, deterioration of his relations with the Surrealist group; 1939: expelled from the movement; went in the same year to the USA, where he lived in Del Monte, California. 1948: returned to Europe, from 1952 in Spain; large retrospective exhibitions in Tokyo in 1964 and in New York in 1966.

Delvaux, Paul
Born in Antheit, Belgium in 1897. 1917–24: studied at the Academy of Art in Brussels; around 1936 turned to Surrealism. 1947: the film *Le Monde de Paul Delvaux* was made, with a commentary by Paul Eluard; 1950: professor of monumental painting at the Ecole National d'Art et d'Architecture in Brussels, at which he taught until 1962.

Dominguez, Oscar
Born in La Laguna, Tenerife in 1906, he died in Paris in 1957. Grew up on Tenerife, had his first exhibition there, 1933; 1934: moved to Paris; friendship with Eluard and the Surrealists; 1938: took part in the large Paris Surrealist exhibition; 1945: in the Brussels Surrealist exhibition; 1957: committed suicide.

Dubuffet, Jean
Born in Le Havre in 1901. Went to the Academy in Le Havre and in 1918 for a few months to the Académie Julian in Paris; then studied philology, philosophy and music, painted at the same time; from 1930 he worked as a wine merchant. 1942:

finally decided to devote himself to painting; 1973: retrospective exhibition in the Solomon R. Guggenheim Museum, New York.

Duchamp, Marcel
Born in Blainville, France, in 1887, he died in Paris in 1958. 1915: went to New York, took part in the founding of the Dada group there and also of various societies and journals; 1918: Buenos Aires; 1919: back in France, contacts with the Paris Dada and Surrealist group; 1938: involved in the large Surrealist exhibition in Paris; 1942: organized a large Surrealist exhibition in New York.

Ende, Edgar Carl Alfons
Born in Hamburg-Altona in 1901, he died in Netterndorf, near Munich, in 1965. Apprenticed as a scenery painter, briefly attended the Kunstgewerbeschule in Altona; 1931: moved to Munich; 1933: prohibition on exhibiting by the Nazis; 1947: co-founder of the Neue Gruppe München; 1952: exhibition in the Museum of Fine Arts, New York; 1966: memorial exhibition in the Haus der Kunst, Munich.

Ernst, Max
Born in Brühl, near Cologne, in 1891, he died in Paris in 1976. Studied philosophy and psychology in Bonn; 1914–8: military service; 1919: founded with Baargeld and Arp the Cologne Dada group; 1921: first exhibition of collages in Paris; 1922: moved to Paris, joined the Surrealist group; 1941: went to the USA; 1946: settled with the painter Dorothea Tanning in Sedona, Arizona; 1953: returned to Paris; lived from 1958 in Huismes (Touraine) and became a French citizen.

Fini, Leonor
Born in Buenos Aires in 1908. Studied in Trieste; 1933: moved to Paris, contacts with the Surrealist group, in whose actions she participated; 1937: individual exhibitions in New York; collaboration on various films; many book illustrations.

Fuchs, Ernst
Born in Vienna in 1930. 1945–50: studied at the Vienna Akademie der bildenden Künste; 1946: first individual exhibition in Vienna; 1949–61: lived mainly in Paris, with trips to Germany, England, Israel, Italy, Spain, and the USA; 1958: founded his own gallery in Vienna.

Hausmann, Raoul
Born in Vienna in 1886, he died in Limoges in 1970. 1900: came to Berlin; 1918: co-founder of the Berlin Dada movement; 1919–20: edited the journal *Der Dada*; 1933: moved to Spain, later to France; 1959: organized the large Dada exhibition in Amsterdam; 1967: exhibition in Stockholm.

Hausner, Rudolf
Born in Vienna in 1914. 1931–6: attended the Akademie der bildenden Künste in Vienna; trips to Egypt, England, France, Greece, Italy, Palestine, Switzerland, and Turkey; 1946: first exhibition in Vienna; 1966: professor at the Hochschule für bildende Künste in Hamburg; 1968; professor at the Akademie der bildenden Künste in Vienna and full professor at the Hochschule für bildende Künste in Hamburg.

Hutter, Wolfgang
Born in Vienna in 1928. 1945–54: studied at the Akademie der bildenden Künste; 1946: first exhibition in Vienna; since 1966 professor at the Akademie für angewandte Kunst in Vienna.

Lam, Wifredo
Born in Sagua-la-Grande, Cuba in 1902. 1920–23: studied at the San Alejandro Academy, Havana; 1924: moved to Madrid; 1937: went to Paris, there met Picasso and the Surrealists; 1941: moved to New York; 1947: a protracted stay on Haiti, 1947–51 in Cuba; from 1952 moved between Paris, New York, and Milan; since 1963 promoted by Fidel Castro as a Cuban painter.

Lehmden, Anton
Born in Neutra in 1929. Studied with Albert Paris Gütersloh at the Vienna Kunstakademie; since 1945 has lived in Vienna.

Magritte, René
Born in Lessines, Belgium, in 1898, he died in Brussels in 1967. 1916–8: studied at the Art Academy in Brussels; from 1927 to 1930 lived in Paris, close contact with the Surrealists; after his return to Belgium, he became the central figure of the Belgian Surrealists; 1965: comprehensive exhibition in the Museum of Modern Art, New York.

Masson, André
Born in Balagny, Oise, in 1896. Studied at the Academy of Fine Arts, Brussels; 1912: continued

his studies at the Ecole des Beaux-Arts in Paris; seriously wounded during the First World War; 1922: back in Paris, became a member of the Surrealist movement; 1929: split from the Surrealists; from 1932 lived in the South of France; 1941–5: lived in the USA; return to France; from 1947 in Provence.

Matta, Roberto (Roberto Sebastian Matta Echaurren)

Born in Santiago, Chile, in 1911. Studied architecture in Santiago; came to Europe in 1931; 1934: worked in Le Corbusier's studio in Paris; 1937: met the Paris Surrealist group; after the outbreak of the Second World War moved to New York; 1942: stayed in Mexico; between 1950 and 1955 in Rome and Paris on several occasions; 1957: comprehensive exhibition in the Museum of Modern Art, New York.

Miró, Joan

Born in Montroig, near Barcelona, in 1894. Studied at the art academy in Barcelona; 1918: first exhibition there; 1919: moved to Paris; joined the Surrealist group; 1928: trip to Holland; 1941: first comprehensive exhibition in the Museum of Modern Art in New York; 1944: first ceramics in collaboration with Artigas; 1947: journey to the USA; 1975: opening of the Miró Museum in Barcelona.

Morandi, Giorgio

Born in Bologna in 1890, he died there in 1964. 1907–13: studied at the Academy of Fine Arts in Bologna; 1910: trip to Florence; 1930: teacher at the Academy in Bologna.

Oelze, Richard

Born in Magdeburg in 1900. 1921–5: studied at the Bauhaus in Weimar; 1932–6: lived in Paris, contacts with the Surrealists; spent the first ten years after the First World War in poverty and oblivion; rediscovered in the mid-1950's.

Picabia, Francis

Born in Paris in 1879, he died there in 1953. Attended the Ecole des Beaux-Arts and the Ecole des Arts décoratifs in Paris; involved in the founding of the New York Dadaist group; 1916: founded the journal *391* in Barcelona; 1920: met André Breton and from then until 1923 was close to the Surrealist group; moved to the South of France, from then on only loose contacts with the Parisian Surrealist scene; in Paris again from 1945.

Picasso, Pablo (Pablo Ruiz Picasso)

Born in Malaga, Spain, in 1881, he died in Mougins, France, in 1973. Graphic artist, painter, sculptor, ceramist, and writer; generally considered the most important and versatile painter of the first half of the 20th century; his rich work went through many different stylistic periods. 1896–7: studied at the art school in Barcelona, from 1897 at the art academy in Madrid; 1900: in Paris for the first time, settled there in 1904; 1946–54: concerned mainly with ceramics; lived from 1961 in Mougins (near Cannes).

Pollock, Jackson

Born in Cody, Wyoming, in 1912, he died in Southampton, near New York, in 1956. 1925: began his art studies in Los Angeles; around 1929 came to New York and studied there at the Art Students League; undertook several study trips through the USA; came to abstract art in 1940, and became the best-known representative of the so-called 'action painting'.

Ray, Man

Born in Philadelphia in 1890, he died in Paris in 1976. Broke off his architectural and engineering studies in 1907 to become a painter. 1912: first exhibition in New York; involved in the founding of the New York Dadaist group; 1921: came to Paris, close contact with the Dadaists and Surrealists there; around 1922 developed a new photographic technique, the so-called 'rayography'; made several films, in particular *Le retour à la raison* in 1923 and *L'Etoile de Mer* in 1928; 1940: returned to the USA for ten years, where he mainly painted again; then returned to Paris.

Schwitters, Kurt

Born in Hanover in 1887, he died in Ambleside, Westmorland, in 1948. 1909–14: studied at the Dresden Kunstakademie; 1923–32: edited the journal *Merz*; 1925: collaboration with El Lissitzky in Hanover; 1930: member of the Cercle et Carré group; 1932: member of the Abstraction-Création group; 1937: moved to Norway; 1940: to England.

Tanguy, Yves

Born in Paris in 1900, he died in Woodbury, Connecticut, in 1955. At first served in the merchant navy; various journeys to England,

Spain, Portugal, and South America. From 1922: in Paris. 1930: stayed in Africa; 1939: moved to the USA, where he settled in Connecticut in 1941, and in 1948 became an American citizen; 1953: on the occasion of a travelling exhibition of his work stayed for a longish period in Europe.

Tanning, Dorothea
Born in Galesburg, Illinois, in 1912. Studied at the Chicago Academy of Art; close to Surrealism from 1936; married Max Ernst in 1946.

Toyen (Marie Čermínová)
Born in Prague in 1902. Member of the Prague Devetsil Surrealist group; from 1938 the group was increasingly isolated because of the Nazi régime; 1947: Toyen moved to Paris.

Wols (Wolfgang Schulze)
Born in Berlin in 1913, he died in Paris in 1951. After photographic training, studied briefly at the Bauhaus in Dessau; went to Paris in 1932; 1933–6: stayed in Spain; then returned to France; 1942–5: lived in the South of France, returned to Paris; 1947: one-man exhibition in the Galérie Drouin; 1950: one-man exhibition in the Hugo Gallery, New York.

Zimmermann, Mac
Born in Stettin in 1912. Studied in Stettin; 1934–8: journalist in Hamburg; 1946: first exhibition; professor at the Academy in Dessau, later in Berlin; 1958: moved to Munich.

'Instead of barking white it snows black
little ones come along the path
they do not know if they are little animals
 or a lilliputian landscape
the errish err from one irredenta to
 another
the cooks lie chastely curled on the
 ground
cackling kernels.'

These concise lines from Arp's *Irrländer-Konfiguration* ('Errish Configuration') contain the whole inventive riddle-like humour of their author, who seldom indulged in superfluous twirls, whether visual or verbal. With simple means he achieves arrangements which with forms or words produce or reveal bizarre subliminal relations.

The Alsatian artist Hans (or Jean) **Arp** was one of the most stimulating and original figures of modern art. Through his acquaintance with Kandinsky he was for a time in contact with the Blaue Reiter group. During the First World War he avoided being called up for German military service by playing the madman in front of psychiatrists. In 1916 he founded, together with Hugo Ball, Tristan Tzara, Marcel Janco, and Richard Huelsenbeck, the Cabaret Voltaire, whose main artistic figure he became. Between 1926 and 1930 he was a member of the Paris Surrealist group.

Arp's art is related in equal measure to Dadaism, concrete art, and Surrealism, but retains a certain independence from all three. His whole work, a mixture of plastic art, painting, and lyric poetry, is the expression of his conviction that art and nature are not basic opposites, but that it is the artist's duty to indicate how one is permeated with the other. He compares art with a fruit which must grow out of the artist. Correspondingly, we find in his paintings, his reliefs and his sculptures a recourse to 'grown' and 'organic' forms: clouds, mountains, seas, fruits, animals, people. Marcel Janco called Arp the 'poet of a true and sensual mysticism', and his work 'a work of angels and of chance'. Chance and experiment played an essential

part in his work (for instance, he used the patterns formed by scraps of paper thrown on to the ground at random), which, nevertheless, always retains the expression of a strict deliberate form. Only after the Second World War did Arp achieve international recognition, and in 1954 he received the important sculpture prize at the Venice Biennale.

The illustrated example is in every respect typical of Arp: the choice of simple, amoeba-like, and yet clearly divided forms,

and a gently humorous treatment of the individual elements. Leaf-like and fungus-like, proboscal and fluttering human qualities all combine here as lightly and effortlessly as if they had just sprung together from the eternally creating protoplasm.

1 Hans Arp
The dancer, **1917**
Oil on canvas, 121 × 109 cm
Paris, Private Collection

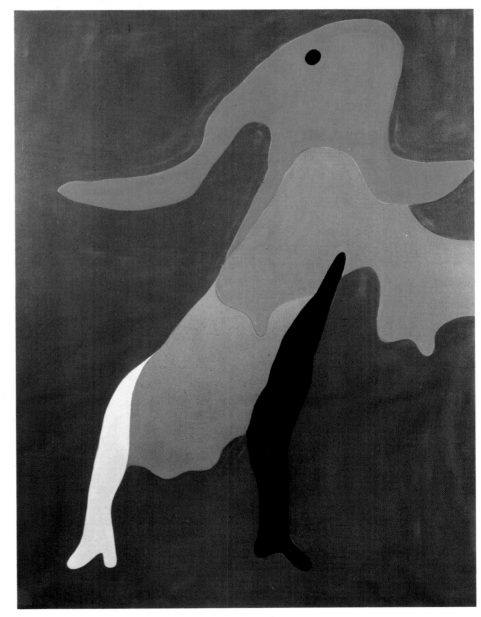

Francis **Picabia** was throughout his life a provocative, changeable personality, never satisfied with what he had achieved, a personality who did not originate a school, but a stimulus. Arp called him a 'Columbus of art', who 'sailed without a compass'.

He worked according to the principle that 'an artist should always only create for himself, without concerning himself about the effect of his work on the art dealers, critics, and admirers. . . . He is filled with the marvellous riddle of the self, and he lives in a lucid, never completely satisfied, daily renewed introspection.'

He was the son of a Cuban painter, was born in Paris, but constantly changed both place of residence and friends; initially he experimented with Impressionism, then painted in a Cubist style for a time, and in 1909 painted *Caoutchouc*, one of the first instances of non-figurative painting (Kandinsky's famous watercolour dates from 1910). His paintings of around 1912 are clearly influenced by Italian Futurism. In 1915 he met Marcel Duchamp in New York, and founded the Dada group with him there. He also carried out provocative acts directed against the current conception of 'art', in the same way as Duchamp; thus, for example, he put his signature beneath an ink stain, and called it *Holy Virgin*. In general, however, his approach remained more playful than Duchamp's, and for this reason he did not reach extremes in his artistic development, as Duchamp did.

The years 1915 to 1919, in which he created many 'ironical machines', like those illustrated here, are considered as Picabia's 'mechanical period'. Here he celebrates the machine not with the earnest enthusiasm of the Futurists, but using their image in order to make ironically distanced statements. With its rhythmical movements, its approaching and withdrawing functional elements, the machine becomes for Picabia a symbol of the erotic and sexual relations between man and woman.

The picture *Machine tournez vite*, which with its multitude of moving elements is close to Futurism, distributes the roles in an unambiguously classifying way: the large, slowly revolving central wheel (no. 2) = man, and the small, fast wheel (no. 1) = woman. The *Parade amoureuse*, set in a perspectively alienated space, with its quotation of individual machine parts indicates the general 'behaviour' of

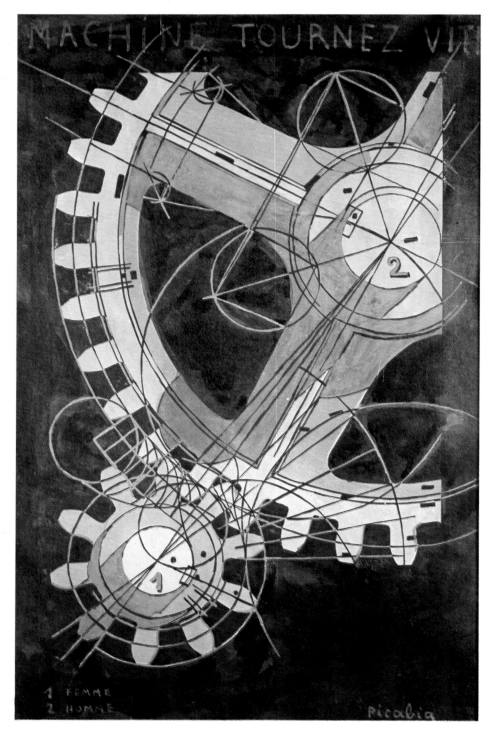

2 Francis Picabia
Machine tournez vite, c. **1916–8**
Gouache on cardboard, 49 × 32 cm
Mr. and Mrs. F. Shore Collection 34

machines, and, like most of Picabia's pictures, is not constructed in a functionally correct fashion. The clattering, ringing, and puffing which one involuntarily associates with it already suggest the 'kinetic' machines of Tinguely.

Picabia reflected much on love and death, and expressed these reflections in much gentler images, especially in a literary way. In a work entitled *The Cold Look*, he once wrote: 'After our death we should be put into a ball, this ball should be made of multicoloured wood. . . . We would be rolled in it to the cemetery, and the gravediggers entrusted with it would have transparent gloves on, in order to remind the lovers of tendernesses.'

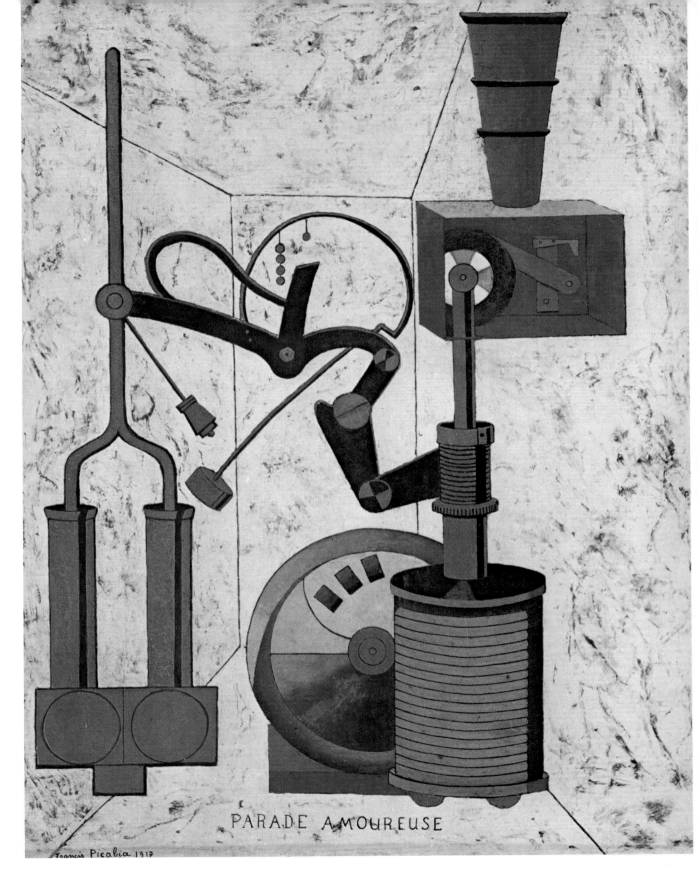

3 Francis Picabia
Parade amoureuse, **1917**
Oil on cardboard,
73 × 96 cm
Chicago,
Morton G. Neumann
35 **Collection**

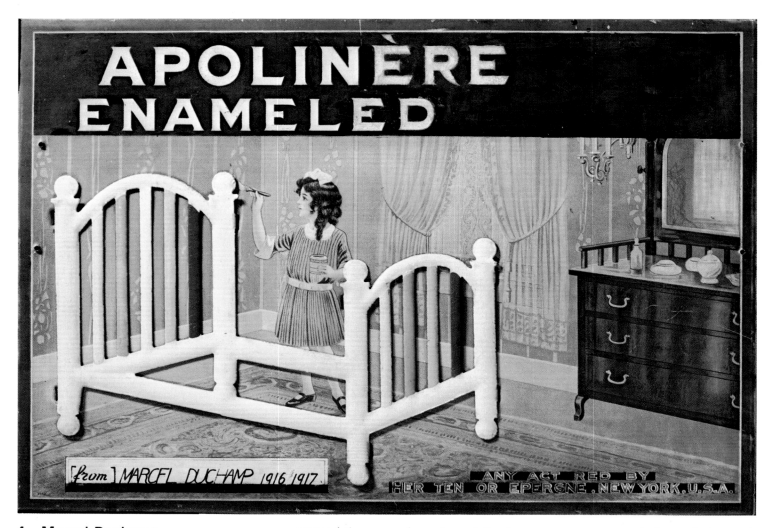

4 Marcel Duchamp
Apolinère enameled, **1916–7**
Cardboard and painted advertising
sign for Sapolin Enamel,
24.5 × 33.9 cm
Philadelphia, Museum of Art
Louise and Walter Arensberg Coll.

Marcel **Duchamp**, who came of a highly artistic family—three of his siblings were well-known artists—was one of the most radical and most influential personalities of modern artistic development. His influence can still clearly be felt in the artistic production of our own day.

Like many painters, he started, at the beginning of the 20th century, with Impressionist landscapes and portraits; later he was occupied by problems of Cubism and Futurism. In 1912 Duchamp

created the second version of the famous painting *Nude descending a staircase*, in which he makes the phases of a set of movements visible with rhythmically recurring formal elements. The picture created a scandal at the Armory Show in New York in 1913, and was almost destroyed by the indignant public. But while the impression of this 'provocation' may reflect on the level of consciousness of the New York public, still lagging behind European artistic development, the scandal created by Duchamp by exhibiting his first 'ready-made', a bicycle wheel mounted on a stool, was undoubtedly deliberate.

The examples illustrated on this page are also two-dimensional 'ready-mades'. Duchamp liked using objects, or reproductions, which he, according to an 'inspiration', changed only slightly; he thus deliberately wanted to take the traditional

concept of the artistic genius and the unique quality of the artistic product *ad absurdum*. *Apolinère enameled* was originally an advertisement for a paint firm, Sapolin Enamel. Duchamp changed the sound by erasing and adding letters, so that SAPOLIN became APOLINÈRE and ENAMEL became ENAMELED. New combinations of letters were thus created, allowing several interpretations: the first word clearly refers to the poet Apollinaire; the second word can in the first place be seen simply as the English word 'enameled' —but if it is pronounced in a French way, then it is very close both to 'un homme laid' (an ugly man), and 'un hommelet' (a little man). Seen in this way, it appears as a very ambiguous homage to Apollinaire. The girl painting a bedstead can in addition be seen as a reference to the painted nude of the 'art painter', which—when seen 36

through the sober eyes of Duchamp—is also no more than the application of paint.

L.H.O.O.Q. (which may be pronounced as 'Look!'), or *Mona Lisa with moustache*, was a cheap colour reproduction which Duchamp changed with a few strokes; Picabia took it as the title page for his journal *391*. The important thing here is not the by no means original idea of making a female face male by the addition of a moustache, but much more the decision to carry out this desanctification specifically on one of the holiest objects of bourgeois museums. The mysterious formula L.H.O.O.Q. was also used by Picabia on several of his pictures and in his manifestos of around 1920.

The ready-mades, which to many had seemed to be an end product of art itself, were not yet Duchamp's last word to art. He took part in various Surrealist exhibitions with 'objects': for instance, in 1921, he showed a birdcage filled with sugarlump-like cubes of marble, plus a cuttlebone and a thermometer. The title (in English in the original) was *Why not sneeze, Rose Sélavy?*

But Duchamp's most important final word to art was the so-called *The large glass*, whose full title was *The bride stripped bare by her bachelors, Even*, created between 1915 to 1923. So many reflections went into this painting during the course of its long creation that it would take many many pages to give an exhaustive description of this work together with all the preliminary ones which appeared in a separate folder. Duchamp himself produced a ten-page text to accompany the picture. We will here restrict ourselves to some comments

5 Marcel Duchamp
L.H.O.O.Q.
(**or** *Mona Lisa with moustache*)
Reproduction of Leonardo da Vinci's *Mona Lisa*; **beard and moustache added by Duchamp in pencil, 19.7 × 12.4 cm**
37 **New York, Mary Sisler Collection**

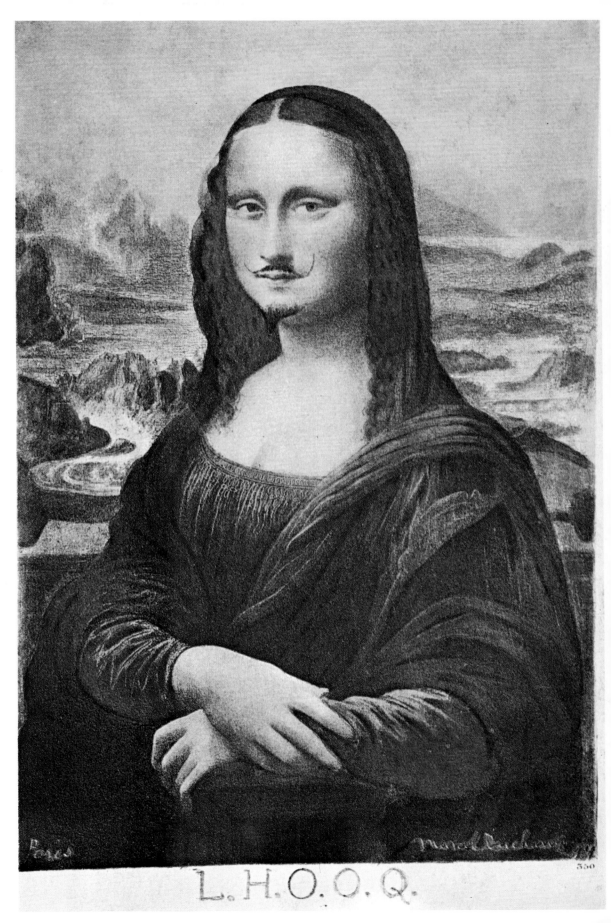

L.H.O.O.Q.

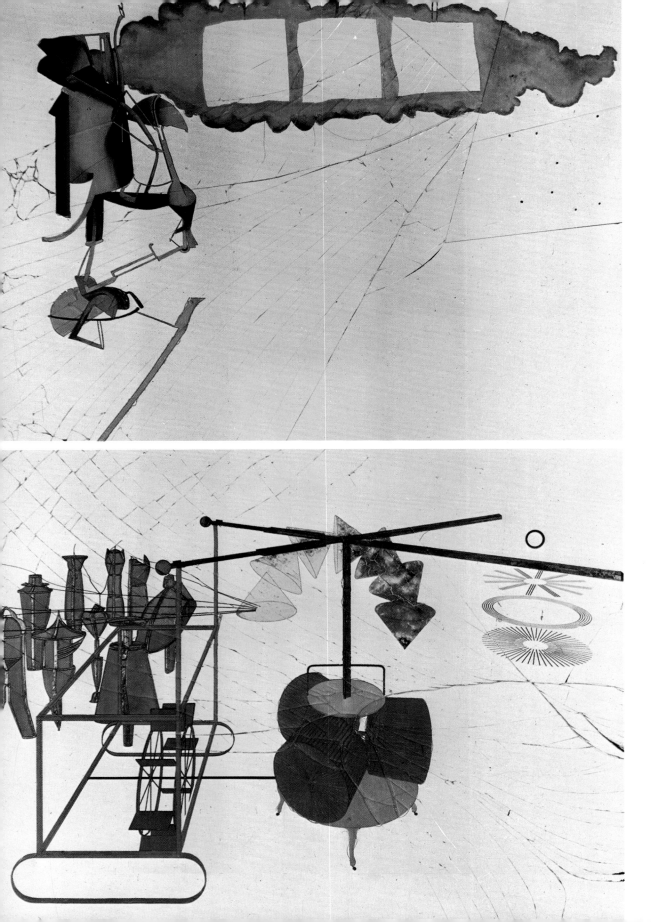

by Breton, who was of the opinion that: 'In order to understand the objectively valid work *The bride stripped bare*, one must be in possession of an Ariadne thread.' In his essay *Marcel Duchamp, the beacon, the bride* (1934), Breton wrote: 'We are here really dealing with a mechanical and cynical interpretation of the love phenomenon: the transition of woman from maidenhood to non-maidenhood becomes the subject of a totally unsentimental speculation—one would think that it came from an extra-human being, concerned to imagine this occurrence.' The form in the upper part of the picture with the three 'air flaps' represents the 'woman hanged', the cylindrical forms underneath are 'nine male Eros machines or bachelor machines'. In addition, it is emphasized as 'noteworthy' that 'the chocolate grater—whose point serves as the support for the scissors—is, in spite of the relatively conspicuous position that it occupies in the glass, above all designed to designate the bachelors concretely, applying the basic slogan of self-determination: the bachelor grates his own chocolate'.

6 Marcel Duchamp
The bride stripped bare by her bachelors, Even, **or** *The large glass,*
1915–23
Oil, enamel, lead paper, lead wire, broken panes of glass,
227.5 × 75.5 cm
Philadelphia, Museum of Art,
Katherine S. Dreier Bequest 38

The technically very versatile Man **Ray** was one of those artists who succeeded in changing from the Dadaist to the Surrealist scene. He had broken off his architecture and engineering studies in order to study painting. After initial experiments with Fauvism and Cubism, his style shows an increasing schematization of Cubist forms in the direction of abstract art. In 1915 he became friends with Marcel Duchamp, and began to make contacts with the Dadaists. His best-known work of this period is the painting *The tightrope walker and her shadow* (1916), composed of large coloured areas and suspended connecting lines. In 1917, together with Marcel Duchamp and Francis Picabia, he founded the New York Dadaist group. His Dadaist approach of that period is expressed not only in his paintings, but also in collages and objects reminiscent of Duchamp's ready-mades. One of the best known is the *Gift* of 1921: an iron, whose entire surface is covered with spikes. In 1929, when a Dadaist exhibition took place in Gallery Six, Man Ray came to Paris, stayed there, and soon gave up painting, in order to devote himself entirely to photography. The Surrealists were above all interested in his so-called 'rayographies', which he created by putting objects (bottles, glasses, etc.) on photographic paper, illuminating and developing the whole. Breton, with reference to Man Ray, said that photography was an 'art which was richer in surprises than painting'.

The painting *Dada*, created at the time of the foundation of the New York Dada group, is at first sight nothing more than an abstract picture. Only on closer inspection do anthropomorphic forms become clear, and, correspondingly, a slightly comically startled gesture of four 'arms'. The Klee-like matchstick man walking into the top right-hand corner of the picture, together with the 'randomly' applied paint in the bottom left-hand corner, mock all demands for harmonious balance of the picture. The 'little man' steps with his many feeler-like limbs like a hostile but interested insect towards the central 'figure', and thus creates the impression of a meeting of heterogeneous elements. Why is the picture called *Dada*? It could equally be called *Blabla*, or nothing at all. *Dada* here means: there is something that you cannot immediately categorize, it is not abstract, not figurative—and yet it is 'something'—'Dada', precisely. The question of what 'Dada' signifies was in any case considered un-Dadaist; the question used to be met with the reply: 'What is Dada? An art? A philosophy? A fire insurance? Or state religion? Is Dada real energy? Or is it nothing, in other words everything?'

7 Man Ray
Dada, **1916–7**
Oil on cardboard, 62 × 46 cm
Private Collection

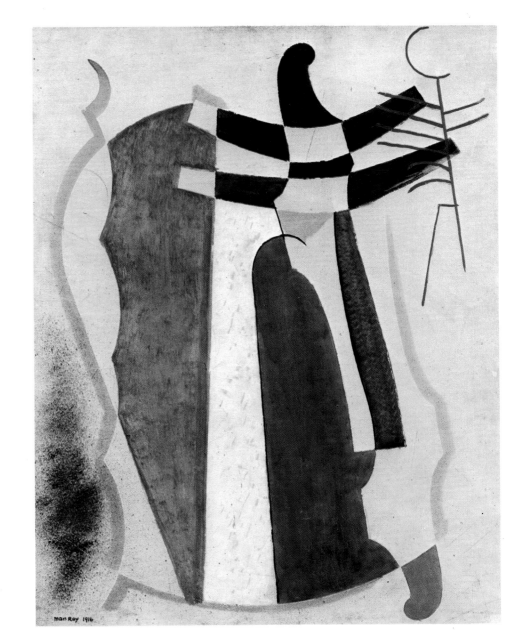

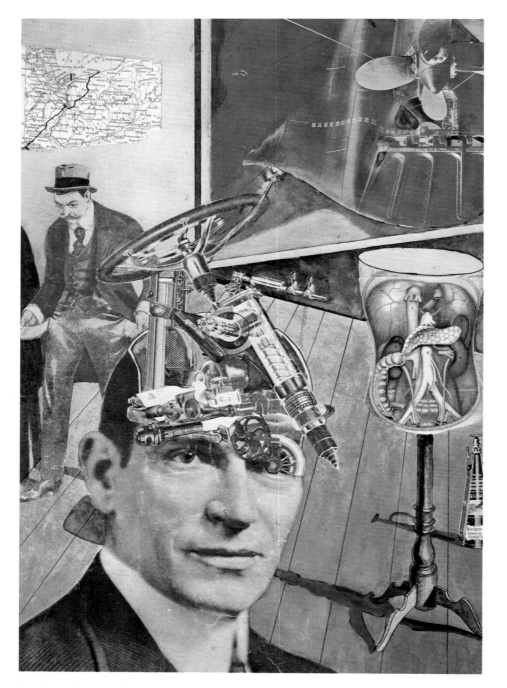

8 Raoul Hausmann
Tatlin at home, **1920**
Photomontage and gouache,
45 × 30 cm
Berlin, Hannah Höch Collection

The former Zurich Dadaist Hans Richter wrote in his retrospective book *Dada*: 'Hausmann tried everything. His versatility was inexhaustible. In everything he did there was an undertone of humour, but it was a fantastical gallows humour, born of hatred. It was what Breton calls *humour noir*. One day he was a photomonteur, on the next a painter, on the third a pamphleteer, on the fourth a fashion designer, on the fifth a publisher and poet, on the sixth an optophonetician, and . . . on the seventh day—he rested with his Hannah' (the artist Hannah Höch).

Raoul **Hausmann** was, together with Johannes Baader, George Grosz, John Heartfield, Hannah Höch, Walter Mehring, and others, a member of the Berlin Dada group. The Berlin Dadaists were the first to use little pieces of photos, usually of contemporary relevance, and to make the fragments into new, complex, visual statements on reality. Raoul Hausmann described himself as the real 'inventor' of this photomontage technique (John Heartfield and George Grosz disputed this claim, however, pointing to their own work).

Hausmann called himself a 'Dadasopher'; he was one of the most active spokesmen of the Berlin Dada movement. From 1919 to 1920 he edited the journal *Der Dada*, and subsequently he collaborated for a time on the journal *Plastique*, led by Sophie Taeuber and Hans Arp. In 1927 he invented his 'optophonetic construction', which allowed him to transform coloured forms into music and vice versa. It is based on Hausmann's 'optophonetic poems', random sound compositions, which, printed in unconventional typography, were to be recited as 'language actions' in close relation to the breathing action of the reciter.

Our example *Tatlin at home* is one of Hausmann's early photomontages. Unlike the often poster-like, political photo collages of John Heartfield, concentrating on *one* statement, there is here a multitude of more or less clear suggestions, conveying less information than 'atmosphere': a man turning his pockets out, machine parts, a propeller and other aeroplane parts which as a result of the frame appear as a 'picture within a picture', a map, neatly numbered organic forms in a jar: the spiritual innards of a technician.

All the Berlin Dadaists were very enthusiastic about Vladimir Tatlin's Constructivist machine art, the so-called 'engineer art'. With his photomontage, Hausmann created a lightly satirical homage to the scientifically thinking man of the new age, who carries the steering

wheel of his new age in his own head. Richard Huelsenbeck, one of the earliest Dadaists, did not like **Schwitters**, he thought him to be a petty bourgeois. In his essay *Dada and Existentialism* he disapprovingly describes a meeting with him: 'When I came to Hanover . . . I visited Schwitters in his house in the Waldhauserstrasse. It was shortly before Christmas, and the tree was already standing decorated in the living room. Frau Schwitters was bathing her son in a huge oldfashioned bathtub. We, who believed the military barracks or the empty room to be the most suitable place of residence, could not stop laughing at Schwitters. Here was for us the German forest and a bench with hearts carved in it.' Another former Dadaist, Hans Richter, shows more admiration for Schwitters, although he also qualifies this by saying: 'And at the same time, he was a real bourgeois, more miserly than generous.' On the other hand, he emphasizes that 'his humour and wit were simply part of the freedom that he possessed as man and artist.' His 'art and his life were a living epic. Something dramatic was constantly happening. The battles for Troy could not have been more varied than a day in Schwitters' life. When he was not writing poetry, he was pasting collages together, when he wasn't pasting collages together, he was building his column, washing his feet in the same water as his guineapigs, warming the paste pot in the bed, feeding the tortoise in the seldom used bathtub, declaiming, drawing, printing, cutting up journals, receiving friends, publishing *Merz*, writing letters, loving . . . and amidst all that he never forgot, wherever he went, to pick up discarded rubbish and to stuff it in his pockets' (Hans Richter, *Dada*).

Both our examples are the results of a sensitive poetry of litter, which from randomly discovered elements originates forms which create a no longer random effect: with glazing, partly covering paint application, Schwitters achieves a penetration of the individual formal elements, full of nuances, and which in parts still indicates suggestions of Futurism. The

fragments of writing of the *Star picture* also contain—whether deliberately or not—some politically explosive material.

The *Hair navel picture* carries on its reverse side the words: MERZ IS NOT DADA. The word MERZ (a random fragment from the word Kommerzbank) signifies, apart from the artistic realization of the decline of civilization, Schwitters' almost personal Dadaism, which was much more intimate, private, and unprovocative than 'official' Dadaism.

9 Kurt Schwitters
Star picture, Merz picture 25 A, **1920**
Montage, collage, oil on cardboard,
104.5 × 79 cm
Düsseldorf, Kunstsammlung
Nordrhein-Westfalen

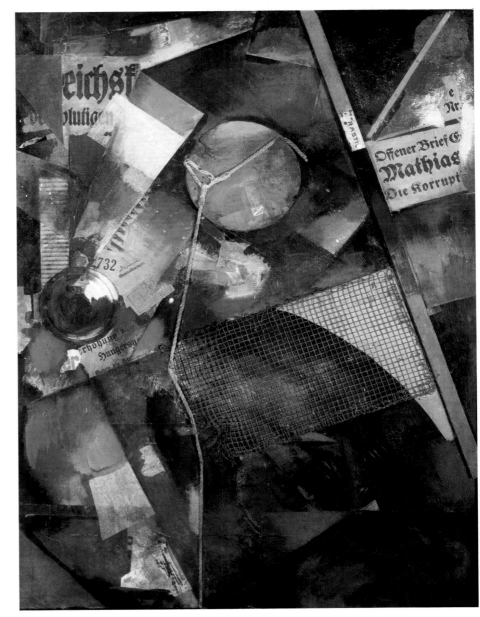

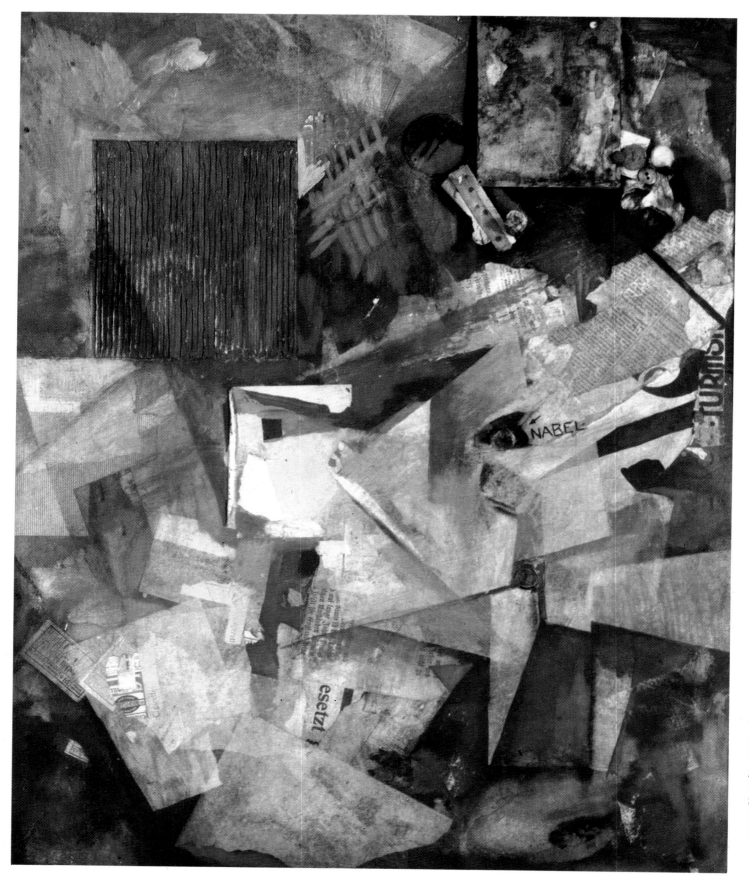

10 Kurt Schwitters
The hair navel picture
Collage,
89 × 71 cm
London,
Lord's Gallery 42

'In order for a work of art to be truly immortal, it must completely go beyond the bounds of the human: healthy human reason and logical thought are out of place; this way art comes closer to dream and the spiritual condition of a child.

'The truly profound work must be raised by the artist from the most remote depths of his being: no rushing of a river, no birdsong, no rustling of leaves.

'It is especially important to liberate art from everything it contains which is already known, all objects, all things which have already been thought, and all symbols must be got rid of . . .' (Giorgio de Chirico, quoted by André Breton in *Surrealism and Painting*, 1928).

De Chirico wrote these sentences in 1913, in other words before anyone had started thinking about Surrealism. The decisiveness with which he puts forward the Surrealist philosophy and Surrealist demands is thus all the more astonishing. The phrase 'all symbols must be got rid of' seems to us to be of especial significance. It was after all, before the arrival of Surrealism, quite normal to motivate thematic incursions beyond sensual reality with expression directed towards the symbolic. It was only Surrealism which demanded that the content flowing from the unconscious should not be given a fixed symbolic significance, but should initially be allowed to speak for itself in all its bewildering qualities, as 'the marvellous'.

No phenomenon in visual art exerted a greater influence on the Surrealists than de Chirico's work. Giorgio de Chirico, who is considered the founder of the so-called *pittura metafisica*, was the son of an Italian who worked in Greece as an

11 Giorgio de Chirico
Piazza d'Italia, **1912**
Oil on canvas, 47 × 57 cm
Milan, Emilio Jesi Collection

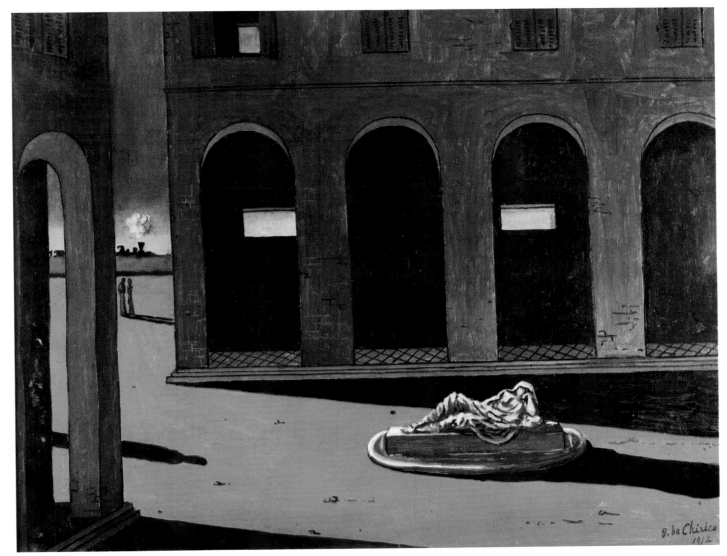

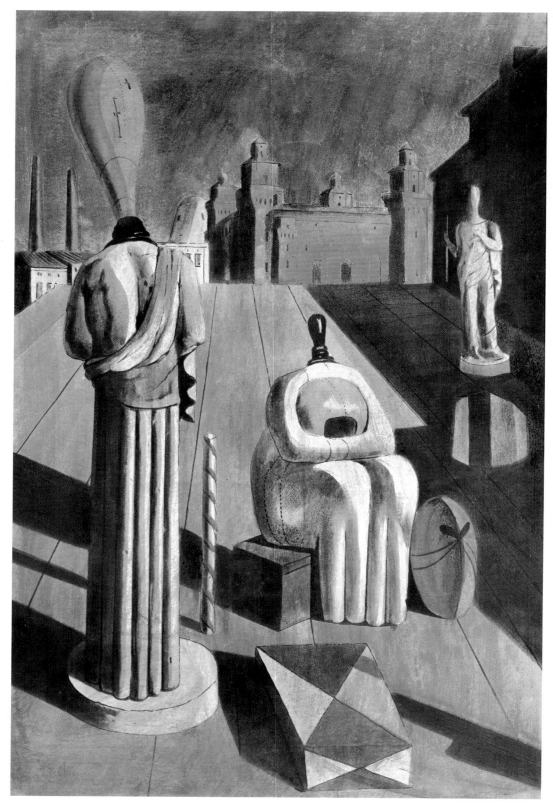

engineer. His childhood impressions thus included the Greek light, Greek myths, and Greek Classicism. After his father's death, de Chirico went to Munich, where he attended the Academy of Fine Arts and in addition became interested in philosophy, especially in Schopenhauer and Nietzsche; his interest was also aroused by Böcklin's symbolic and mythical representations and by Max Klinger's dreamy, fantastical work.

From 1909 he worked in Italy. His experience of Turin, with its straight streets, its geometrically exact squares, its arcades, its stone reliefs, and its light, was to be crucial for his work. Here he found experiences tangibly poeticized, which sometimes came to him suddenly in other places, too, from a quietly and clearly present architecture, as for example one day in Versailles: 'On a bright winter morning I was in the courtyard of the palace of Versailles. Everything was quiet and still. Everything looked at me with a strange and questioning expression. Gradually I saw that every corner of the palace, every column, every window had a soul, a mysterious soul. I looked around me at the heroes of stone motionless under the bright sky, in the cold rays of the winter sun, which illuminates without love, and they were like sad songs. A bird was singing in a cage hanging in a window. I felt the whole mystery of why men are impelled to be creative. And the creations seemed to me to be still more mysterious than the creators themselves. For me the strangest thing which pre-history has left us is the experience of the omen. Omens will always exist. They are an eternal proof of the anti-logical in the universe. The first man had to see warning omens in everything and shuddered at every step' (quoted in André Breton's *Surrealism and Painting*, 1928).

In 1911 began de Chirico's period of dead, motionless, strange scenes, blind monuments, white, impersonal light, sharp

12 Giorgio de Chirico
The disturbing Muses, c. **1916**
Gouache on paper, 94 × 62 cm
Munich, Staatsgal. Moderner Kunst 44

shadows, frightening stillness. Breton later saw the works of 1912–14 as 'nothing but petrified pictures of the declaration of war'. Our example *Piazza d'Italia* (1912), one of a whole series of Piazza d'Italia pictures, has particularly menacing aspects, with the elongated shadow of a figure not present in the picture, the green light coming from the back, through the black arcades, and the almost involuntary association of the whistle of the locomotive piercing the impersonal stillness. Locomotives, whose smoke rises vertically to the sky, are a frequently recurring motif of the early pictures; they perhaps represent a childhood memory, since de Chirico's father worked as a railway engineer in Thessaly. But at the same time they also evoke an impression of movement, made impersonal by the machine—a movement in the background, which, however, only emphasizes the oppressive stillness of the foreground.

Around 1914, other motifs in addition to architectural forms were introduced, such as the portrait of Apollinaire with the circle of a shooting target drawn in on his left temple; when, two years later, Apollinaire was shot in the head, de Chirico's friends attributed prophetic gifts to him.

A conspicuous new motif of this period is represented by the so-called 'manichini', the mannequins. They are probably based on a drama by Alberto Savinio, *The Songs of Half-Death*, whose main figure is the 'uomo senza volto', the man without properties, voice, or face. *The disturbing muses* depicts a mixture of such mannequins with statue-like and pillar-like formal elements, giving them something inalienably ennobling and absolutely objective. The boards of the scene suggest theatrical architecture, and already look forward to de Chirico's metaphysical interiors. In the background rises the four-towered Castello Estense of Ferrara, in the glowing evening light. Ferrara was the town where in 1916 de Chirico had, together with Carlo Carrà, reflected on, made more profound, and developed the concept of 'metaphysical painting', of which he had already worked out the basic

features. Later, de Chirico defined what he understood by 'metaphysical': 'It is the still and unsensual beauty of material which seems metaphysical to me, and things which through the clarity of colour and precision of measure are the opposites of all confusion and muddiness.' It is noteworthy that this definition (consciously?) omits any mention of the frightening effect which is created by the magical frozen quality of this world of objects.

From his time in Ferrara onwards, de Chirico often turned to smaller objects, such as rusks, pretzels or biscuits, which, totally isolated from their function, provide insoluble puzzles as components of painted collages. His settings are now also predominantly interiors, stuffed full of tools, angle bars, boards, dolls, easels and

so on. Making a very broad generalization, one might say that the agoraphobia of wide open places was now replaced by the claustrophobia of the cramped cell. In both cases, however, any association or reminiscence of life is suppressed by the substitute world of the object created by man.

Between 1918 and 1919, de Chirico's explicitly metaphysical period came to an end, and he now turned to primarily romantic-mythological themes—for which the Surrealists never forgave him.

13 Giorgio de Chirico
The death of a spirit, **1915–6**
Collage and oil on canvas,
37.5 × 34.5 cm
London, E.L.T. Mesens Collection

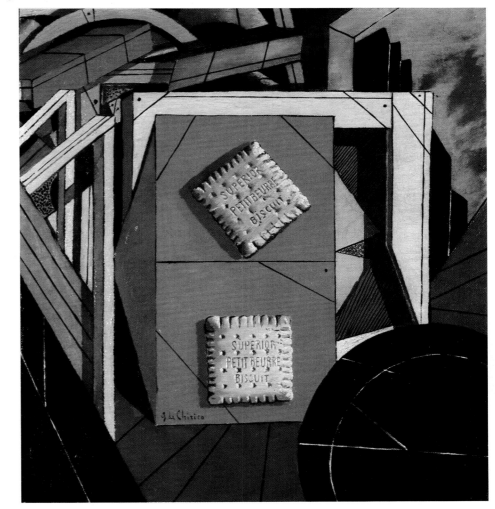

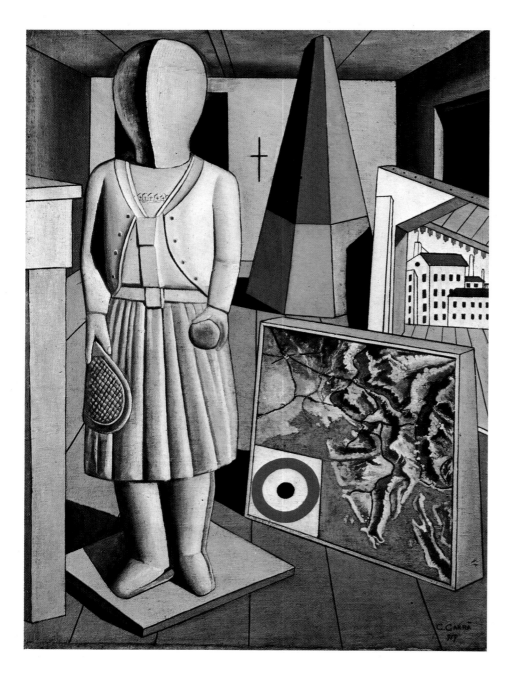

maps should be any less worthy of study than the bottles and pipes to which Paul Cézanne owes his reputation as a great painter.'

Already before his meeting with de Chirico, Carrà painted precise pictures reduced to the essential. He consciously opposed a massive, self-contained physicality to the dynamics of Futurism.

When he met de Chirico in the military hospital in Ferrara in 1916, the latter had already developed the essential features of *pittura metafisica.* Carrà saw his own intentions confirmed when de Chirico spoke of the 'magnificent sense of solidity and balance which distinguished great Italian painting.' Both painted together for six months in the rooms of the Ferrara convent where the hospital was lodged, and both were equally enthusiastic over Giotto, Masaccio and Uccello, as representatives of the *'principio italiano'*. Above all, they discovered in Giotto's archaic greatness the 'great reality' and the 'magic stillness of form' which they wanted to realize analogously in their own works. At the same time, they created that mysterious quality which strikes us in their lifeless pictures.

The metaphysical Muse was painted during the fruitful year in Ferrara. It evokes a magical impersonal mood not in an empty space in the open, as, for instance, in de Chirico's *Disturbing Muses*, but in an oppressively cramped interior. The outside world is only present via the painted houses on the canvas, which, however, because of their totally distorted perspective (which also applies to the other objects in the room) do not create any kind of illusionistic impressions. The room, whose doors are admittedly open, but which only appears all the more closed in because of the blackness beyond, contains the most varied objects: a painting, a map with an incomprehensible sign, a kind of cupboard or mantelpiece, a coloured pyramid which pierces the ceiling, a cross, and also the statue-like 'muse'. This has the impersonal head of the *manichini*; the

14 Carlo Carrà
The metaphysical Muse, **1917**
Oil on canvas, 90 × 66 cm
Milan, Emilio Jesi Collection

When Carlo **Carrà** moved away from the Futurist ideals to which he had for many years subscribed, and turned instead to immobile, impersonal scenes, his earlier followers reproached him with having abandoned the fullness and dynamics of life. He replied to this: 'I do not see why mannequins, children's sand patterns, and

46

white tennis racket in its hand already points the way to Claes Oldenburg's soft sculptures. It intensifies the impression of another world, totally divorced from ordinary functions, created by the whole arrangement.

The Knight of the Occident seems at first glance to be close still to the Cubist formal construction. But a closer examina-tion shows that the principle of the lifeless mannequin has here been taken to its furthest extreme. The galloping rider, an essentially dynamic subject, which Futurism had realized in various phases of movement, here becomes a frozen, lifeless rider: a phantom nailed together out of panels, that reminds us of long-past life like an empty shell.

15 Carlo Carrà
The Knight of the Occident, **1917**
Oil on canvas
Milan, Gianni Mattioli Collection

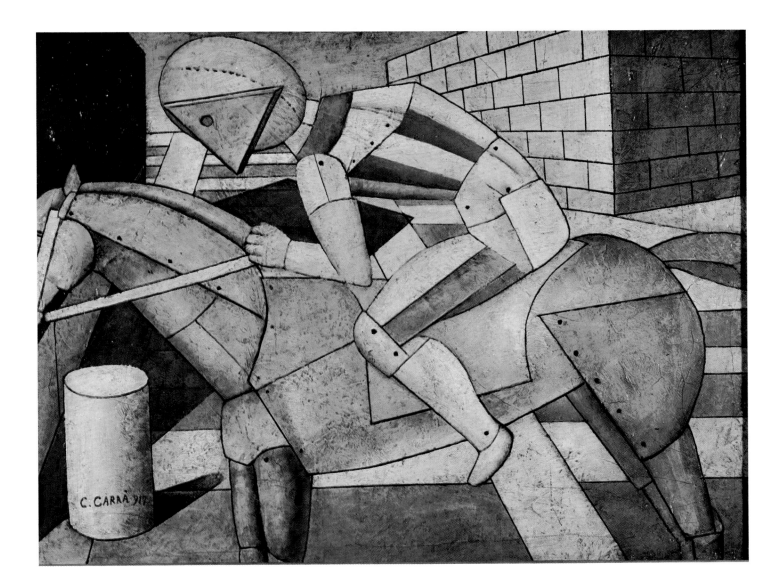

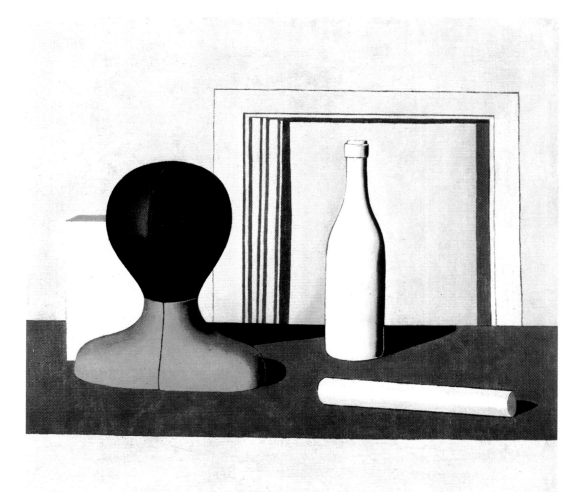

16 Giorgio Morandi
Still-life, **1918**
Oil on canvas
Milan, Private Collection

Morandi destroyed a large part of his work dating to the period before he met de Chirico and Carrà, so that his development up to that point is difficult to document. For a time he painted in the style of Cézanne, and for a brief period he was also close to Futurism. Of the Old Masters, he was especially impressed by Giotto, Masaccio and Uccello.

Shortly before he met de Chirico and Carrà, his style suddenly changed: he now preferred simple, precise, plastically painted forms, often smooth, rounded, and as though polished, as well as sensitively combined colours. De Chirico reacted spontaneously and positively to this style, which with its bright light and sharp shadows seems to carry de Chirico's metaphysical spaces into the realm of the still-life. De Chirico once wrote of him: 'He looks with the eye of a man who believes; and the inner skeleton of things which for us are dead, because they do not move, appear to him in their comforting aspect, the aspect of eternity. He thus is part of the lyrical basic attitude of the latest European art: the metaphysics of the most everyday objects, of those things which custom has made us so familiar with that we, however attentive we may be to the mysteries of external phenomena, often merely see them with the eye of one who sees and yet does not understand.'

The *pittura metafisica* had no programme in the usual sense, and was not represented by a real group. Its main representatives were de Chirico and Carrà —Morandi is more of a fringe figure, who throughout his life remained something of a solitary artist, and concentrated on the modest world of the still-life, on cups, bottles, bowls, mannequin busts, and bread, to which, through his precise drawing and the clarity of light, he gave an elegant and at the same time mysterious tranquil dignity.

If we compare the two pictures on this page, we may see from just one of many possible examples how varied were the sources on which Surrealism was based.

'With Picasso we knock the walls in. The painter abandons neither his reality nor the reality of the world. . . . He dreams, he imagines, he creates. . . . After wandering around for ever in dark or bright chambers, the irrational, with Picasso's pictures, absurdly called Cubist, took its first rational step, and this first step finally gave it the justification for its existence' (Paul Eluard, *Physics of Poetry*, 1935).

Like the other Surrealists, Eluard greatly admired **Picasso**; and, like them, he also of course occasionally read tendencies into his work which probably did not correspond in equal measure to Picasso's intentions. The Surrealists saw in his Cubist works less the aspect of formal innovation than the essentially new, no longer imitative relation to the visible world, and they connected it with the assumption that it went together with the emergence of the irrational. Picasso himself retained a distanced, if tolerant attitude towards the Surrealists, and for some time he remained a sympathetic figure on the edge of the movement. Much later (in 1961), Breton did, admittedly, in spite of all his continued admiration for Picasso, occasionally speak in quite sober terms of the artist's inner relation to Surrealism: 'What really stood in the way of a more complete union of his and our views was his unswerving preference for the outer world, the world of the "object", and the blindness which this attitude brings in the realm of dream and imagination' (*Eighty Carats . . . and still a Shadow*).

In the fourth number of *La Révolution surréaliste* the Surrealists published Picasso's *Three dancers*, which, as a result of its composition, simultaneously obscuring and expressively intensifying the depicted physical situation, offers various

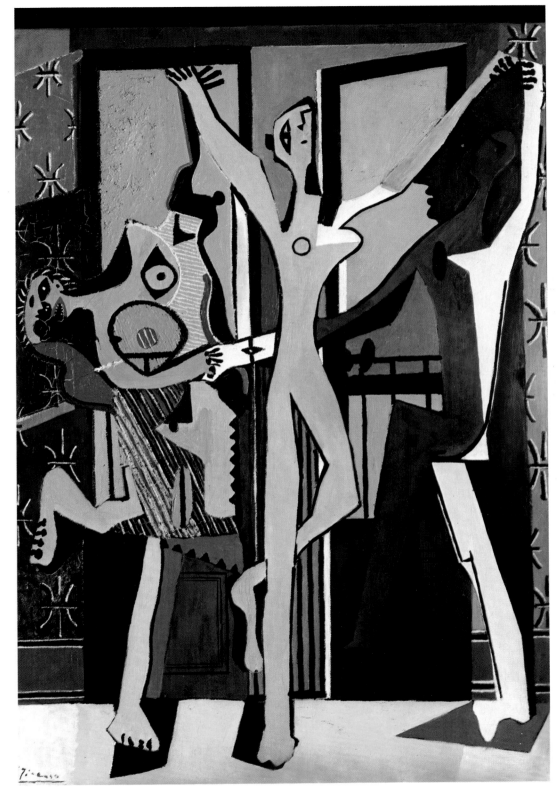

17 Pablo Picasso
Three dancers, **1925**
Oil on canvas, 215.5 × 142.5 cm
London, Tate Gallery

18 Pablo Picasso
Woman's head, **1941**
Oil on canvas, 37 × 54 cm
Prague, Národní Galerie

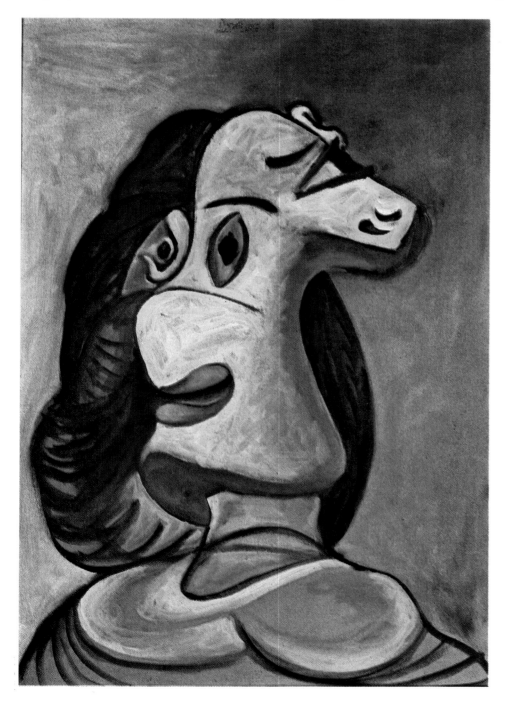

possibilities of a Surrealist interpretation: thus the distortion of the individual elements, which are related to one another in such a complex way that objects take on a double aspect—such as, for example, the large black shadow face merging with the right figure, or the ambiguity (with erotic associations) of formal elements which simultaneously appear as breast, eye, and mouth. Besides the avoidance of any imitation of nature and the ambiguities which leave room for associations stemming from the unconscious, it may well also have been the decisive expression of a liberating gesture which fascinated the Surrealists seeking uncharted territory.

Woman's head is one of a series of distorted female figures executed between 1929 and 1931 and between 1937 and 1944. The animal-like mouth opened at the side, the ear which is transformed into an eye, the growth with nostrils, make clear the simultaneity of different formal aspects: but the head is at the same time a monster which, if one looks at the picture from an analytical point of view, poses the question of what sado-masochist statement of the unconscious on the subject of 'woman' is here being made.

'At the beginning of the Dadaist and Surrealist movements, which wished to effect the combination of poetry and visual art, the serious error was committed of not doing justice to **Chagall**. The writers owe much to him. . . . Today Chagall's work can be judged more justly. His great lyrical outbreak occurred around the year 1911. At this moment, the metaphor, through Chagall alone, made its triumphant entry into modern painting. In order to destroy previous spatial thought (a process already started by Rimbaud) and at the same time to liberate the object from the laws of gravity and encumbering mass; in order to tear down the barriers between the various elements and sovereign territories, this metaphor finds from the beginning picturesque support in the sleepwalking and eidetic or aesthetic pictures, which were described only much later, but with all the characteristics which Chagall had given them. There has seldom been anything so completely magical as this work, whose marvellous prismatic colours eradicate and transform the torture of Modernism, while at the same time he has completely retained the old unaffectedness with regard to the expression of those things which herald the principle of desire in nature: towards flowers and declarations of love' (André Breton, *Genesis and Artistic Perspectives of Surrealism*, 1941).

Chagall was never a member of the Surrealist movement. But his visions—his painted dreams, memories and desires, his whole inventory of flying brides and bunches of flowers, winged clocks, floating cocks, cows, and violinists—are very close to the intentions of the Surrealists. He, too, referred to the effective power of the unconscious, and rejected any specifically symbolic interpretation of his pictures; he believed that anyone could interpret them in any way that they liked.

Chagall certainly offers the viewer a mass of fantastical elements and situations which stimulate the imagination, and inspire invention and storytelling. At the same time—by no means excluding this

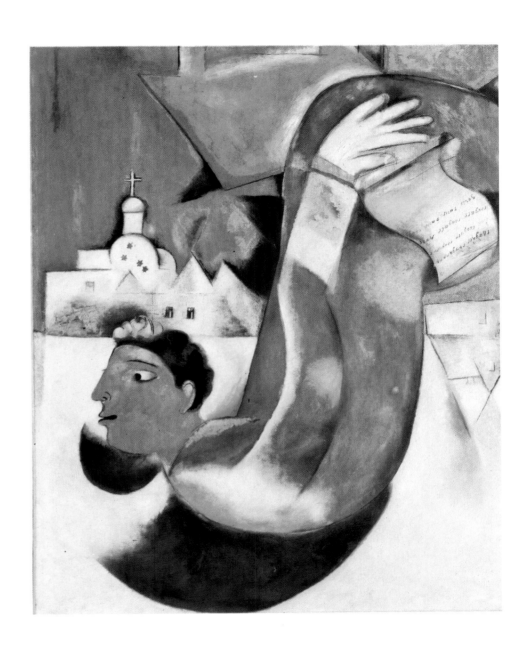

use of imagination on the part of the viewer —it is in many pictures possible to find clear connections with concrete aspects of the painter's own life. In our example *The holy Droshky coachman*, the architecture in the background suggests reminiscences of Chagall's native Russia, which—often together with the world of Hassidism— occur again and again. The *Double portrait with wine glass* already in its title indicates concrete references; it is a self-

19 Marc Chagall
The holy Droshky coachman, **1911**
Oil on canvas, 148 × 118.5 cm
Krefeld, Private Collection

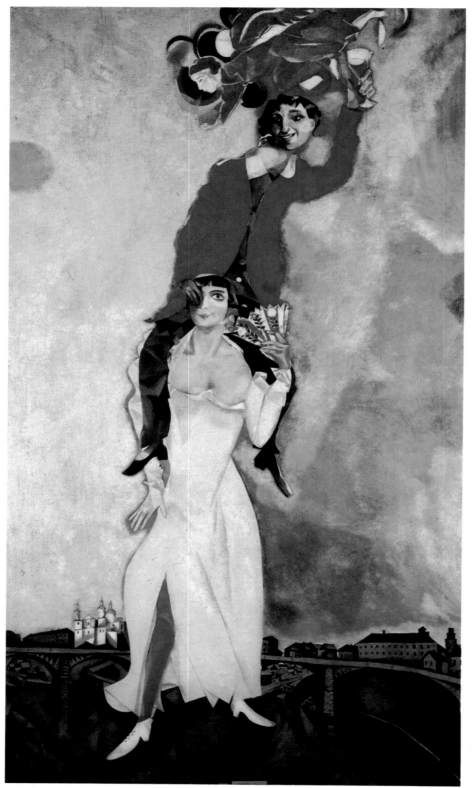

portrait of Chagall with his bride Bella Rosenfeld, radiating a mood of happiness and exuberance which is intensified into a fantastical weightlessness.

Chagall's earlier works still occasionally contain superficial echoes of Cubist composition. The abandonment of perspectival space and of realistic proportions in general is typical: in our examples, there is no middle ground to provide some kind of spatial connection between the church, or the silhouette of Paris, and the figures in the foreground. The abandonment of the unambiguous categorization of 'up' and 'down' is also typical, so that in *The holy Droshky coachman* a house can stand on its head, and the figures in the *Double portrait* can be suspended in the air above the waters of the Seine.

20 Marc Chagall
Double portrait with wine glass, **1917**
Oil on canvas, 233 × 136 cm
Paris, Musée National d'Art Moderne

Max **Ernst** was self-taught as a painter. He originally studied philosophy and psychology. Soon, however, he began to become attracted by the work of van Gogh, Picasso, and Macke. At the same time, he was interested at an early stage in the artistic creations of the mentally ill. His own works—drawings, watercolours, and paintings—were at first influenced by August Macke, with whom he was friendly, and for a short time also by Futurism. He served in the First World War, then returned—deeply affected by it—to Cologne, where, together with Hans Arp and Johannes Theodor Baargeld, he founded the Cologne Dada group 'Zentrale W/3'.

In 1919 Ernst saw in the Munich Goltz bookshop a copy of the Rome journal *Valori plastici*, showing reproductions of de Chirico's 'metaphysical' paintings, which impressed him deeply: 'I had the feeling that I was understanding something with which I had long been familiar, as when the appearance of something that we have already seen opens up to us a whole realm of our own dream world, which one has through a kind of censorship refused to see and to understand.'

The exhibition of his collages in Paris in 1921, realized at Breton's invitation, gave him the opportunity of making contacts with the Surrealists. He then finally moved to Paris in 1922, and subsequently

21 Max Ernst
Rendezvous of friends, **1922**
Oil on canvas, 130 × 195 cm
Cologne, Museum Ludwig

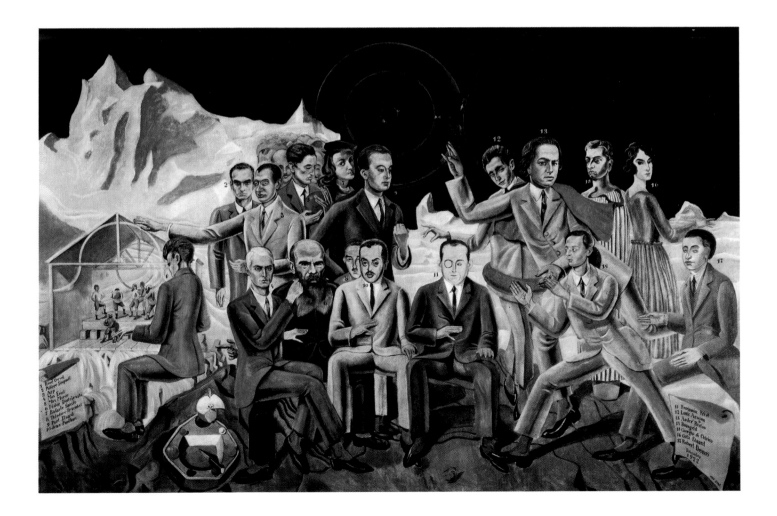

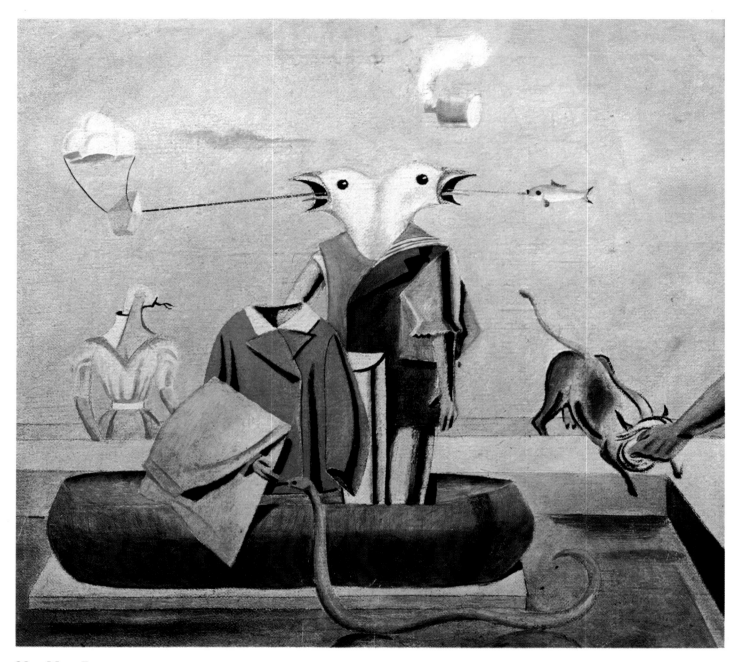

22 Max Ernst
Birds, fish, snake, **1919–20**
Oil on canvas, 58 × 62.8 cm
Munich,
Staatsgalerie Moderner Kunst

developed into one of the most versatile artists of Surrealism. In 1922 he painted the famous 'Group portrait' or *Rendezvous of friends*: under a night-black sky, against a pale blue ice or moon landscape are gathered—not without treading on one another's toes—the Surrealists, including Raphael and Dostoevsky. The only woman is Gala Eluard, who later became Salvador

Dali's wife. An unending line of figures stretches into the distance. Ernst's lifelong friendship with Paul Eluard became of great human significance for him, and in 1938 even impelled him to leave the Surrealist group in solidarity with his friend who had been excluded from it. As early as 1922, Eluard wrote a poem about Max Ernst, which testifies to the respect which 54

Ernst at that time enjoyed among the Surrealists. We quote from the second part:

Consumed by the feathers and vassal of the sea,
he let his shadow go by in the flight of the birds of liberty.
He left the stage to those who are engulfed in the rain.
He has given their roof to all those who are preserved.
His body was uninjured,
the body of others came, to destroy
the uninjured that he preserved
since the first trace of his blood on earth.
His eyes are in a wall
and his face is their heavy-hanging bauble.
One lie more in the day,
one more night, and there are no more blind.

Breton was for a long time fascinated by Ernst's apparently unfailing ability always to create new creatures: 'After he showed us, in the creation of new creatures which were not overbred or more monstrous than an agave, a sphinx, an ostrich, or a modern machine for the seasoning of barrels, from then on Max Ernst began to question the substance of things. He gave them total freedom to determine their own shadow, stance, and form once again . . . we thus wait with great impatience for Ernst to change into another and another phase, just as one always says with curiosity that one is waiting to see how the synthesis of all real values is realized, which have been given him in the realm of his possibilities, in order to understand the world, and to allow us gradually to understand it' (André Breton, *Surrealism and Painting*, 1928). After the end of his Dada phase, Ernst at first painted various large oil pictures, like *Birds, fish, snake*. Birds . . . a subject which was increasingly to fascinate Ernst. Loplop, 'the highest of the birds', finally even became a kind of *alter ego* for Ernst, who sometimes called himself 'Schnabelmax' ('Beakymax'). Ernst saw in the bird—in its patiently waiting contemplation, its unsuitedness to the flat earth, its comic clumsiness 'on foot', its figure already

developed in prehistoric times, and its fast, even aggressive mobility in flight—a kind of metaphor of the artist. In our example we are indeed dealing with anthropomorphized domestic birds, who cannot get away because they have to stand on human legs in a kind of stranded boat transformed into a monument. The wide open beaks, and what is flowing in and out, indicates an affinity to more fantastic

23 Max Ernst
The elephant Celebes, **1921**
Oil on canvas, 130 × 110 cm
London, Private Collection

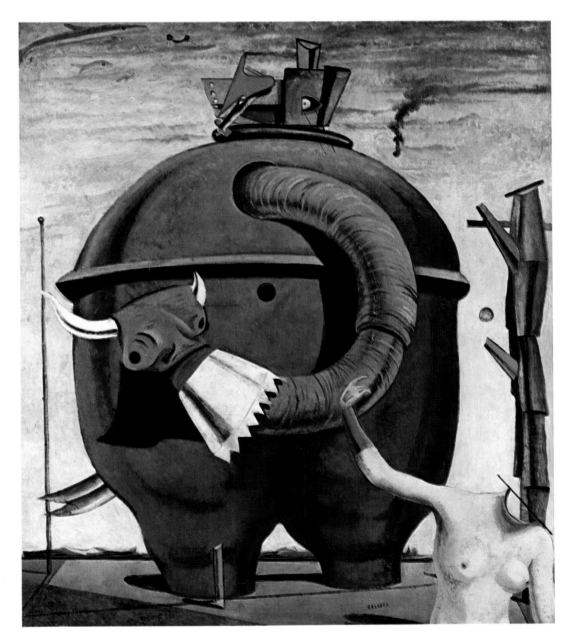

24 Max Ernst
Bride of the wind, **1927**
Oil on canvas, 65 × 81 cm
Dr. Henry M. Roland Collection

realms than the respectable sailor suit would suggest. At around the same time he created the considerably larger painting *The elephant Celebes,* which, like *Birds, fish, snake* and *Men will know nothing of this,* may be considered a collage. The sense of the comic which often distinguishes Ernst's work is revealed in the *Elephant Celebes,* in the statically impossible, pencil-thin pointed tube which serves the broad foot of the colossus as a kind of pedestal. As we have already indicated in the introduction, Max Ernst, the *homoludens,* was a great experimenter, who proceeded patiently seeking and finding. In his essay *What is Surrealism,* the catalogue foreword to an exhibition in Zurich in 1934, he wrote: 'For painters and sculptors it seemed at the beginning not to be easy to find techniques corresponding to those of *écriture automatique,* with technical means of expression appropriate for the attainment of poetic objectivity, i.e. to ban understanding, taste, and conscious will from the creative process of the work of art. Theoretical investigations could not help them, only practical efforts and their results.' Ernst 'discovered' in this way the rubbing technique (*frottage*), and its application to painting, *grattage,* where, as in the example *Bride of the wind,* layers of paint are applied on a basic surface made uneven by objects laid under it, usually with a light background, and then, half at random, half consciously scratched off again in the raised places. These forms are then figuratively completed, so that a regular 'picture' is created.

25 Max Ernst
Herringbone forest, **1926**
Oil on canvas, 38 × 46 cm
Bonn, Städtisches Kunstmuseum

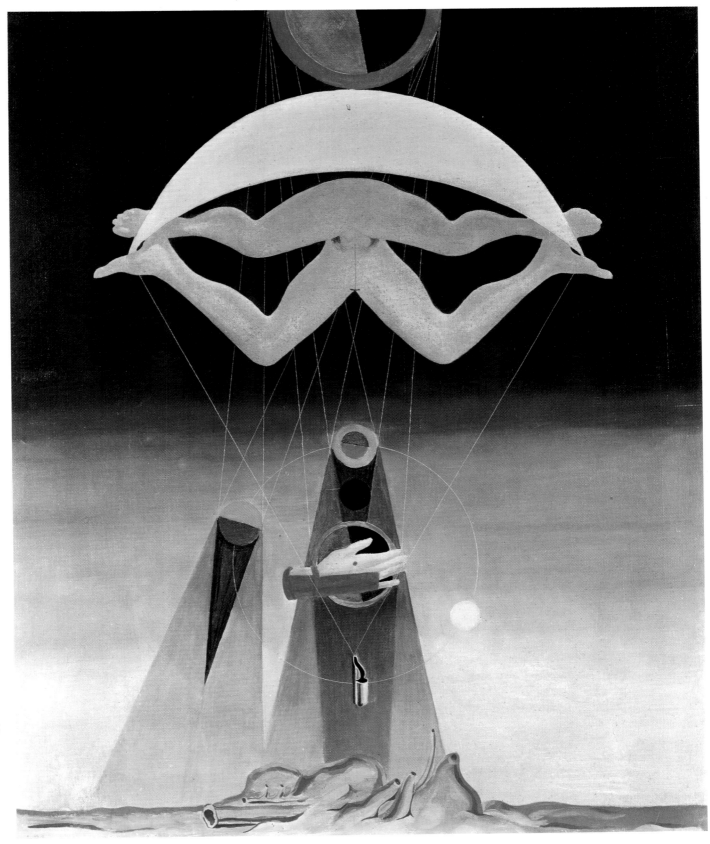

26 Max Ernst
*Men will know
nothing of this,*
1923
**Oil on canvas,
80.5 × 64 cm
London,**
57 **Tate Gallery**

27 Max Ernst
Lust for life, 1936
Oil on canvas, 73 × 92 cm
London, Private Collection

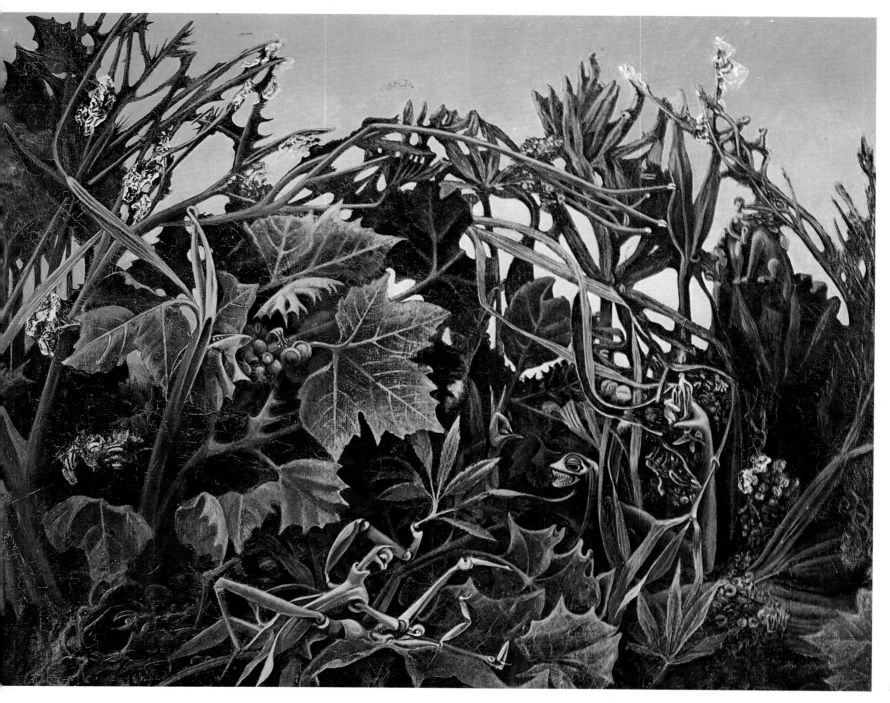

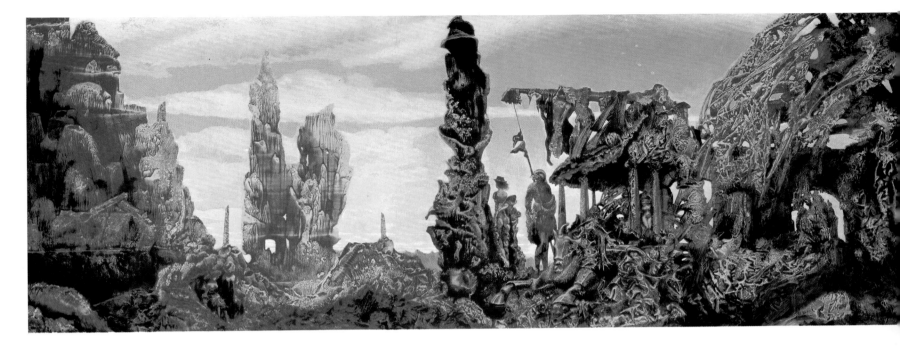

The *Herringbone forest* is one of a series of forest pictures, all created between 1926 and 1929 according to the same scheme: a plinth, above it a forest, and above that a planet (sun or moon). The structures of these forests were all devised in the same way: punched sheets of metal were pressed into the still wet paint, and the ridges created in this way were then painted. The forest is a theme constantly recurring in Ernst's work in many different forms, especially that of the dark habitat not yet reached by civilization. The invasion of technicized, domesticized humanity into the forest will kill it. In his prose piece *Le mystère de la forêt*, Max Ernst writes: 'Who will be the death of the woods? The day will come when a forest which was hitherto a woman-chaser decides to visit unlicensed cafés only, to walk asphalted roads and to keep company with the Sunday strollers. It will live on bottled newspapers . . .'

The picture *The Lust for Life* does not show a domesticated forest—on the contrary, all is a jungle of entangled undergrowth: devour and be devoured. In *Cahiers d'Art* Max Ernst described the two animals in the lower part of the picture as so-called 'demoiselles', female insects which devour their mate after the sex-act. The title, *The Lust for Life* is thus probably not without a certain irony.

Europe after the rain II (and partly also *The song of the grasshoppers to the moon*) belongs to a series of pictures which use the technique of 'decalcomania' developed by Oscar Dominguez in 1935; thin paint is applied to a basic surface with a smooth object, usually a pane of glass, pressed flat. The uneven distribution of the paint forms structures, which, when further extended by precise painting, create metamorphoses of plants, men and ruins: dead material thus begins to proliferate, and the living decays. *Europe after the rain II* is a kind of retrospective extract from the map-like vision of Europe (*Europe after the rain I*, 1933) which he painted a year after the Nazis' coming to power: an empty continent laid bare, seeming to point forward to the mass destruction of the Second World War. The second version of the picture is a landscape of ruins, proliferating in hidden life. As in a children's puzzle, we discover new figures everywhere, which seem to be as though paralyzed by the general decay.

28 Max Ernst
Europe after the rain II, **1940–2**
Oil on canvas, 54.5 × 147.5 cm
Hartford, Connecticut,
Wadsworth Atheneum—
Ella Gallup Sumner
and Mary Catlin Sumner
Collection

29 Max Ernst
The song of the grasshoppers to the moon,
1953
Oil on canvas, 89 × 116 cm
**Cologne, Wallraf-Richartz Museum
and Museum Ludwig**

At the time of the creation of this picture, in 1941, Max Ernst emigrated to the United States. From 1942 he edited, together with David Hare, André Breton, Marcel Duchamp, and other emigrés in New York, the journal *VVV*, which was subsequently to become one of the catalysts of the Surrealist movement developing in the USA. During this American period, Ernst also experimented, in his so-called 'oscillations', with methods of automatic paint application ('paint dripping'), and thus provided a decisive stimulus for Jackson Pollock and Abstract Expressionism.

Tanguy was the son of a naval officer, and himself spent years at sea. From 1922 he lived in Paris. One day he saw in an art dealer's window de Chirico's *A child's brain*. He was so deeply impressed by it that he decided to become a painter himself. According to Tanguy himself, he had until then never held a brush in his hand. His first pictures are vaguely Expressionist and at the same time naively painted scenes of daily life and fantastic inventions with many clearly erotic allusions.

In 1925, after a scandal created by the Surrealists on the occasion of a banquet

30 Yves Tanguy
The band of extremes, **1932**
Oil on wood, 35 × 45 cm
London, Private Collection

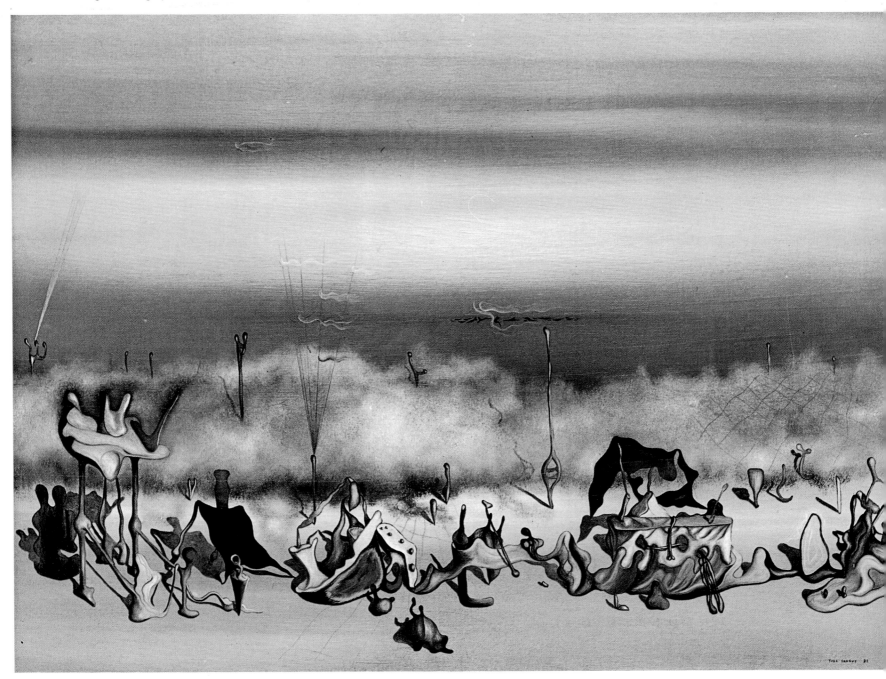

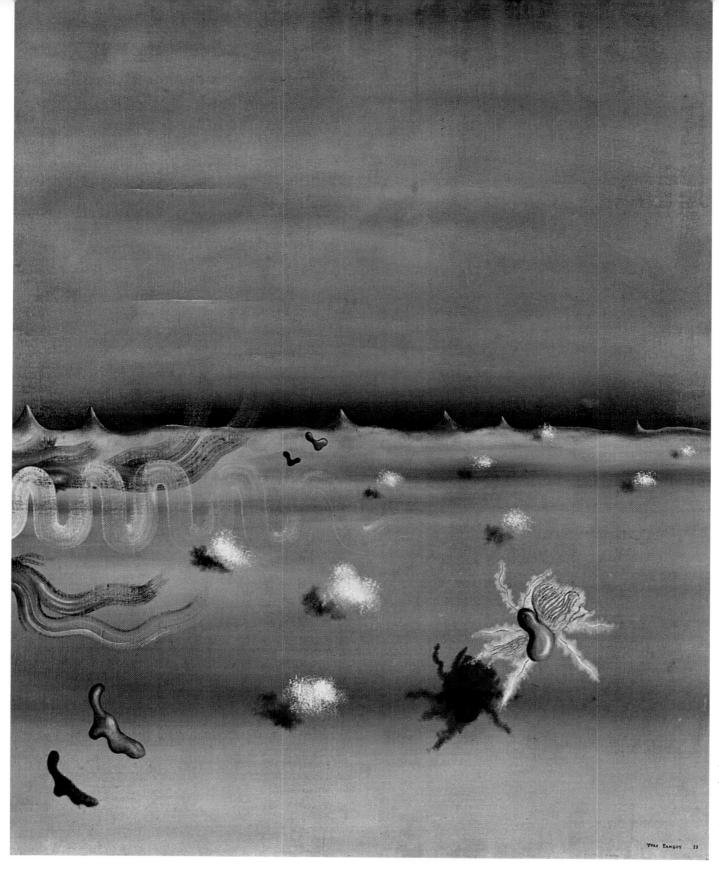

31 Yves Tanguy
*A thousand
times*, **1933
Oil on canvas,
65 × 50 cm
Private
Collection** 62

for the writer Saint-Pol Roux, he visited Breton, and from then on belonged to the tighter group of Surrealists and to the regular illustrators of the journal *La Révolution surréaliste*. After only a few years, Tanguy developed his own style, his specific subject matter, which he was largely to retain throughout his life: half-abstract, half-figurative pictures, in which various objects of a partly organic, partly mechanical nature stand in a cool light before a milky or smoky, almost empty landscape. The description 'landscape' is justified with reference to Tanguy's pictures inasmuch as the horizon line is always retained, usually straight, occasionally broken by hills or mountains. The viewer's eye can wander over these images like a walker on a beach who may discover a mussel here, a jellyfish there, a worm, or a nameless object. But he can also dream himself into an underwater world which has existed for eternities and has not been seen by any eye before, or he finds himself transported into extra-terrestrial realms, in which life is only just beginning. The objects of such landscapes can, as in *A thousand times*, be small, soft, hairy, pinnate, as though created a moment ago, or they can be smooth, as though polished, washed and ground for centuries. The title *A thousand times* seems to indicate that we are here concerned with events which occur thousands and thousands of times within the organic world. The 'hard', bony objects, springing from a lasciviously technical imagination, stand before milky horizons and share the same light, called by Breton 'the great, subjective light which pervades Tanguy's pictures', which he incidentally also praises because they 'are just as concrete as those which he paints of familiar things'.

Tanguy's pictures cannot really be analysed, and such an undertaking would probably be against Tanguy's intentions: he once said of himself: 'I expect nothing of my reflections, I am sure of my reflexes.' It thus seems to us to be most satisfactory to quote some of the more vivid comments that have been made about him, which may at least convey some of the

atmosphere of his work and personality. Benjamin Péret wrote in *Yves Tanguy, or the Goose Barnacle torpedoes the Jivaros*: 'And I thus ask into the blue: what if Tanguy were a colour?/ Then he would be a very fresh, very luminous yellow,/ answers me a voice/ And if he were an animal?/ —Then he would be a young giraffe./ And if he were a fruit?/ Then it would be the sloe/ . . . Who does not now see how the silhouette of Yves Tanguy/ is outlined, surrounded by a swarm of dragonflies? . . .

In his essay *Yves Tanguy, Prologue* (1932), André Breton wrote: 'I have thoroughly investigated his strange round pale blue eyeballs, in a cage, which closes us in in Paris. They are of thin slate, and bear within them very old traces; they are like what one sees of the heavens when one is lying comfortably in the bracken. In a dream it appears to me, crowned with beans, and our bed is the sun which rises when it rains.'

32 Yves Tanguy
Infinite divisibility, **1942**
Oil on canvas, 101.5 × 89 cm
Buffalo, N.Y.,
Albright-Knox Art Gallery

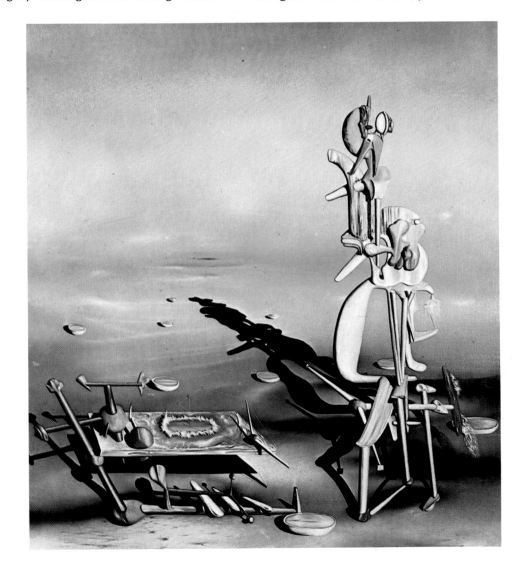

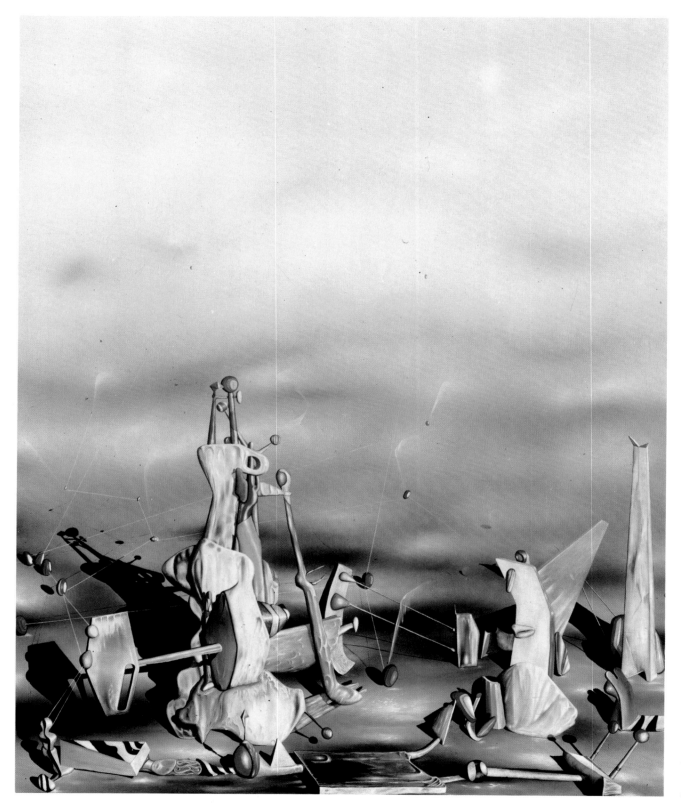

33 Yves Tanguy
*The palace with the
window rocks,* **1942
Oil on canvas,
64 × 52 cm
Paris, Musée National
d'Art Moderne** 64

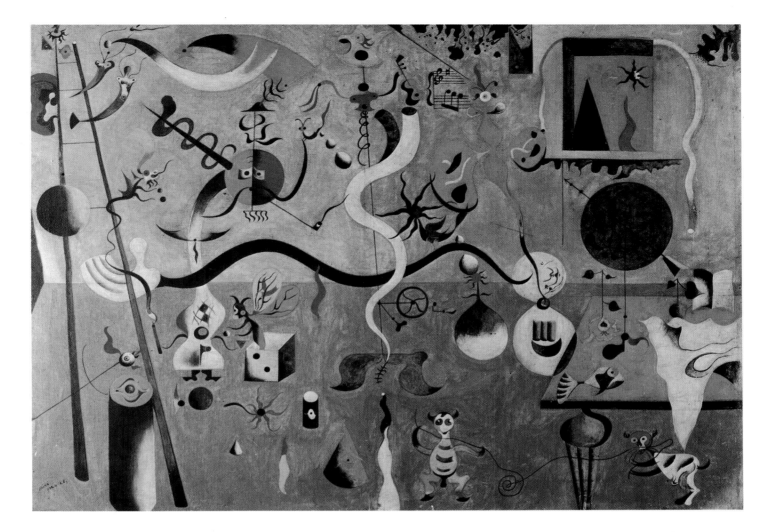

Miró's turn to Surrealism can be placed fairly accurately at a specific point in his work: it first becomes manifest in the picture *The ploughed earth* of 1923–4. Previously, Miró had painted mainly southern landscapes, especially his native farm at Montroig near Barcelona. *The ploughed earth* still deals with a rural theme, but the depicted objects and animals take on bizarre, fantastic forms; thus, we find a tree with an ear, and something tree-like with flapping arms, while the figures of the animals only bear a slight resemblance to those depicted in nature stories. From that period, Miró painted in a 'Surrealist' style, at first with a strong graphic tendency, later making increasing use of various different techniques. 'Thus a piece of thread can create a world. From a thing which one is inclined to see as dead, I find a world. And when I give the whole a title, it becomes fully alive for the first time. I find my title during the progress of the work, by putting one thing next to another' (interview with Yvon Tallandier, in *XXe Siècle*, Paris, 1968). Few of Miró's pictures are so suited to the illustration of his principle of 'putting one thing next to another' than his *Harlequin carnival*. We will attempt a description of these chambers full of unchained ghost figures: in the first place, there is a room, receding in matt grey and brown tones, with a vague suggestion of perspective. From the left, black threads shoot in, on which various bizarre creatures are hanging: two bright

34 Joan Miró
The Harlequin carnival, **1924–5**
Oil on canvas, 66 × 93 cm
Buffalo, N.Y.,
Albright-Knox Art Gallery

35 Joan Miró
Dog barking at the moon
Oil on canvas, 73.5 × 92 cm
Philadelphia, Museum of Art,
A. E. Gallatin Collection

mermaids, a little winged dragon, a bird's head with a red waving crest; behind this, a ladder, perspectively foreshortened, with a multicoloured ear. Under the ladder, a cylindrical form with an eye. The middle of the picture is marked by two intersecting basic shapes: a balanced black snake figure, which on the left-hand side flows into a white hand and a rising white snake figure, which branches into a tube-like brown growth. The snaking formal elements are repeated in many variations over the whole picture, like the moustache of the blue and red head, which belongs to a long-necked white figure with the suggestion of the classical harlequin pattern on its breast; or like the arms of a red starfish, or a red flame which is licking up in front of the window outside, etc. From above fall amorphous black forms. They include musical notes and also a guitar, which is held by a creature with red breasts; this being is developed out of a long vertical line, rising out of a brown form. A blue table leads out of the right-hand side of the picture, on which are various organic forms. At the foot of the table, two cats are playing with a ball of

66

wool. Like a creature from a child's fantasy, the winged little devil rises from the inside of the die. We may end here our description of the contents of the magical room, though it might be considerably extended. It is clear that we here have a most lovable, and in no way frightening collection of surreal objects and beings. The individual elements stand in friendly relation to one another, none displaces the other, none dominates. Various elements also recur in other's of Miró's pictures, such as the big listening ear, the open window, the ladder, cats playing with threads, spirals, comet tails, flaming, snaking forms, and the 'jack-in-the-box' devil.

We also find again the ladder as the connection between heaven and earth in our example *Dog barking at the moon*. Like the ladder in *Harlequin carnival*, there is strong perspectival foreshortening. The ladder reaches up into a night-black sky, in which hangs a crescent moon with a female breast (the moon in Spanish is of feminine gender, 'la luna'). Unlike in *Harlequin carnival*, where the most varied beings fly through the air, the separation of earth and heaven here carries with it a considerable awareness of gravity. Dog and ladder are unambiguously on the earth, and only the moon floats in the sky. It does remain unclear what the ladder is supported on, but it is clear that its bars are far too far apart for the brightly coloured dog to be able to get to heaven on it. From the late 1940's and 1950's, Miró used two main pictorial techniques: on the one hand is the series of so-called 'slow' pictures with clear outlines and defined colour masses, as in our example *Persons and dog before the sun*. But at the same time he was also working with more spontaneous spattered paint application, occasionally also including alien material, as in, for example, *Composition with strings*. The almost smooth perfection of the 'slow' pictures gives way to various half-random formations, although two very precisely painted figures frolic around, to whom the spotted background only seems to give still more grace and unaffectedness.

The picture *Stormy persons* depicts a kind of middle solution between the two styles.

The anthropomorphic figurations, often described as 'personnages', which we meet in so many different forms in Miró's

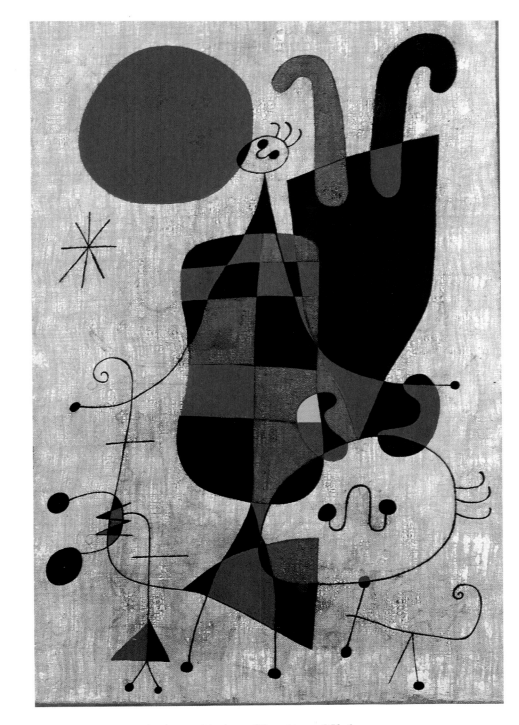

36 Joan Miró
Persons and dog before the sun, **1949**
Tempera on canvas, 81 × 54.5 cm
Basle, Kunstmuseum,
Emanuel Hoffmann Foundation

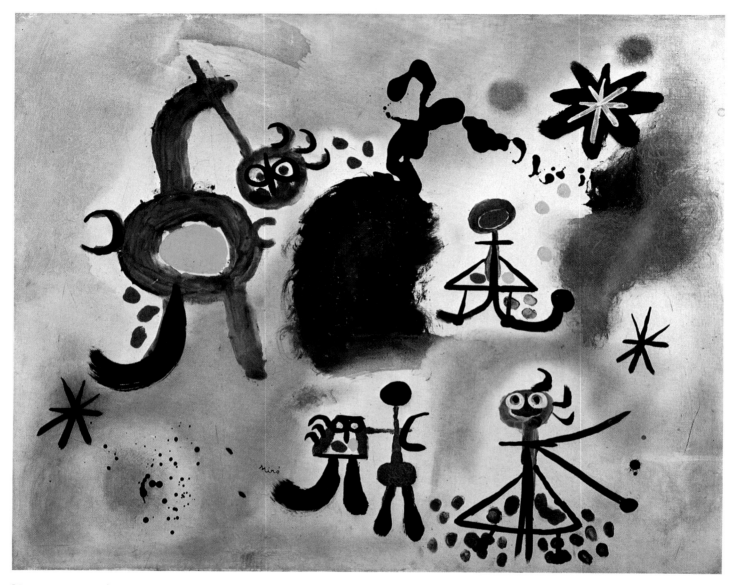

37 Joan Miró
Stormy persons, **1949**
Oil on canvas, 81 × 100 cm
Private Collection

work, are reminiscent both of cave drawings and of children's drawings. Unlike Dubuffet (Ill. 61), Miró's works, however close they may be to childish figures, hardly ever create the impression that we have actual children's drawings before us. They are at the same time all too clearly the expression of an art consciously organizing the entirety of colour and form on the surface.

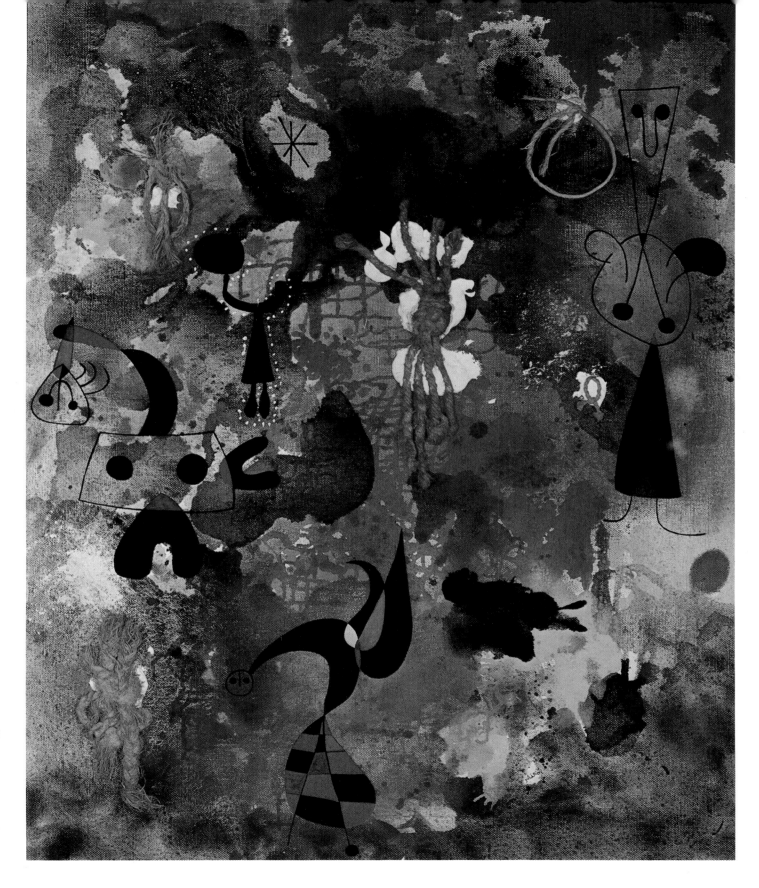

38
Joan Miró
Composition
with strings,
1950
Oil on
canvas,
97 × 77 cm
Eindhoven,
Van Abbe-
museum

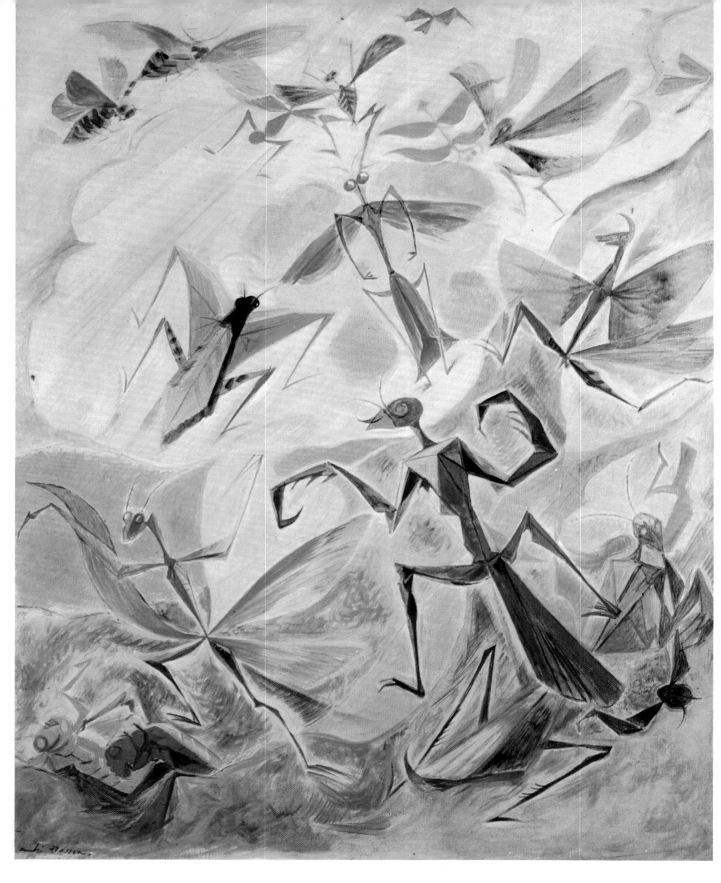

Left 39
André Masson
Summer
pleasures,
1934
Oil on canvas,
92 × 73 cm
Paris,
Private
Collection

Right 40
André Masson
Iroquois
landscape,
1942
Oil on canvas,
81 × 100 cm
Private
Collection

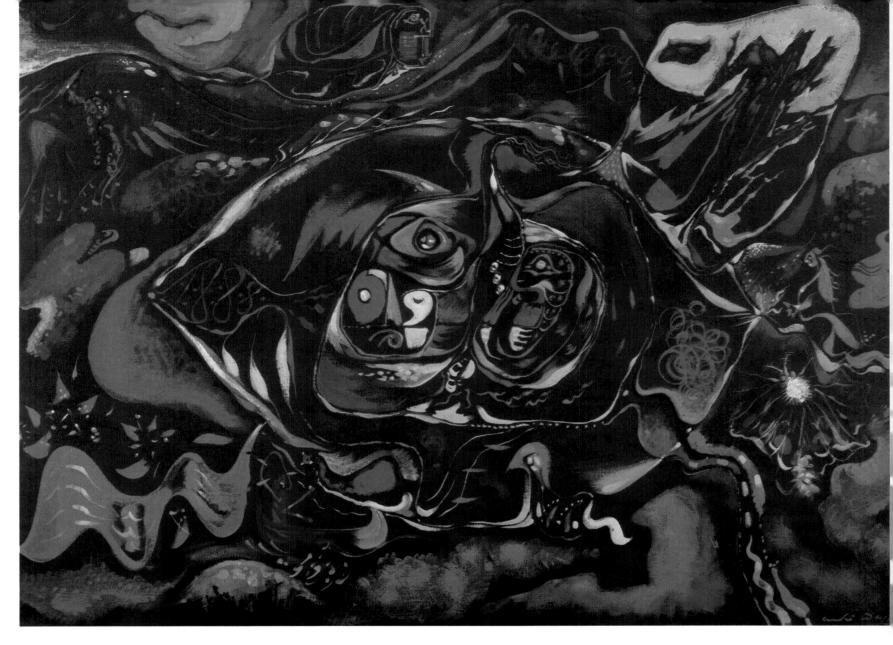

André **Masson's** work is often seen as the most precise pictorial equivalent of the literary technique of *écriture automatique*. 'The hand of the painter indeed takes wings with him', wrote André Breton. It is of course a pointless exercise to attempt to decide whether Max Ernst's half-automatic techniques or Masson's labyrinthine lines are closer to the 'automatism' of the Surrealist writers. For a long time Masson, who in 1929 broke off his relations with the Surrealist group, found it very difficult to transfer the 'automatic' spontaneity which he had originally expressed in his graphic work into the realm of painting. He experimented with various artistic techniques, thus discovering that of 'sand pictures', a half-automatic method, in which sand is thrown or scattered by hand onto a prepared canvas.

Between 1941 and 1945, during his stay in the USA, he created extraordinarily harmonious works, like the *Iroquois landscape*, where a convincing reconciliation of spontaneity of line and differentiation of colour shades is achieved. In those American years, Masson became, through his influence on Jackson Pollock, one of the stimuli which gave rise to Abstract Expressionism. His favourite themes were the dynamics of nature, passion, battle and violence. The picture *Summer pleasures* raises the restless movement of insects to a level of ballet-like grotesque, and in this sense forms a kind of light and relaxed complement to Max Ernst's *Lust for life* (Ill. 27). The colour differentiations within the areas between the principal forms are of formal interest, and especially distinguish Masson's work.

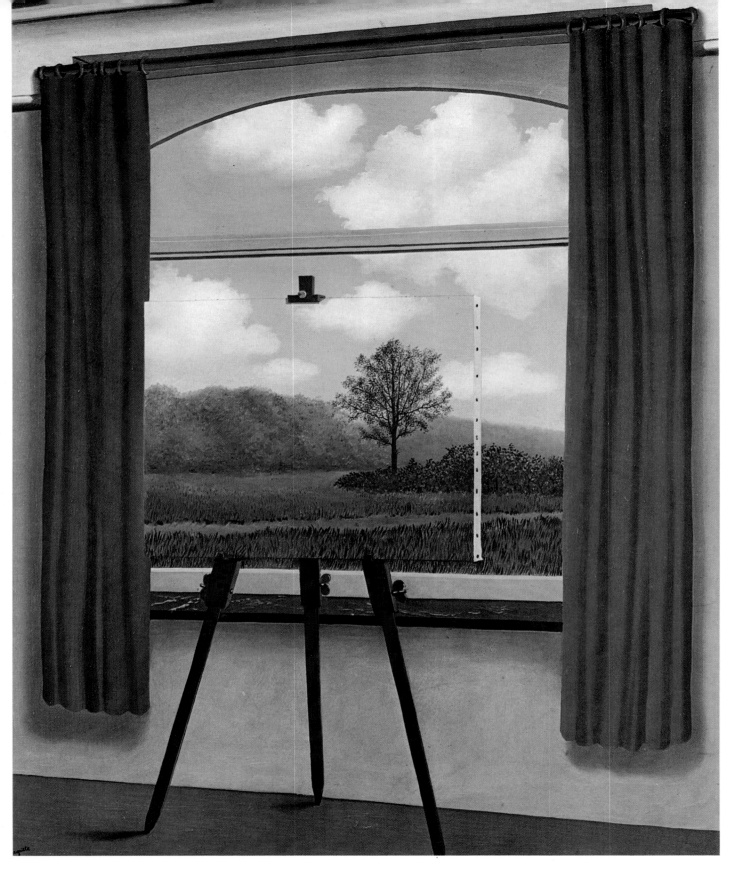

41　René
Magritte
*The human
condition I,*
**1933
Oil on canvas,
100 × 81 cm
Choisel,
Claude Spaak
Collection**　72

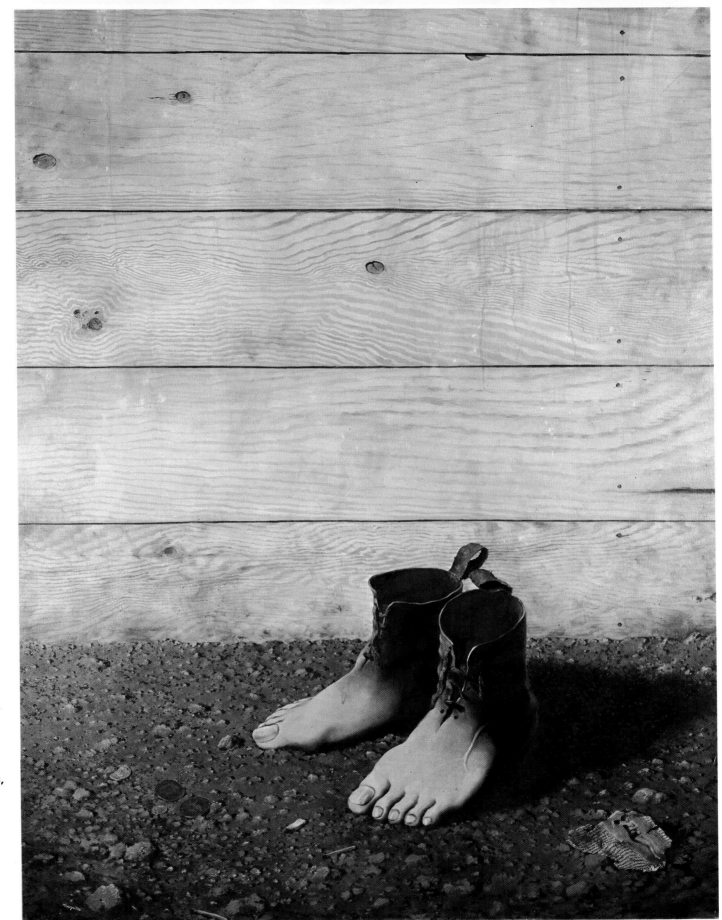

42 René Magritte
The red model,
c. **1936**
Oil on canvas,
183 × 136 cm
Sussex,
The Edward
James
73 **Foundation**

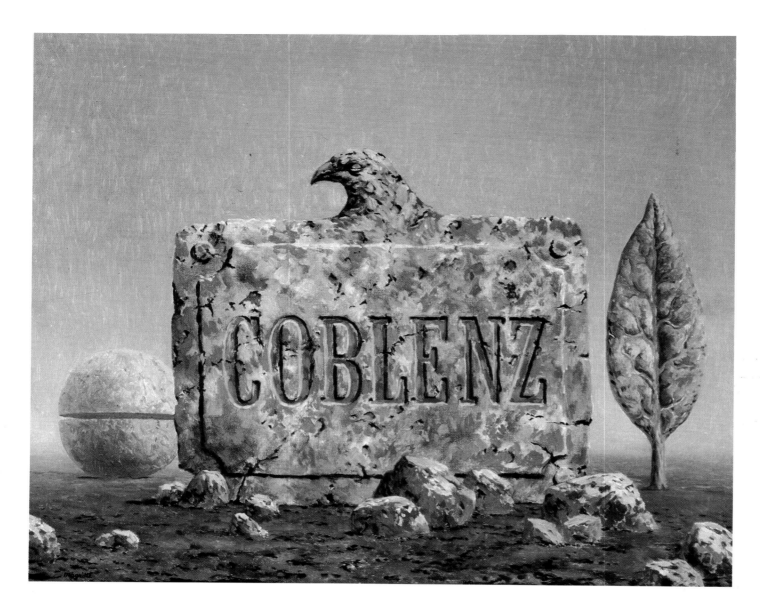

43 René Magritte
The fountain of youth
Oil on canvas
Private Collection

As with Yves Tanguy and Max Ernst, it was a picture by de Chirico (*Song of love*) that led to the decisive artistic break for **Magritte**. He was, as he himself said, moved to tears. After de Chirico, the young Magritte especially admired Max Ernst, even if he did not always share the latter's interest in experiments with painting techniques.

Magritte's early pictures are influenced by themes from the silent film and criminal novels. He was an avid reader of detective stories, and was especially fond of the thirty-two-volume thriller series *Fantômas* by Pierre Souveste and Marcel Allain, which had appeared in his youth. In 1927 he went to Paris where for three years he was in close contact with the Surrealist movement. During that time he developed his essential artistic principles, which he elaborated, varied, and made more precise during the following decades.

Since we have, in the introduction, already dealt at some length with Magritte's ideas on the subject of 'image and reality', we will here take them for granted. Our example *The human condition I* takes as its theme the problem of the imitation of nature in painting, i.e. the relationship between real object and painted representation. Magritte wrote of the picture: 'In front of a window, which is seen from the interior of a room, I placed

74

a picture which depicted exactly that part of the landscape which was covered by the painting. Thus the tree depicted in the picture hid the tree which lay behind it, outside the room. It now existed in the mind of the viewer simultaneously, both inside the room in the painting and outside in the real landscape. And thus it is that we see the world, too: we see it as something existing outside ourselves, although it is only a mental representation of what we experience within ourselves. In the same way we sometimes transfer something which is happening in the present into the past. Space and time thus lose the great significance which only takes daily experience into consideration' (quoted in S. Gablik, *Magritte*, 1971). *The red model* applies the liberties which result from the recognition that painted reality is nevertheless not the perceived reality: it combines the visualization of concepts with the depiction of empirical objects. 'The problem of the shoes', Magritte wrote of the painting, 'shows how the most barbaric things become accepted through the power of habit. Thanks to *The red model* we understand that the combination of a human foot with a leather shoe is in fact based on monstrous habit.' The title *The red model*—there is no sign of a red model anywhere—adds to the painted representation of the tortured feet the demand for a represented representation!

In the 1940's and 1950's he created a whole series of pictures which play on the pervasion of form and material with figures and objects which are frozen and petrified. Hans Bellmer had been working in a similar

44 René Magritte
The fall of the House of Usher
Oil on canvas
Cologne, Zwirner Collection

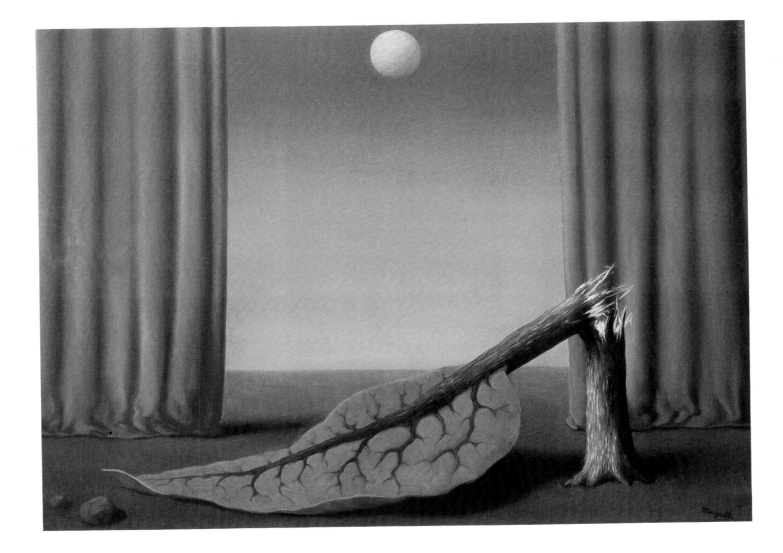

direction since 1934, by painting men constructed of bricks. But, unlike Magritte, Bellmer's pictures lacked the 'atmosphere' which gives the picture a kind of secondary naturalness. This quality of Magritte's works is incidentally also the reason why we do not subscribe to the vew that sees Magritte's pictures as a series of painted collages. Nearly all collages (often deliberately) create the impression of something put together from hetero-geneous component parts, while Magritte usually succeeds in creating a *homo-geneous* atmosphere which pervades the whole picture.

Our example *The fountain of youth*, which belongs to the series of 'petrifica-tions', contains some of the motifs con-stantly recurring in Magritte's work: the bell (in the form found on fool's costumes, or on horses' harnesses), the eagle, and the tree consisting only of one leaf. The word COBLENZ does not for the viewer have any rationally analysable relationship to the whole, but rather, like the title, impels towards a poetically associative com-pletion on the part of the viewer. The leaf-tree also recurs in *The fall of the House of Usher*, based on Edgar Allan Poe's 1839 story of the same name; the story tells of the mysterious and horrible death of the last two descendants of the house of Usher. In order to suggest the atmos-phere of destruction and hopeless exhaustion, we may quote here from the last sentence of the story: '. . . The entire orb of the satellite burst at once upon my sight—my brain reeled as I saw the mighty walls rushing asunder— . . . and the deep and dank tarn at my feet closed sullenly and silently over the fragments of the House of Usher.'

The subject of the *Domain of Arnheim* recurs in Magritte's work in various forms, for instance in the *Mountain call* of 1942, and a similarly titled picture of 1949. The bird is here part of the rock, and at the same time the question is left open whether it is not this bird which has laid its eggs in the nest. The title is also taken from a Poe story of 1847, whose main character is a landscape gardener, who among other things thinks about the creation of new forms of beauty, for 'original beauty is never so great as that which one could create.'

Magritte was for a long time in the shadow especially of Dali and Max Ernst on the international art scene. It is only since the end of the 1960's that he has been finding increasing recognition.

45 René Magritte
The Domain of Arnheim, **1962**
Oil on canvas, 147 × 114 cm
Private Collection

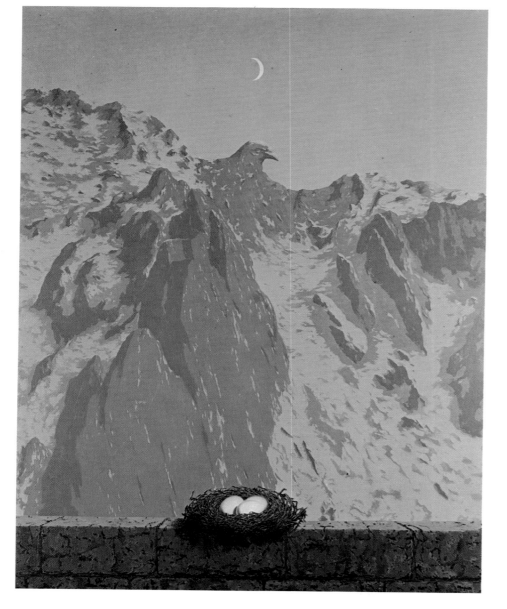

In 1934, Salvador **Dali** was called before the 'Surrealist court', which was to discuss his exclusion. The reasons for these differences were based on aesthetic grounds, including his ties to artistic tradition (he admired, for example, Ernest Meissonier, the perfect master of technique), and also —and this was the most serious charge— he was accused of sympathy for Hitler and Nazism. With his *Composition: invocation of Lenin*, which shows six little Lenin heads on the keyboard of a grand piano, Dali had expressed his admiration for Lenin. But later, in *The mystery of William Tell*, he depicted Lenin trouserless, with an exaggeratedly long posterior, supported by a crutch. The reproach of turning away from shared communist ideals and of admiration of Hitler was particularly serious since Dali had in 1931 claimed to have put himself at the service of the revolution. Dali did not take the accusations seriously and attempted to put an end to the meeting. He declared himself to be ill and unable to take part in the hearing, and, as proof, appeared with a thermometer in his mouth which he took out every couple of minutes in order to read his temperature. He emphatically called on artistic freedom, and claimed that this permitted him to project himself into the mind of both Hitler and Lenin. The final exclusion of Dali, after the differences between him and Breton in particular had become more and more irreconcilable, eventually occurred in 1939, shortly before the outbreak of the Second World War.

In 1927 Dali painted what is probably his first Surrealist picture, *Blood is sweeter than honey*. In the following year he settled in Paris and there for some years became for many people the embodiment of Surrealism. Using the 'paranoiac-critical' method, which aims at the intensification of the production of associations, he created, with his astonishing technical ability, 'dream photographs' of fears, desires, weaknesses, instinctiveness, brutality, putrefaction, and decay, with cold, mannerist 'objectivity'. Dali's writings, too, are full of extraordinary, provocative, often repellent images. We may quote two

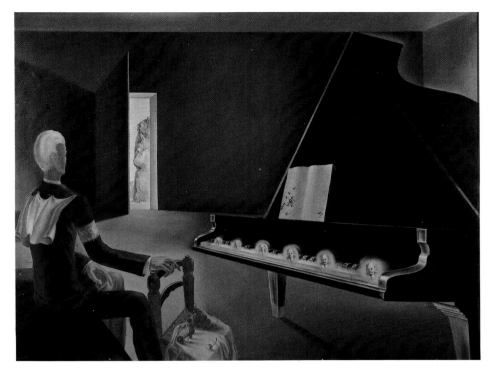

examples: 'One may hire oneself a small, clean, totally senile woman, exhibit her as a torero, lay on her previously shaved head a herb omelette: it will shake to and fro as a result of the constant trembling of the little old lady. One can also put a twenty-franc piece on top of the omelette' (quoted in André Breton, *Salvador Dali*, 1936). 'For we Surrealists are, of which one may be convinced if one examines us with only slight attention, strictly speaking not artists nor real scientists. We are caviar, and caviar, believe me, is almost the embodiment of extravagance and the spirit of good taste, especially at concrete moments like the present, when the irrational hunger of which we are talking has—in spite of its immeasurability, impatience, and megalomania—become so acute through the salivating expectations of waiting that it, in order to activate step by step its next glorious conquests, must first swallow the fine, intoxicating, and dialectic grape of caviar, without which the fat, stuffing food of future ideologies threatens to paralyse the vital and philosophical rage of the historical belly' (ibid.).

46 Salvador Dali
Composition:
invocation of Lenin, **1931**
Oil on canvas, 114 × 146 cm
Paris, Musée National d'Art Moderne

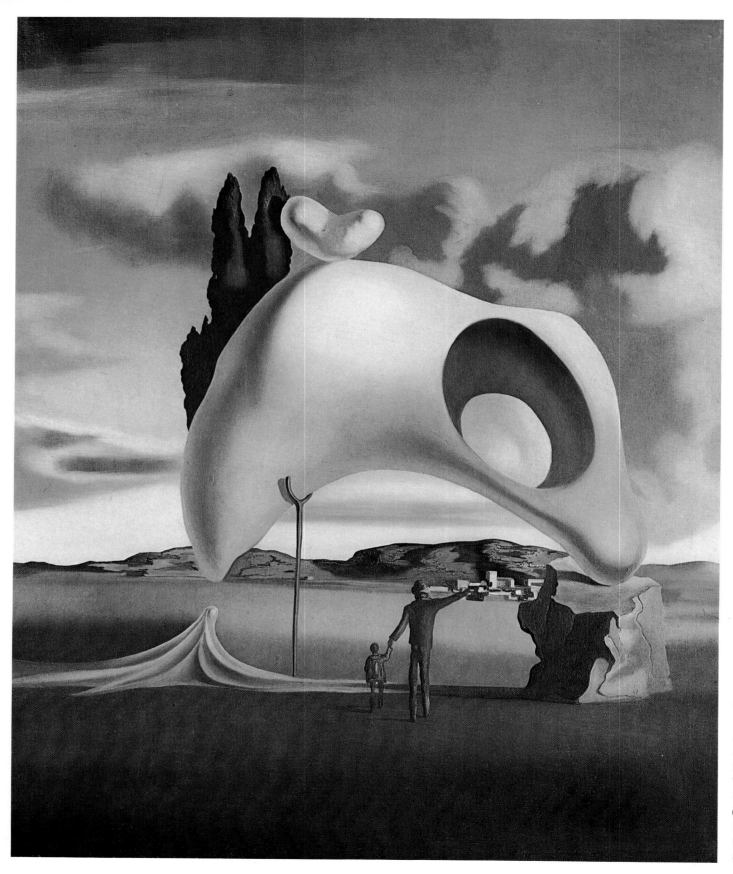

47 Salvador Dali
Atavistic ruins after the rain, **1934**
Oil on canvas, 62 × 52 cm
Rome, Carlo Ponti Collection

78

Dali was enthusiastic about Gaudi's *art nouveau* architecture which had managed to subject all forms to human needs and moods. In the journal *Minotaure* he published a text under the title *On the frightening and edible Beauty of Art Nouveau Architecture*. The results were as a rule less pleasant and 'edible', even if Dali claimed that behind 'shit, blood, and rot' lay the 'Golden Age'. Most pictures reveal frightening aspects: eaten faces, deformations, pathetic gestures before the endless void.

Our example *Atavistic ruins after the rain* shows a close formal relationship to the *Architectonic Angelus of Millet*; Millet's *Angelus* was one of Dali's thematic obsessions, repeated with many variations between 1932 and 1935. In our example, Dali is himself depicted with his father in the plain of Ampurdan, the backdrop for many of Dali's Surrealist scenes. The whole stone figure is like a drawing combining the clearly sexually accented male and female figure in the *Architectonic Angelus*. A constantly recurring motif is the crutch, which supports the most varied parts of the body and its growths. It occurs in our examples *Atavistic ruins after the rain, The burning gifaffe* and *Sleep*; frequently it indicates impotence or weakness in a more general sense. Of the picture *Sleep*, Dali declared that the various crutches were needed in order to produce the necessary psychic complement to sleep—'if only one were missing, then the result would be sleeplessness'. A distinctive characteristic of these crutches is, however, the fact that they themselves often appear extraordinarily thin and fragile; the slightest shift in weight would surely break them or make them fall.

The grand procession, too, which is coming to tempt St. Anthony (who cowers in the bottom left-hand corner, Ill. 51), structuring the picture diagonally from bottom left to top right, stands on fragile legs. The picture was painted for a competition which the film producer Albert Levin had announced for a film based on Maupassant's *Bel ami*. Dali took part in the competition with this picture; the prize was

won by Max Ernst. In a landscape typical of Dali, spider-legged elephants carry a kind of chimney and an obelisk (a phallic symbol?). The elephant with the obelisk also appears in *Dream caused by the flight of a bee around a pomegranate, a second before waking up*. According to Dali himself, the elephant concerned was Bernini's elephant in Rome. Another elephant carries a magnificent, though partly already dilapidated baroque building

48 Salvador Dali
The burning giraffe
Oil on canvas, 35 × 27 cm
Basle, Kunstmuseum,
Emanuel Hoffmann Foundation

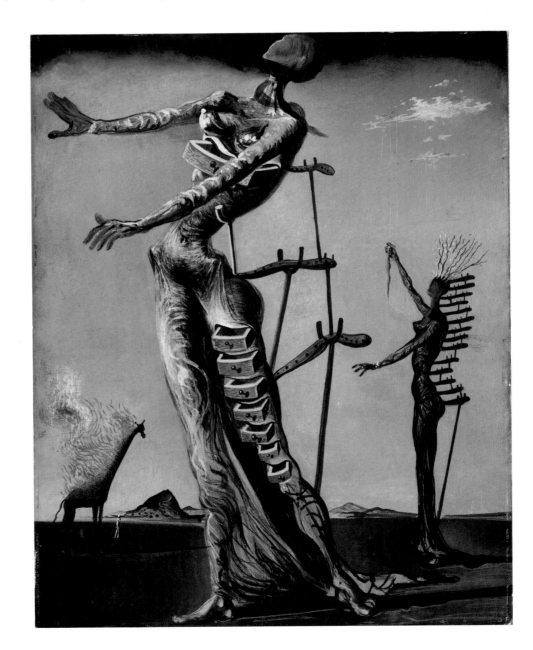

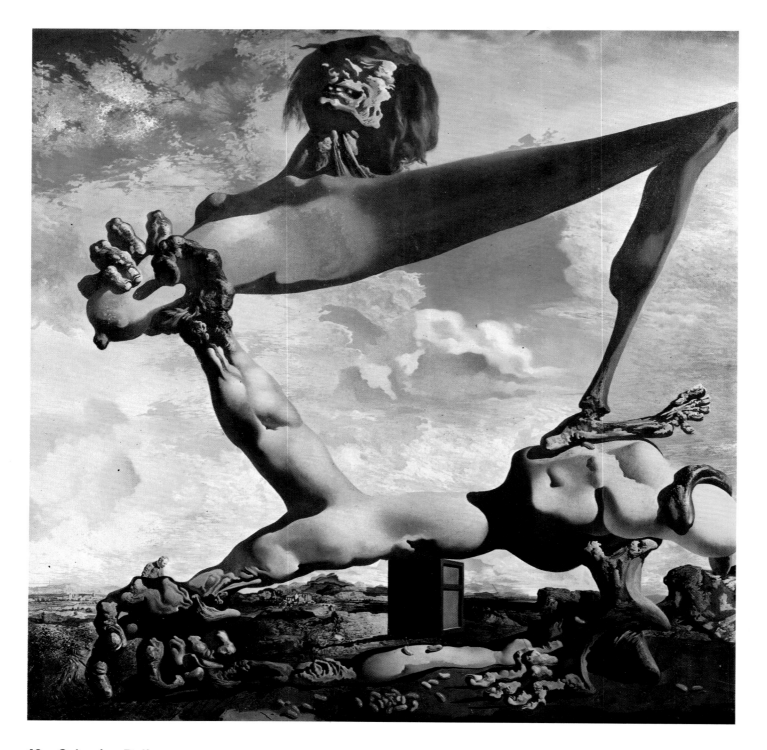

49　Salvador Dali
Soft construction with cooked beans—Premonition of civil war, **1936**
Oil on canvas, 100.5 × 100.5 cm
Philadelphia, Museum of Art, Louise and Walter Arensberg Collection

whose portal is a full-bosomed female torso. This erotic 'offer' is repeated in the impressive female figure on the pedestal. The white horse which leads the procession shies back before the cross of the hermit, at whose feet lies a skull. The exorcizing gesture with the cross is repeated in miniature by a figure in the background dressed in a monk's cowl. Above it, and clearly belonging to it, floats, almost equally small, a white, non-material figure. At the right-hand edge of the picture the silhouette of parts of the Escorial dissolves into the blue of the clouds (a reference to the heavenly Jerusalem?). We have described this picture in some detail, because its wealth of detail and its different aspects show some of Dali's typical painting techniques —the instability and distorted length of the figures; the diminution and enlargement effect (here the great white horse almost breaking out of the picture, and the tiny monk in the background); the multiplica-

50 Salvador Dali
Sleep, c. **1937**
Oil on canvas, 50 × 77 cm
E. F. W. James Collection

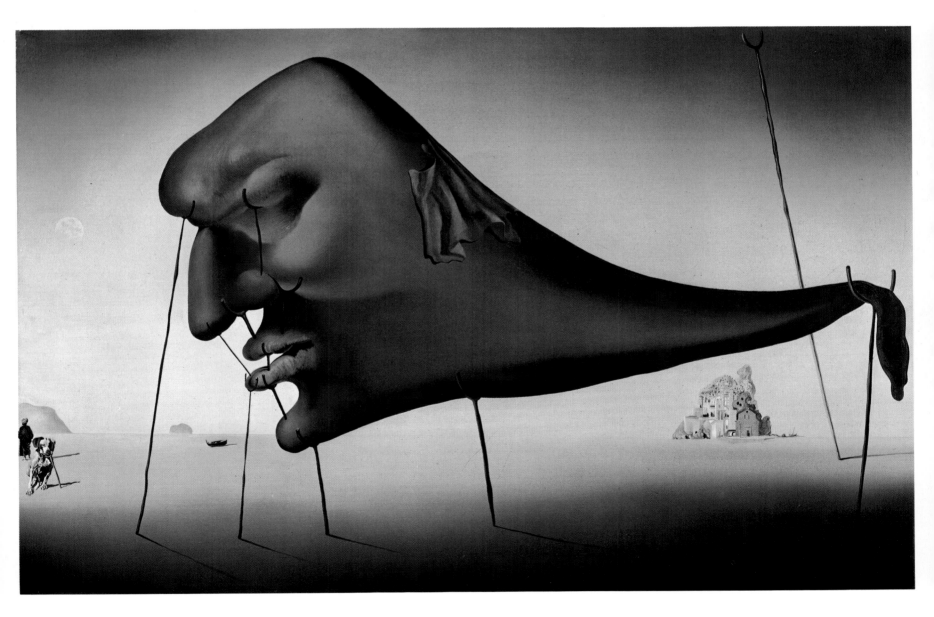

tion effect; the double exorcism with the sign of the cross; the empty, totally illuminated landscape, the logically executed perspective of the picture and the technique, often verging on the *trompe l'oeil*, which creates the impression of the actually experienced. The enlargement and diminution effect also occurs in *Soft construction with cooked beans*: behind the great, cruel, and pathetic gesture of the foreground, stretches into the far distance a landscape with houses and trees; in the middle ground appears in the lower left quarter of the picture a bent, grey, tiny man (similar to the 'chemist of Figueras in search of absolutely nothing' in the picture of that name). Figure, dog, house, and boats in *Sleep* obey the same principle. The effect created by this technique is the monumentalization of the events in the foreground, which in its exaggeration corresponds to the often pathetic quality of Dali's figures.

In 1940 Dali went to America, where some of his already more or less clear preferences and characteristics became especially marked. Maurice Nadeau writes about this period in his *History of Surrealism*: 'In the USA he (Breton) made the final break with Salvador Dali, whom he maliciously called "Avida Dollars" ('Dollar-Greedy'), and who was now wild

51 Salvador Dali
The temptation of St. Anthony, **1946**
Oil on canvas, 89.7 × 119.5 cm
Brussels, Musées Royaux
des Beaux-Arts de Belgique

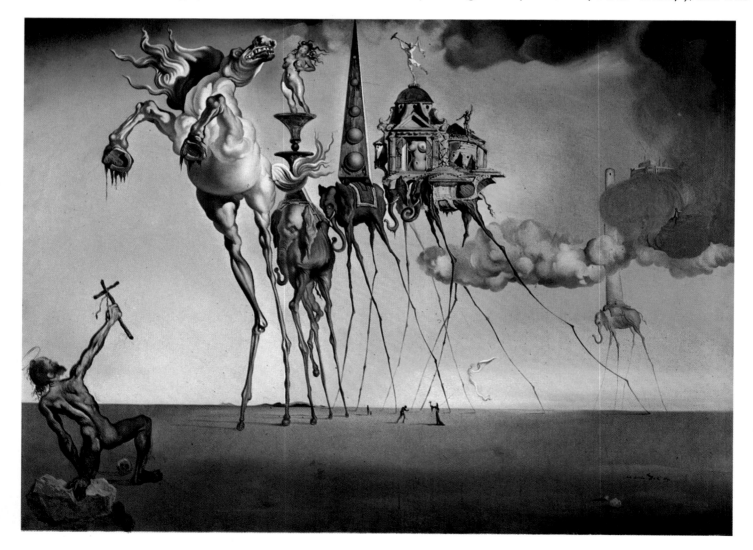

about Franco. Dali had in fact long sympathized with Fascism, and as early as 1934 the group had called him to account for his strange attempt to see a Surrealist renewer in Hitler. In 1939 he produced a fantastic theory of the racial superiority of the Romance dominant peoples, in which it was not difficult to see a Spanish version of the Northern philosophy. In the States, Dali worked together with the Marx Brothers, gave quantities of fashion tips to the big New York couturiers, and cynically capitalized on his ability, by working for advertizing agencies. Having fallen for the charms of Franco, the only thing lacking was for him to start enthusing about the Pope.'

When Dali returned to Europe in 1948, a phase tending strongly towards Catholicism did indeed begin, with religious depictions, and in 1948 the first version of his *Madonna de Port Lligat* was blessed by the Pope.

In his later work Dali showed an increasing tendency towards an academic painting technique in his large formats and unusual perspectives. *The discovery of America by Christopher Columbus*, a brilliant composition in white and brown tones, is a superb example of Dali's technical ability. The young Columbus, flooded with supernatural light, takes the first step on to the new land, the banner in one hand with the Madonna coming to life in three dimensions, leaving behind him the Old World, a sinking sea full of flags, lances, ships, and crosses. A bishop with mitre and staff—a further indication of the missionary goal of the voyage—receives the conqueror, whose hope was, however, primarily directed towards the gold of the colonies.

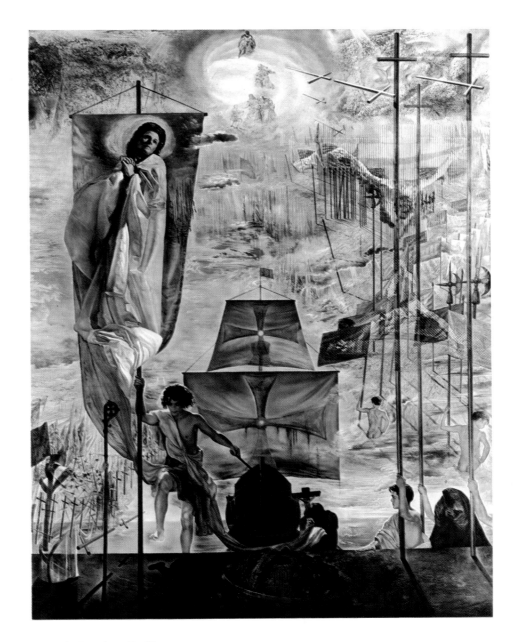

52 Salvador Dali
*The discovery of America
by Christopher Columbus,* **1959**
Oil on canvas, 410.2 × 284.8 cm
Cleveland, Dali Museum,
Mr. and Mrs. A. Reynolds Morse Collection

From the later 1930's, **Delvaux**' work was dominated by a few constantly recurring themes—in particular, half-clothed or naked women with enraptured faces encounter classical architecture, and skeletons (which Delvaux did not wish to be understood as symbols of death). Perhaps no-one has described the atmosphere of Delvaux' pictures better than Paul Eluard.

53 Paul Delvaux
The great avenue, **1964**
Oil on canvas, 140 × 211 cm
London, Acoris Surrealist Art Centre

Nights without Smiles
for Paul Delvaux

The deepest sleep animal-like plant-like
Lets me be created and survive in the night
 without limit.
In the eyes sufficient shadow to see the
 night in them
To see the oldest picture of night
Extended until goodnight to me on this
 bed.

Big naked women purge the desert
This world stands under the domination of
 the glorious flesh
Everything falls home in the moment of
 abandonment
The abandonment of the reflection of a
 dress in an empty mirror

In order to recognize the form and the
 weight of her breasts
The most beautiful one embraces herself
 in her arms in the morning.
The heart hidden in this white mussel
She runs from the bloody high water of the
 dawn red.

Filigree bodies confirm the fossil of their
 pale skeleton
Brighten the abyss.
The arches of the night ideal intimacies
Never bound herbs go higher than time.
Thus half-opens and lies the space of the
 earth.

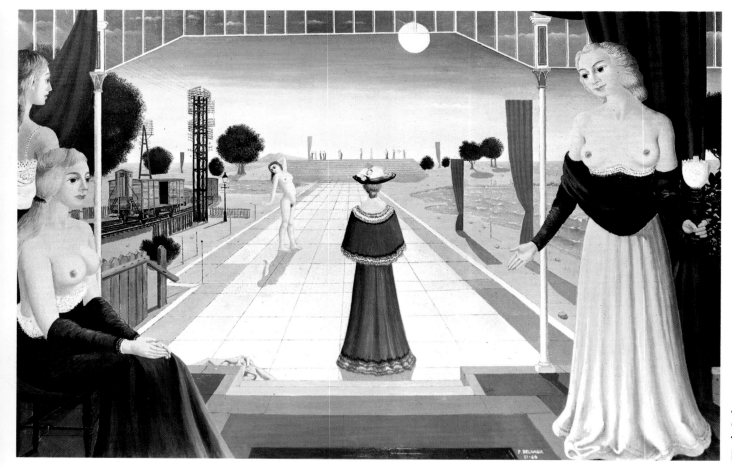

Right 54
Paul Delvaux
Sleeping Venus, **1944**
Oil on canvas,
172.5 × 200 cm
London, Tate Gallery 84

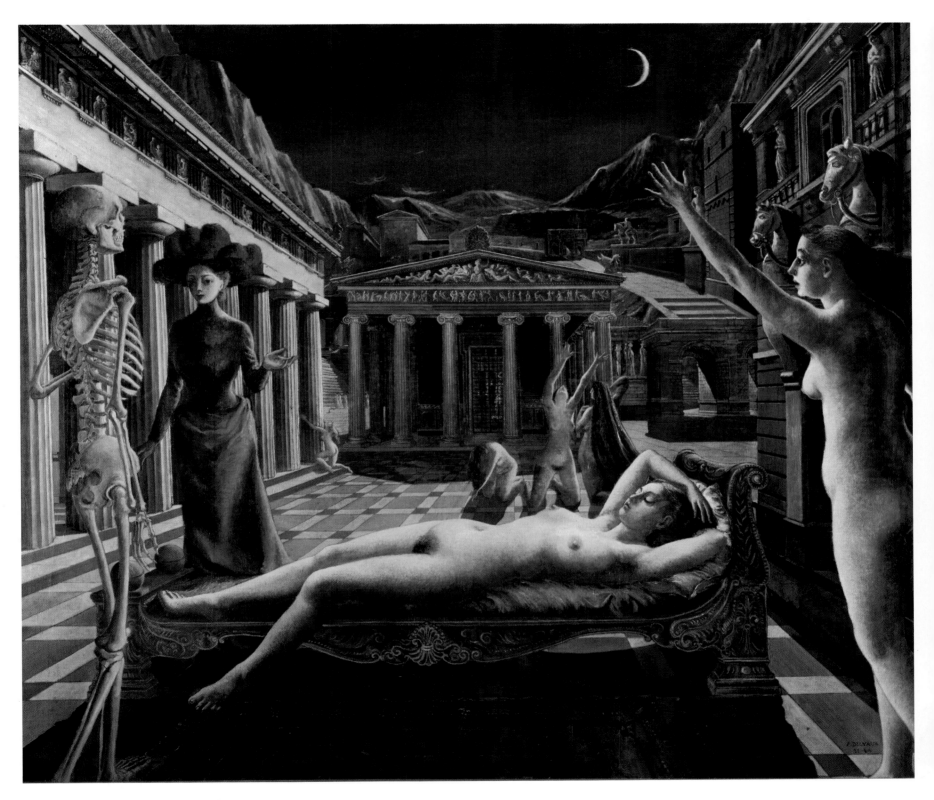

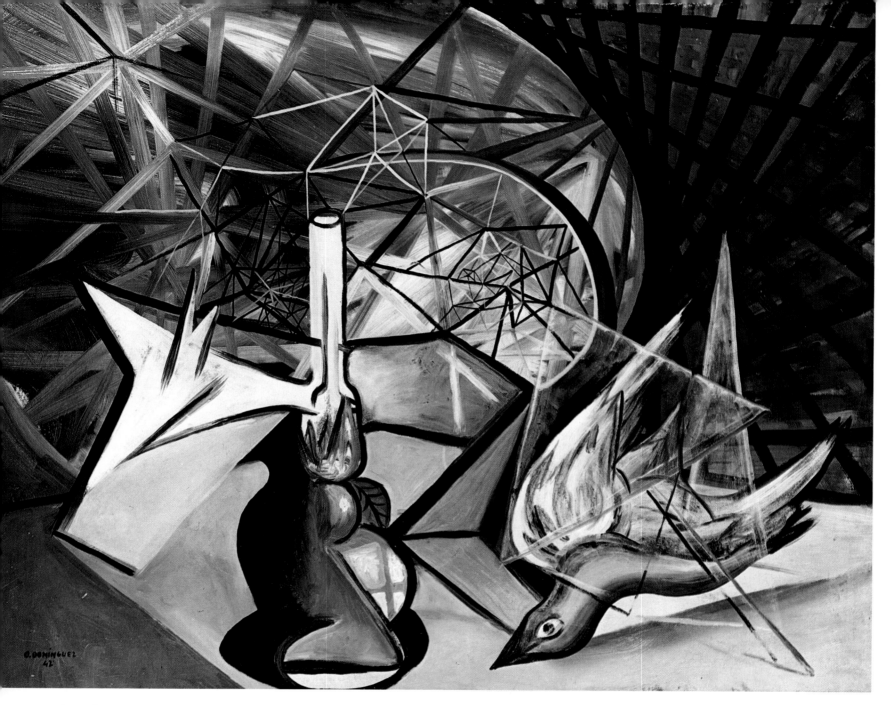

55 Oscar Dominguez
Still-life with birds, **1942**
Oil on canvas, 52 × 78.5 cm
London, Acoris Surrealist Art Centre

Oscar **Dominguez** became especially productive for the Surrealist movement through his 'invention' of what he called the technique of 'decalcomania' (1935).

In its simplest form, the paint is pressed between two sheets of paper, by which process formal suggestions of landscapes, grottoes, rocks, reefs, entwining plants, are created. Psychodiagnostics had used a similar technique since 1921, the so-called Rorschach test. Later Max Ernst in particular came back to this method. During the period of his close collaboration with the Surrealists, Dominguez created several fantastic objects, most of which have now disappeared, but we do know about some of them via the description of his friend and collaborator Marcel Jean: 'The typist stretched two fine ivory hands with long sleeves (back-scratchers) out over glass fragments. "Exacte sensibilité" was a white sphere from which the hand stretched, which injected a subcutaneous injection back into the ball.'

After the outbreak of the First World War, Dominguez was largely isolated from the Surrealist movement. He now related more and more to recent artistic tradition. The *Still-life with birds*, which, with its dramatic movement mocks the concept of 'still-life', shows clear borrowings from Futurism and Picasso. Oscar Dominguez' whole oeuvre still awaits a comprehensive appreciation.

One of the last people to join the Surrealist group before its dissolution with the Second World War was Roberto **Matta**. In 1939 Breton wrote of him in the essay *On the newest Tendencies in Surrealist Painting*: 'One of our youngest friends, Matta Echaurren, has recently mastered a sensational style. With him, too, there is nothing consciously directed, only what springs from the desire to increase the perceptional ability by means of paint, an ability which he possesses to an unusual degree. Every picture painted by Matta during the last year is a celebration in which all happy accidents are gathered, a pearl which shines like a ball of snow in all physical and spiritual lights.' In his, 1944 essay, *Matta*, Breton wrote: 'Matta's richness consists in his totally new scale of colours, which he has used since his earliest works; it is perhaps the only one of its kind, certainly the most fascinating since Matisse. This scale, whose gradations begin with a certain changing purple-pink (a colour which has in the meantime become famous, and which was apparently discovered by Matta—"surprise", I once heard him say, "will flare up like a ruby containing fluorine in ultraviolet light") fans into all colours of the spectrum.

Matta's spectrum, which indeed includes both the analysis of sunlight in the open air and the analysis of salt crystals, goes so far that it may, by means of the various possibilities which are created by the introduction of black light, be enriched still further . . . Something equivalent to this phenomenon only exists in the representations of the primitive on the one hand and in a few esoteric texts of the first order on the other: "The raven's head vanishes on break of darkness; by day the bird flies without wings, it spits out the rainbow, its body becomes red, and over its back swims the pure water", we read, for example, in Hermes.'

The extraordinarily atmospheric colours of *Painlessly to give light*, creating perspectives and scattered like fireworks over the night sky, could not be described more accurately.

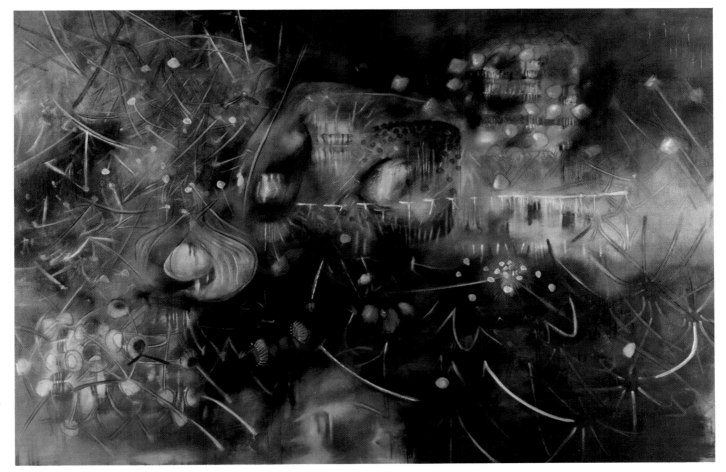

56 Roberto Matta
Painlessly to give light,
1955
Oil on canvas,
200 × 300 cm
Brussels,
Urvater
87 **Collection**

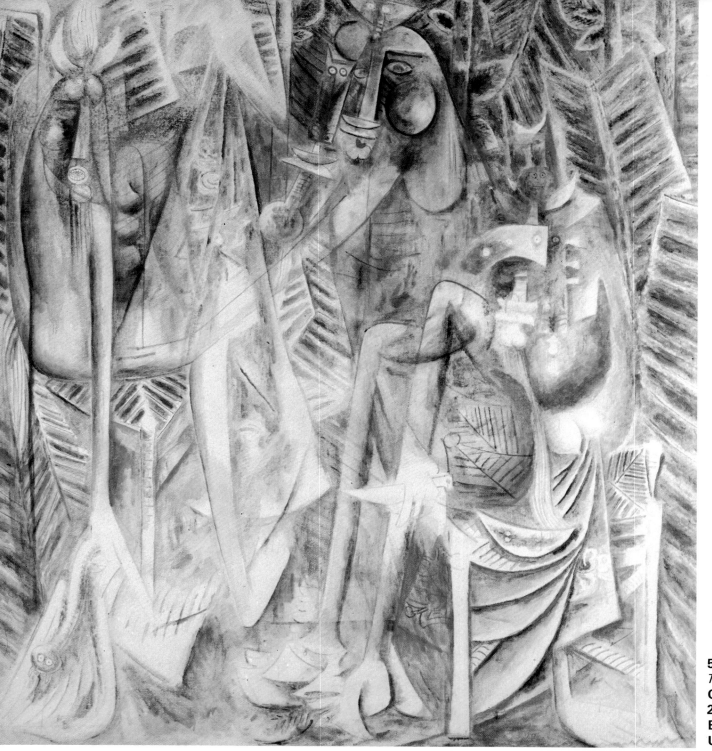

57 Wifredo Lam
The astral harp, **1953**
Oil on canvas,
210 × 190 cm
Brussels,
Urvater Collection

Of all young painters, Picasso particularly admired the Cuban Wifredo **Lam**. This was probably especially connected with the fact that Lam's starting point was the conceptual world of the natives of Cuba, Haiti, and Africa, of idols, masks, and images of gods, a world which Picasso only discovered for himself during the course of his creative career.

In our example *The astral harp*, a light forest is transformed into transparent, totem-like animal-men, whose profoundly expectant, menacing quality is manifested not least by the knife that one of the creatures holds in its hand. The horned spirit is a creature (called Eleggùà in Cuba) which influences people's fates, and haunts doors and crossroads.

Maria Čermínová belonged, after the end of the First World War, to the artistic avantgarde in Prague. She called herself **Toyen** after the last two syllables of the word 'citoyen', the first French word she learnt. Her early works were stylistically close to Cubism, but she later gradually moved towards Surrealism.

In her later pictures she used to work with silhouette-like figures, and with erotically or emotionally emphasized suggestions. The picture *Le paravent* shows a wall screen folded out in three panels, on which on the right and left is the shadow of a male figure. In the middle appears, connected to the screen, but also emerging from it by virtue of the strong light and shadow areas and the dissolving outlines, the figure of a *femme fatale*: clothed in a tigerskin-like costume, faceless, but with a lower body like the face of a beast of prey, which lustfully and aggressively opens its red-painted lips. On its shoulder and breast are the shadowy impenetrable faces of two cats. The impression of the lurking menace is increased by the delaying gesture with which the figure pulls on the poisonous green glove over its white wrist. Two butterflies, each of which casts its own shadow, seem to be the only three-dimensional real beings. With their associations of night, mad flight, and obsession with light, they only strengthen the mysterious impression of the scene.

It is interesting that this visualization of the fascination and danger which man may feel with regard to woman should have been painted by a woman.

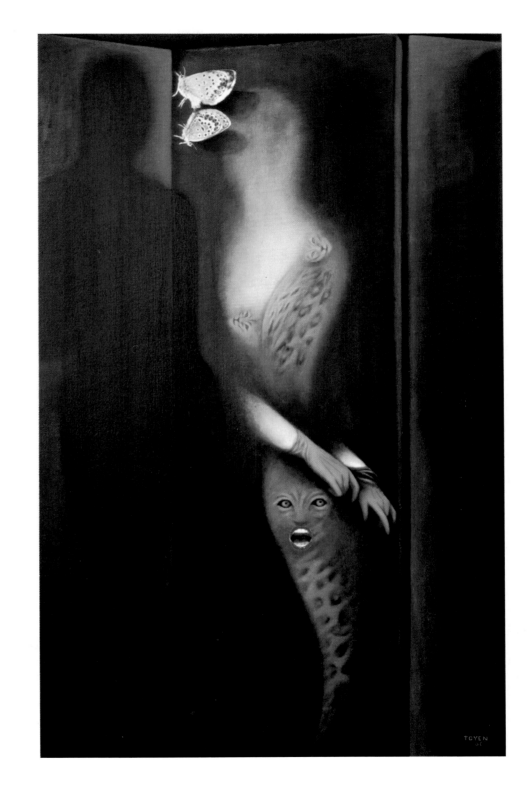

58 Toyen
Le paravent, **1966**
Oil and collage on canvas, 116 × 73 cm
Paris, Fonds National d'Art Contemporain

59 Peter Blume
The light of the world, **1932**
Oil on fibreboard, 51 × 46 cm
New York,
Whitney Museum of American Art

Peter **Blume** was born in Lithuania, but grew up in the USA. Fascinated by the clear and unambiguous forms of the technicized industrial world, he painted his early works in a simple realistic style. From the beginning of the 1930's we can see in his painting the advent of Surrealism, as found in many forms in America at about this time: no distortions, no archaic or mythical signs, but an alienating combina-tion of set pieces from the ordinary every-day world.

Our example, which with its title arouses expectations of a somewhat religious theme, does not fulfil these expectations, but confuses the viewer with an apotheosis of the scientific age. It remains an open question how far the depiction is to be understood in an ironic sense. *The light of the world,* a supradimensional spherical

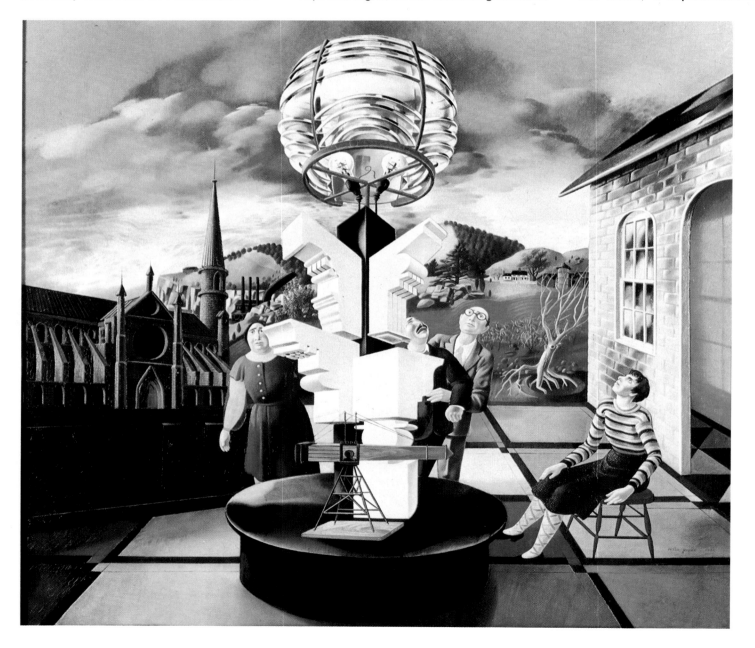

bulb lit up by bulbs inside it, rises above fragments of Greek temple architecture like the crowning of human history over the fragments of a paling past. The pictorial area is essentially divided into opposing spheres: on the left, a Gothic church, in violet ecclessiastical hue, shadows, a women dressed in violet, who—clearly caught in the sphere of medieval belief—does not even see the light of the new era. On the right-hand side, the bright, raised area probably represents the enlightened thought of the technical age. In front of a simple brick dwelling without any ornament sits a young woman in what was at the time no doubt a fairly 'progressive' striped pullover; she looks composedly and with interest at the bright phenomenon, which is also looked at by two men. One, a scientist type, looks at it critically, obviously more interested in the detail than in the whole, while the other, the embodiment of the primitive, unreflecting type, gazes submissively and nonplussed. Four people . . . four different ways of relating to the fact, here emphasized, that the light of this world is not from heaven but is indeed of this world.

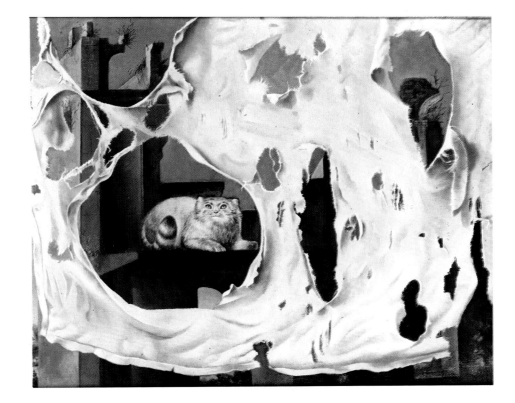

60 Leonor Fini
The cat Manul, **1943**
Oil on canvas, 36.5 × 45 cm
London, Acoris Surrealist Art Centre

Leonor **Fini**, the most famous woman amongst the Surrealists, was born in Argentina, but grew up in Italy. She painted her first pictures in Milan, where she was in contact with Carlo Carrà and Arturo Tosi; later she moved to Paris, where she was close to the Surrealist group, and occasionally took part in their exhibitions. De Chirico, Cocteau, Dali, Eluard, and Max Ernst were enthusiastic about the young, extravagant painter, and about the morbid, vulnerable beauties, the delicate and lascivious girls, sirens and sphinxes, the homosexually erotic atmosphere of her pictures. Jean Genet, the

impassioned adorer of the abnormal, described the highly conflicting charms of her painting with the words: 'All the ladies stretched out in alcoves and their elegant lovers are afflicted with the plague.'

Fini paints smoothly, unemotionally, carefully, with glazed application of paint layers. The Old Masters (especially Lucas Cranach), the Pre-Raphaelites, and Art Nouveau inspired her work in different ways. The often ornamental *morbidezza* of her work does not always avoid the pitfall of refined salon art. Leonor Fini herself lives a worldly bohemian life amidst old furniture, silk cushions, veils, pearls, and

lace, surrounded by many cats, which also frequently appear in her pictures. Our example is the mysteriously menacing portrait of a cat by the name of Manul, which looks at us through an attractively ragged cloth and thus gives the painter the chance to demonstrate the delicacy of her painting. The 'surrealism' of the pictures does not consist in the communication of unconscious spiritual matters; it only becomes discreetly apparent through the mysteriousness which is achieved by the fact that the cat is present behind the ragged curtain in all its lurking animal mystery, but yet is not tangibly 'there'.

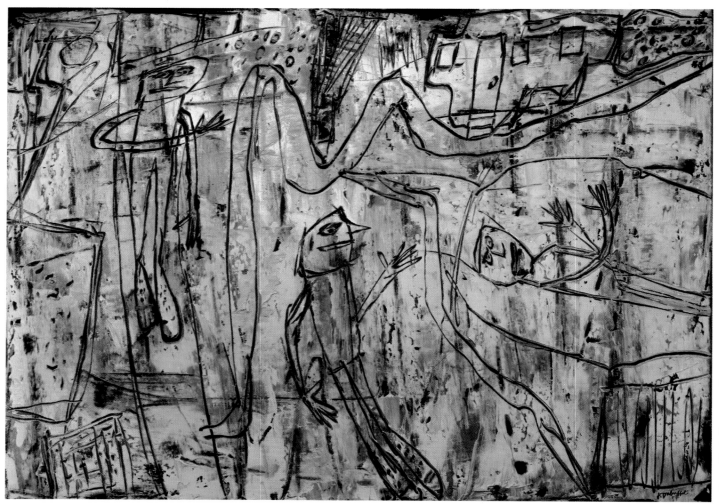

61 **Jean Dubuffet**
The winding path, **1957**
Oil on canvas, 89 × 117 cm
Private Collection

Dubuffet's work is close to Surrealism, even if he was no programmatic Surrealist in the narrower sense. His subjects do not come from his own unconscious, but are based thematically on the collective unconscious, on the pictures of children, the mentally ill, and primitives, and on anonymous wall scribblings.

Dubuffet was for a long time undecided whether he should become a painter. While still at school he had enrolled for the Academy in Le Havre, but then he studied literature, philosophy and music. For ten years he was a wine dealer, before he finally decided to commit himself to painting. Urged by the writer Georges Limbour, who from 1922 to 1929 had been a member of the Paris Surrealist group, he

exhibited for the first time in Paris in 1944: the public was as shocked as in the days of the prime of Dadaism. But whereas Dadaist art gave the spoilt public's taste something tangible to grasp, with its wit, originality, and a certain kind of aesthetic quality, Dubuffet's work was seen as nothing but provocative blundering. Only writers of various tendencies were from the beginning greatly interested in Dubuffet's *art brut*. In 1945, in his collection of tests *Prospectus aux amateurs en tout genre*, he described his radical artistic ideas in the following words: 'I am thinking of paintings which are quite simply made out of one, monotonous mud, without any variation, neither in tone nor in colours, not even in the gleam or in the

arrangement, and which only create their effect through those many kinds of signs, traces, and living imprints, which the hand leaves when it handles paste.' Accordingly, he worked with thick colour pastes (Hautes Pâtes), and preferred earthy tones in his range of colours.

The surface of *The winding path* has, through the use of spatulas, scraping, and scratching, taken on the texture of a disintegrating wall. The title is based on the path, seen from above, as in children's drawings, which is not even stepped on by the frontal men, who stand with expansive gestures between the paths.

In the drawings of children, the mentally ill, and so on, as in hieroglyphic languages, the 'what' is often more important than the

92

'how'. For the highly civilized, adult, 'normal' viewer, on the other hand, the charm of such pictures is less often in their content than in the whole encounter with a primordial quality which one has oneself lost, with the atmosphere of a world in which one does not oneself live, but in which one in the last analysis would not like to live.

The work of Dorothea **Tanning** is distinguished by a marked preference for erotic themes. In her pictures of the 1940's, we often meet the precisely painted fantasies of awakening young girls. Later,

female nudes are, as in our illustration, often joined by animals, which, with the animal warmth which they radiate, intensify the already sensual atmosphere. Usually they are animals with long and thick fur, as, for example, the dog in the 1952 *Interior scene accompanied by sudden joy.* In this picture, a young negro embraces a white, cloth-like 'figure', which dissolves into ends of material, folds and baubles. A similarly ambiguous play with physical forms is the female nude in our example, for it remains ambiguous whether this white, seductive form belongs to a woman of flesh and blood, or whether it is

the hallucinated projection of an erotically fixed consciousness into a white puffed-up sheet. The sensual quality of the whole arrangement is intensified by the large jet-black eyes and the little open mouth of the lower lapdog, as well as by the light which falls on the rounded hips before the blue clouded sky and which seems to combine the form of the rising moon with the female body.

62 Dorothea Tanning
Evening in Sedona, **1975–6**
Oil on canvas, 112.5 × 146 cm
Paris, Private Collection

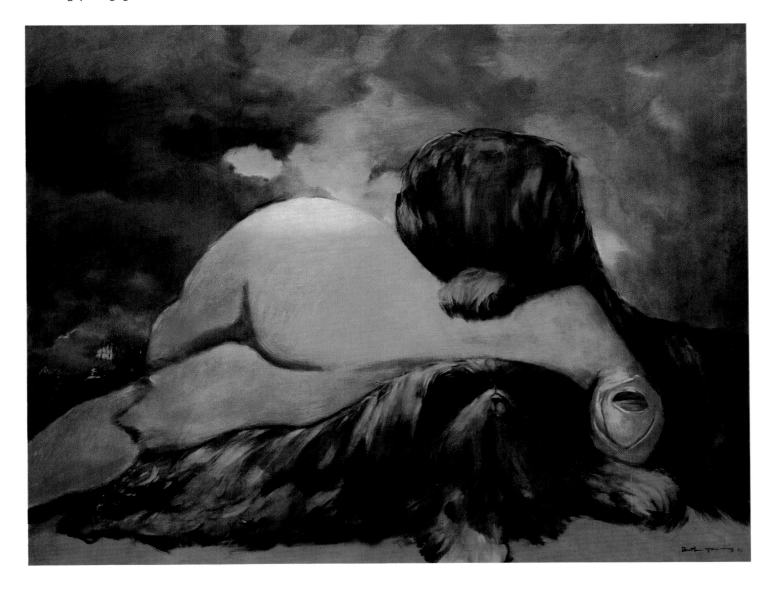

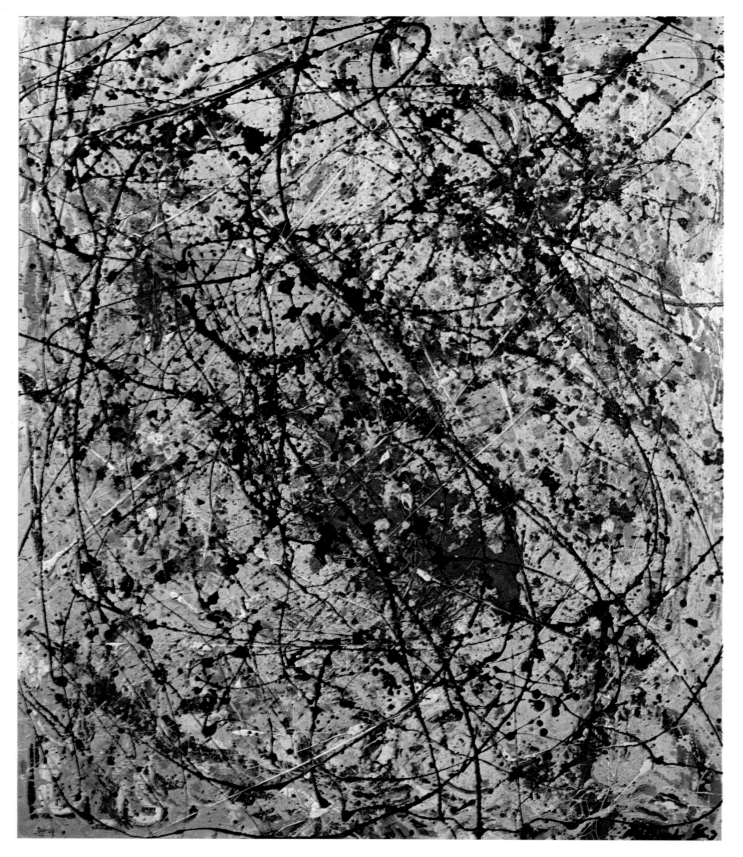

63 Jackson Pollock
Reflection of the great bear,
1947
Oil on canvas,
110.8 × 92 cm
Amsterdam,
Stedelijk
Museum 94

Pollock and Wols, the main representatives of Abstract Expressionism and Informal respectively, cannot strictly be reckoned as part of Surrealism. But their works are close to the Surrealist programme inasmuch as they are based on a painting technique analogous to that of *écriture automatique*. It is the influence of Ernst and Masson (Ill. 40) that here makes itself felt. Like the Surrealists, who in their attempts at automatic writing sought as far as possible to be completely free of all restraints and of the influence of outside ideas and associations, so **Pollock** behaved in his painting process: his pictures are not 'pictures' in the traditional sense, they are the traces of painting 'actions' made manifest. Pollock spatters and drips the canvas with liquid paint in a kind of meditative soliloquy, which is not 'depicting' (for instance in the sense of Dali's 'dream photography'), but is a spontaneous gesture. He himself describes his actions thus: 'Painting is the discovery of one's own self', and 'I want to illustrate rather than to express my emotions.' 'If I am *in* my picture, I am not conscious of what I am doing. Only after a period of becoming familiar with it do I see what I have painted.'

In **Wols'** work, the relationship to inner reality is expressed more figuratively and at the same time in a more complex way than in Pollock's drip paintings. In this brief space the most characteristic qualities of Wols' work can perhaps best be summed up by the words of his long-standing friend and supporter Pierre-Henri Roché: 'What does Wols do? Like a diver he goes down to the depths of himself, and his hand draws everything that he sees—spider webs, grasses, algae, forests, monsters, molluscs, mountain towns, houses as ships, islands, ornamental butchers, attractions, folds, and knots of fear. All that, and many other things besides. *These visions he orders in a crisis.* Certainly, sometimes one can recognize things, but that is not the point. The point is his plea, his ecstasy, his anger.'

64 Wols
Burning bushes, **1944**
Oil on canvas, 12 × 18 cm
Private Collection

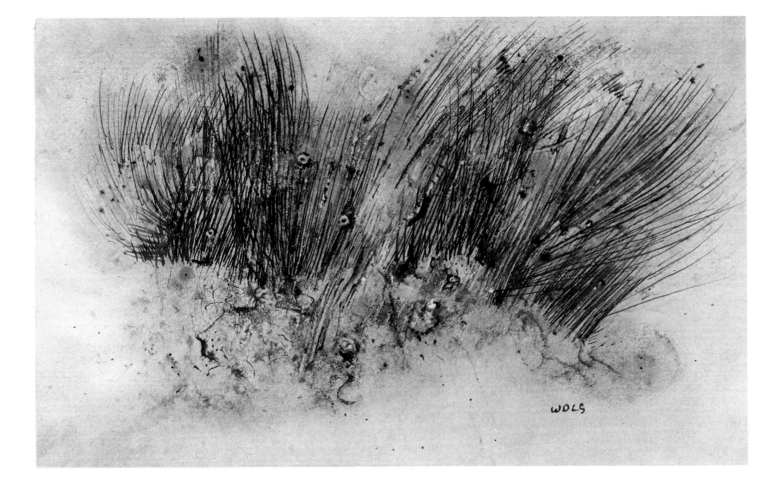

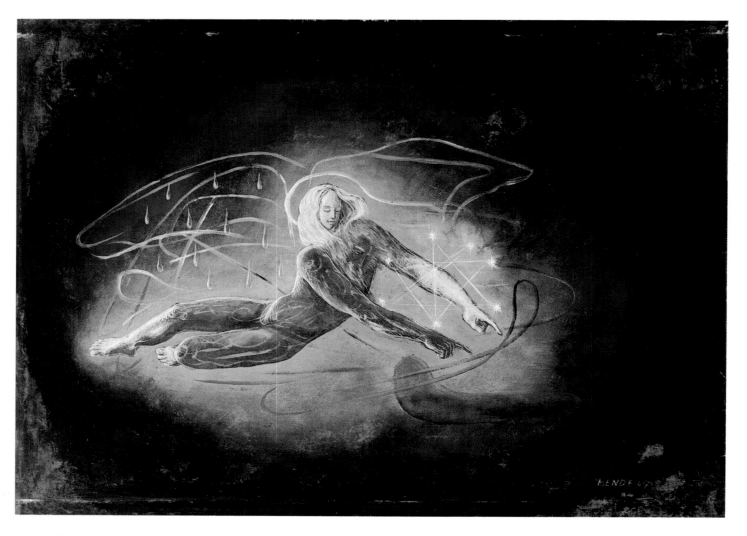

65 Edgar Ende
The birth of the tear, **1947**
Oil on cardboard, 50 × 68 cm
Munich,
Staatsgalerie Moderner Kunst

Edgar **Ende**'s *The birth of the tear* occurs through a pathetic creative gesture—a vague suggestion of Michelangelo's *Creation of Adam* in the Sistine Chapel. The androgynous creative being itself possesses Michelangelo-like powerful limbs, but pale, feminine, rapt features. The tear, as suggested here especially through the colouring, appears as a mild relief from the dull, heavy, dark brown. It shines brightly in the blue gleaming light of an aura reminiscent of glaciers or crystals.

The mythical figure hints at a dissolving lemniscate—clearly a symbol of the dissolving tension. The star figure formed of seven white stars gives this gesture the consecration of holy legitimacy.

Unfortunately, the lines which cover the body of the figure, and especially those which surround it in the air, appear all too unmotivated, vaguely decorative; they thus confuse the statement, which the picture's title, the gesture and the colouring jointly create, with unconnected and random features. It might perhaps be mentioned in this connection that Ende began his career as a scene painter.

'I am afraid of going to sleep—a fact which can be broadcast', Richard **Oelze** once confessed. This extraordinarily taciturn, withdrawn artist works slowly, and very precisely, square centimetre by square centimetre. At work he likes to wear a black suit, paints in the afternoons, reads at night, keeps away from the madding crowd of cultural activity, and feels his way in the fantastic and errie realms of phantoms and ghosts of the dead.

Growing stillness is an almost monochrome picture, completely built up from form—a reduction of organic life 'growing' into the infinite. Amorphous animal heads, some reminiscent of birds, dogs, or sheep, and empty human faces petrify in an unviolent death. Silence reigns : all mouths are closed. But the eyes are awake, and the general paralysis can clearly do nothing about the mute looks. They register the terrible event, how animals and men are here becoming sediments, a quarry, and increasingly belong to an overgrown, crumbling past. *Growing stillness* is the envisaging of a reverse evolution of life and thus the expression of a profoundly pessimistic philosophy.

66 Richard Oelze
Growing stillness, **1961**
Oil on canvas, 98 × 125 cm
Cologne, Museum Ludwig

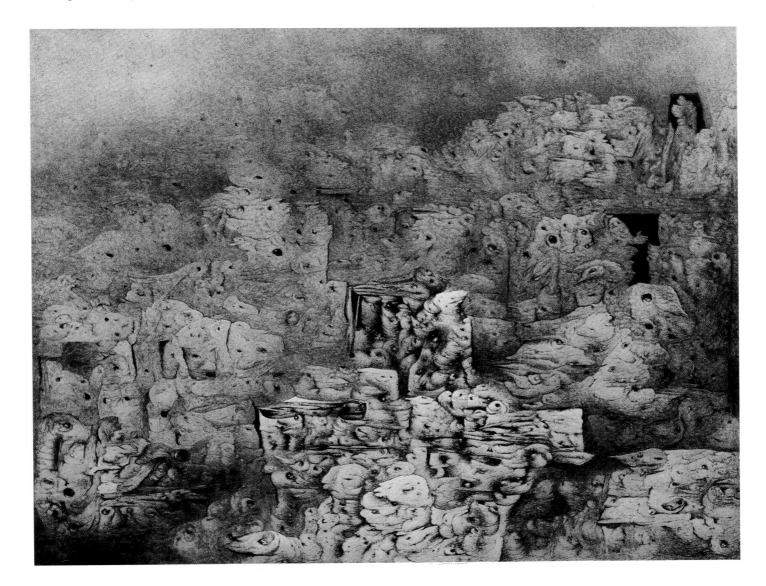

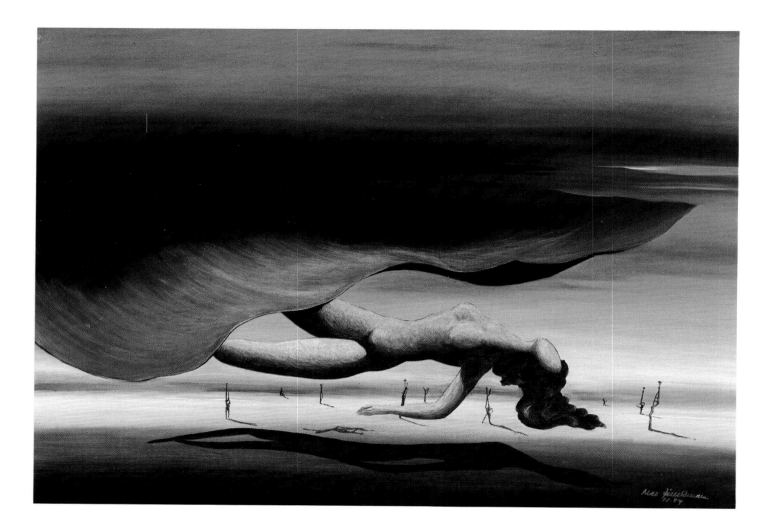

67 Mac Zimmermann
Night (**from the cycle**
Four times of day), **1954**
Oil on fibreboard, 50 × 70 cm
Berlin, Nationalgalerie

In comparison to France, and later Austria, Surrealism never really gained a foothold in Germany, and German Surrealists were rare. Max Ernst, the great exception, can count as half-French, since he spent the greater part of his life in France. Of the younger generation, Mac **Zimmermann** —along with Edgar Ende, Richard Oelze, and Heinz Trökes— is probably the most significant figure on the German Surrealist scene. His models are primarily Dali and Tanguy, as our example *Night* indicates. The beach-like landscape with hazily dissolving horizon in ochre, brown, blue, grey and white, is directly reminiscent of Tanguy. The half-human figurations of the background with their sharp shadows are also close to Tanguy's bizarre pictorial world. Dali's influence may be felt in the immediate transition from the large foreground figure to the tiny figures of the background.

The night sinks protectively and veiling like a blue cloth over the sleeping figure, who floats, suspended from gravity, in an abandoned position above the ground. The sleeping woman is faceless and anonymous, and thus an embodiment of *every* sleeper and of night itself. The strongly allegorical, notional character of the whole arrangement is unmistakable, in spite of all the stylistic closeness, and separates Zimmermann from programmatic Surrealism.

The work of Wolfgang **Hutter** is the most straightforward and thematically un- complicated of the Vienna School. Hutter's layer (i.e. not glazing) technique is much less rich in nuances than that of an artist like Fuchs, but creates magnificent effects.

Hutter was from the beginning of his career close to the world of opera and the theatre. For the new Festspielhaus in Salzburg, he created the large panel *From night to day*. His pictorial world is popu- lated by erotic doll people, bright fantasy plants, appearing to consist of material, and by butterflies and by birds. Typical titles are *Flying gardener girl, The flower prison, The bird servant, The bosomed girl,* or *The painter in his garden*. The child-like, beautiful, empty faces, the colour com- binations, the gestures, have something of the perfumed elegance that one can find in fashion salons: here there is no 'nature' in the sense of growth, struggle, and decom- position; here is a theatre paradise, that knows no transience.

The weather witch, too, is a being from that beautiful dream world. With the gestures of a beautiful dancer, she con- jures up a violent storm, which admittedly from a distance is reminiscent of ragged storm clouds, but in reality is something soft and caressing: the hair of the little witch is mixed with blue strands, clearly blown by winds in opposite directions, one moment to the right, one moment to the left. Dense, fluffy feathers rub up against bubbly foam, floating grapes and balls; fashionable material flowers come out of an aperspectival box—in short, a storm is here brewing which will bring the farmer not a single drop of rain.

68 Wolfgang Hutter
The weather witch, **1964**
Oil on canvas, 40 × 60 cm
Vienna, Galerie Peithner-Lichtenfels

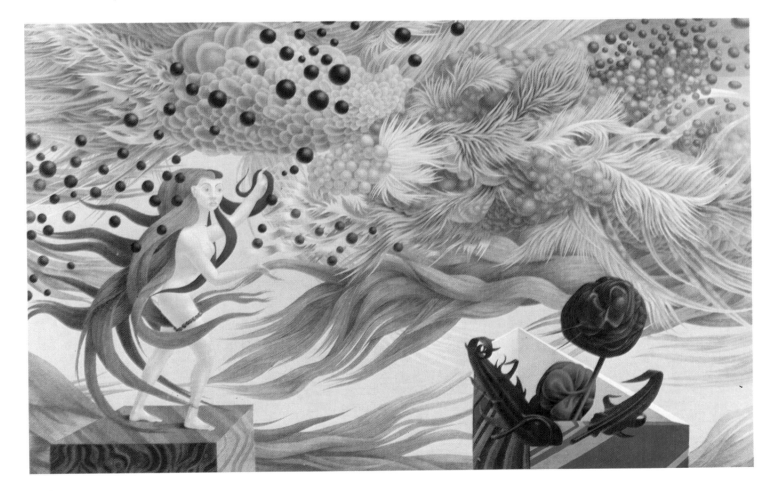

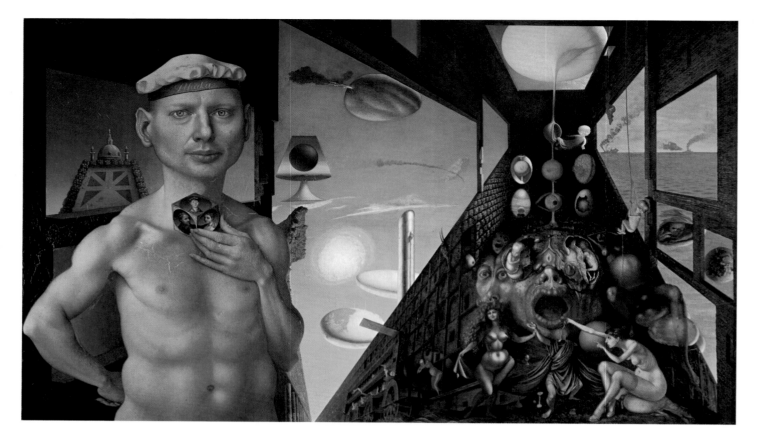

69 Rudolf Hausner
Ark of Odysseus, **1948–51, 1953–6**
Oil on wood, 110 × 150 cm
Vienna,
Historisches Museum der Stadt Wien

The *Ark of Odysseus* is considered to be **Hausner**'s most important picture. He spent almost six years on it, with interruptions, and changed its form several times during this period. Like all Hausner's paintings, it goes beyond programmatic Surrealism in its complex significance-laden quality: the figures, arrangements, and details are deliberate translations of spiritual conditions into visual terms, and are to a certain degree translatable back or further into language. Here we can of course only very briefly go into some of the most distinctive aspects of this pictorial universe of a man's soul.

First, the face of Odysseus, that we meet in almost all Hausner's paintings, is remarkable. It is—in a whole series of pictures—the face of Adam, of man in general. Here it is the face of the modern wanderer . . . it creates a self-portrait-like effect, but is at the same time translated into a monumentality representing man itself. The sailor's cap, a childhood memory, equally recurs in many of Hausner's pictures. Like the medallion with the self-portrait as a boy and his parents, and the appearance of an orderly park landscape in the background on the left, it seems to indicate the protective forces of childhood, which can retain a relaxed and tranquil quality in spite of all catastrophes.

The ark of the wanderer hides the fate that seems to strike him from inside himself, no doubt to be understood as the prestructuring of the world by the psyche. Only human tragedies like wars, represented by sinking battleships on the horizon, or even cosmic changes like the creation or dying away of oval heavenly bodies, take place on the sea or in a green outer space and come from outside the ark. This sense of 'outside and inside simultaneously' is visualized with great sensitivity through an overturning of the 'outer' windowfront into an 'inner' wall.

In the interior a painful drama of becoming and dying is played out: embryonic children are born, break out of their membrane, and seem to die. The thought of them is clearly a painful burden for Odysseus. Two women, one lascivious, the other delicate, suggest on the one hand possible partners for the wanderer, but on the other hand—as in the picture *Adam himself*—also hint at the feminine figure present in every man. In the darkness of the spiritual interior, they turn Odysseus, who on the left-hand side of the picture gazes so composedly, into a headless, fidgety, spineless puppet.

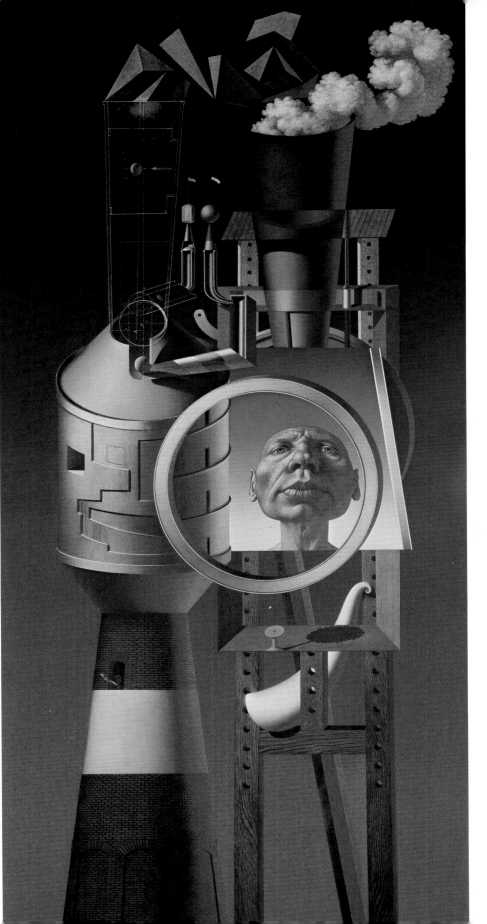

71 **Rudolf Hausner**
Adam after the fall II, **1974**
Mixed technique, 200 × 100 cm
Hanover, Galerie Brusberg

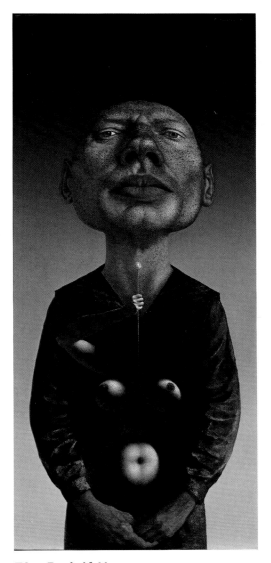

70 **Rudolf Hausner**
Adam himself, **1960**
Mixed technique on wood, 95 × 43 cm
Vienna, Dr. E. Plannger Collection

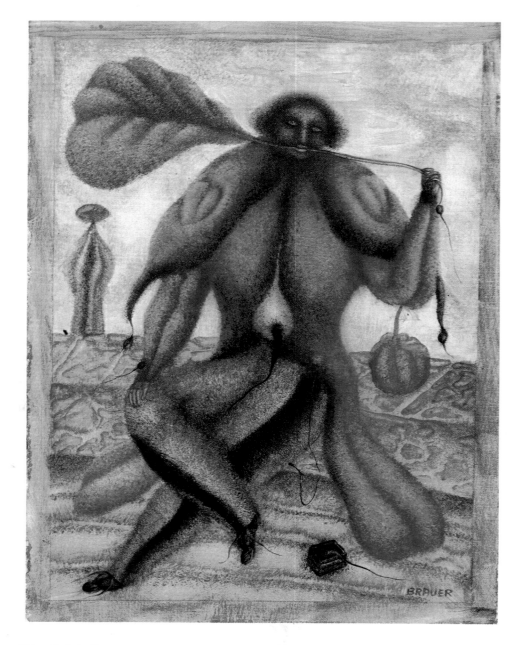

Bulbous fruits and often ornamental, Art Nouveau-style flourishing ends, tails, runners, and roots occur frequently in Brauer's pictures. They often form a close connection between the figures and the vegetable matter which surrounds them.

The bulb eater has roots coming out of his shoes, they grow out of his clothing on his wrists, the folds of his sleeves, his hip, and even the little box lying on the ground has a little blue root cheekily growing out of it. The right hand (as seen by the viewer) contains an ambiguity: it remains unclear whether the continuation of the leaf comes from the big green bulb or from one of the smaller bulbs which protrude from his clothing at other points. The belly is illuminated in the form of an onion, and a root seems to be growing from it, too.

On the ploughed earth sits an earth-brown person, wrapped in a red costume and with a tranquil expression devoting himself to the taste and consumption of a plant.

One may ask what is 'Surrealist' about this picture. It is, perhaps, the sense of the transcendence of daily consciousness, the breaking down of our ingrained habit, and the fact that we no longer see or understand everyday events like eating and drinking. Something is here made visible that we experience every day without thinking about it: the fact that the food that we daily ingest we *make part of ourselves.*

72 Erich Brauer
The bulb eater, **1968**
Watercolour, 20.7 × 15.5 cm
Paris, Private Collection

Brauer's pictorial world is often filled with Oriental or fairytale-like figures. Typical titles include, for instance, *Dream cradle, Thinking cap, Grandfather's dance, Herb dress,* or *Flying mussel.* But in addition to all the fantastic inventions we also again and again meet pictures which are devoted to quite simple everyday activities, like *The melon eater* or *Porter at evening. The bulb eater* is a simple picture of this kind.

The landscape is the constantly recurring principal theme for Anton **Lehmden.** 'Everywhere where Lehmden is, there is landscape,' Albert Paris Gütersloh once said of him. It is not the idyllic, uncon-sumed landscape which obsesses him, but rather the chaotic, bursting landscape, often churned up and destroyed by man and natural catastrophes. The catastrophe of war, which has often ridden over men and landscapes to the same degree, has

occupied him since 1948 in ever new forms. It has manifested itself in huge menacing birds, gaping chasms, wailing giant fish, and tank battles.

War picture III is also called *Fighting men in a landscape*. The earth is burst apart, the heaven in rags, in the background appears a miniature winter landscape, reminiscent of Brueghel. But if one looks carefully, one discovers on trees and on the horizon red tatters of blood, flesh or flames. Hands grow out of the ground, armed with knives. In the sky appear faces and a head, being hacked to pieces by a wildly aggressive bird. A floating body flares up into black flame. And in the midst of it all is a tangle of fighting men, inflicting the most terrible pains on one another. Heads, legs, and feet are painted in different positions simultaneously, thus emphasizing the restless entanglement of the bodies—most especially, the two heads of the man who is being most horribly beaten, whose flesh is being cut from his side: one head has already sunk to the ground, while with the second head he is just as fully conscious as his hand, which plunges the dagger into the flesh of the man in front.

The whole scene, with its powerful graphic conception (as always in Lehmden's work), is kept to only three colours: a cold, dead white, a sharp black, and smoky rust-red. They are the colours of blood, death, and cold.

73 Anton Lehmden
War picture III, **1954**
Oil on fibreboard, 73 × 93 cm
Vienna, Museum des 20. Jahrhunderts

74 Ernst Fuchs
*Moses before
the burning
bush,* 1956
Oil tempera
on wood,
18.5 × 25 cm
Vienna,
Bundes-
ministerium für
Unterricht-
Kunstförde-
rungsankäufe

Ernst **Fuchs** has himself said that programmatic Surrealism very much strengthened him in the desire to obey his impulses like a medium and to give himself completely to the pictures which arose within him. Certainly, he follows quite openly a very conscious 'programme', thought through and formulated by him, and in this sense differing from Surrealism. Fuchs, a baptized Jew, is convinced that the artist must show humanity his own fears, but must also offer the possibility of new confidence.

With a technically perfect style he draws on scenes and symbols from the Old and New Testament and from the Apocalypse. Gustav René Hocke has said that Fuchs is one of the few artists of our age who can still paint angels. In his visionary mythical pictures, Fuchs sees mediators which after the passing away of old myths can inspire men to the creation of new myths, which are, however, closely linked to the old ones. Our example *Moses before the burning bush* testifies to the astonishing abilities of the artist. The picture is conceived as the penetration of earthly material (even if flooded with holy light) and an unearthly holy light figure. Intersecting chains of hills stretch to the horizon. The costume of Moses is fully three-dimensional in its light and shadow, as are the shoes and staff laid aside. In front and behind is the non-material face of Christ, streaming with preciously gleaming tears or beads of sweat, which flow from the flaming crown. The light figure of God the Father carries as a symbol of the old covenant the seven-branched candelabra. The picture, in its artistic, almost artificial perfection, harks back to the Mannerist heritage, to which Fuchs feels himself explicitly indebted. Fuchs himself has explained what he understands by 'artificial' in his book *Architectura caelestis*: 'But most of what has been said is for the unhindered dream of the town, no doubt never built on earth, but heavenly, with its inexhaustible wonders, terraces, stone cataracts of rose quartz and lapis lazuli, vision of the garden of gold and emerald, where every flower is artificial, nothing of nature, but all of art. Oh, artificial town! How the word "artificial" should be understood in quite another way: a gateway to the wealth of the human spirit and its interpretations. And is this dream not the beginning of human life itself?'